Dreams

of

Yves Tanguy

Richard Albright

Copyright © 2017 Richard Albright

All rights reserved.

ISBN: 9781530314843

DEDICATION

This book is dedicated to my wife Jodeane Albright who without her help and encouragement I would never have finished this book

This book is an illustration of fiction. All characters and accounts made public in this novel are the brainchild of the author's imagination.

ACKNOWLEDGMENTS

I want to thank the art professors at Utah State University who allowed me to write my term papers as short stories. They include: Twain Tippits, R. T. Clark and A. J. Meek.

Authors who influenced my writing are: Edward Rutherfurd, Ken Follett, Kim Stanley Robinson, Marion Zimmer Bradley, Edgar Rice Burroughs, Umberto Eco and China Miéville.

PREFACE

In 1987, my wife and I visited Connecticut. We were on a quest to find the best of the best antiques for our home. We also wanted to experience roaming and reminiscing at the oldest cemeteries of the nation. In those cemeteries we located the burial plots of many early authors and artists who were fundamental creators of American culture.

While rummaging around in the back of an antique store in Woodbury, Connecticut, I came upon a dusty leather bound pack of papers. The package seemed like nothing special and was at the bottom of a tall stack of books. Being curious, I managed to release the packet without damaging it or making the stack of books fall. That would have made a lot of noise and attract attention.

The leather-bound bundle was held together by a single piece of brown jute string and upon untying it, I, with care, lifted one flap, then the opposite flap. I then lifted the top and bottom flaps exposing a stack of brown stained letter-sized papers. On the first page I saw the words, "Dreams I have had." It was hand written and the once blue fountain ink had faded to light brown.

If the first page hadn't gotten me interested, the second page began to shape a most fanciful description of situations that could only be described as dreams and dreamscapes. This piqued my curiosity even more.

With head movements, I called my wife over to help me decide what to do. When she saw the stack of dusty papers

and what they contained, she began figuring what they might be. After a short measure of fascination, I re-tied the pack, then added it to a collection of old books that we both chose for our home bookroom.

When we found our way optimistically to the front of the store and placed the stack of books on the check-out counter, the storekeeper began to inventory the books, check prices and punch the prices into the cash register. As the storekeeper reached the leather packet he paused, turning the pack over several times searching for a price. Having found none he faced me and asked what I thought it might be worth. I, being of an honest nature declared, as the thought took me, that it might be a journal of some sort and feigning disinterest that it might be worth—(a sum that I would rather not divulge here).

The gentleman agreed to my premise and offer. At that point we finished the transaction and left the store. We threw the books and items into the car's trunk and drove off to our next destination.

It wasn't until a few years later that I, at long last, found the time and inclination to investigate further. The leather bound pack was relegated to a box of books that we deemed had little enough value and was close to being donated. Again the packet of papers drew my interest and I withdrew it and set it aside. Then I closed the box up and set that aside for donation to the library book sale.

One evening after finishing the dinner dishes, I decided to sit down and read as many of the papers I could. While the handwriting was not easy to decipher, after a few pages I managed to get the rhythm of the writing.

Yes, it was a journal of dreams by whom I did not know. I read on into the night, telling my wife that I would

be to bed in a while. When four a.m. rolled around, she entered the living room to see what kept my attention so late. I was nearly to the last page when she sat down beside me. As the last page was revealed, there at the bottom of the page was a name. It was scrawled in scratchy faded ink, "R. G. Yves Tanguy", dated 1954. The pack of papers was apparently his journal of dreams. My wife convinced me to come to bed and I slept late into the next morning. At that point I drove to the library to investigate this, who I knew was a painter, Yves Tanguy.

I become aware of a book of surrealist painters and was surprised to find him listed and a few color plates of his paintings. I checked the book out, brought it home and began to study this painter and his history.

I read that in 1939, Yves Tanguy encountered the painter Kay Sage in Paris and soon after, journeyed with her to the American Southwest. They wedded in 1940 in Reno, Nevada and began a life together in Woodbury, Connecticut. In January 1955, Tanguy suffered a fatal stroke. His body was cremated and his ashes preserved until Sage's death in 1963. Later, his and Sage's ashes were mixed, then scattered by his friend Pierre Matisse on the beach at Douarnenez in his beloved Brittany, France.

At this time I began to read the papers again in more detail and near the end of the papers he seemed to describe a painting which he titled "Imaginary Numbers." He described the painting as if it were a place. A most odd place indeed.

Over the following year I poured over the writings to gather what his mind might have been like. His dreams it seems, were as diverse and animated as with anyone who had a vibrant and colorful imagination. The dreams ranged

from the light hearted to the dark, not often visited recesses of a depressed psyche. And as a result, it seems that he spiraled, according to some sources, down into his depressing paintings. Not that I think of them as gloomy, but even I perceived a change from his earlier work.

Thus with the original drawings and descriptive narratives that I read in that packet of papers, I here now recount what darkened Mr. Tanguy's door; a journey Yves realized in his dreams.

And I now, as faithfully as possible and with the immense emendations of my wife, who was an editor at the local paper, give an account of this journey he made into his last canvas, "Imaginary Numbers," and I hope that I have, at this time, communicated it faithfully.

Richard Albright

One

Yves Tanguy's paint brush scratched at the canvas then with quick side to side motions, smoothed the French Ultramarine oil paint to a bright gloss. He reached for more paint—the palette held no more, only a thin left-over wash. This didn't happen very often. He was usually quite pig-headed about his inventory. Few times in his painting life did he have to stop just because he ran out of a color. Never, no never was he ever out for more than a day, sometime only hours. He didn't have time to break proceedings. His doctor pushed him to stop smoking. No time to dawdle.

"Kay! Do you have any French Ultramarine?" Yves called to his wife in the other room.

"No, do we need some?"

"Yes. Please add it to your list." Yves paused, looking around at the other tubes of oil colors, counting the blues, greens and hues of red. He found several nearly empty, but those he used seldom, so he continued, "Um, and add a tube of Mars black and Indian red, too."

Kay stuck her head through the door, "Anything else your majesty?"

"No, that'll be...," Yves turned and smiled. She often caught him off guard with her soft come backs. "Be careful downtown, the sky seems to be threatening," he said, clanking a brush in a tin cup of cleaner.

At that same split second, their studio barn shook. The thunder cracked the same time as the flash, then the sky spoiled to black. Darkness invaded their studios. Yves

eyes, for a moment, were flash-blind then returned to normal only to see a storm coming in from the north, another from the south. They met and merged right over their freshly painted barn.

"Looks like the rain has started down in Woodbury," Yves shouted as he got up from his stool. "Come, help me close the windows!" Right then some dust blew in and sprayed across his studio.

"I'm trying to get mine closed," Kay called back through the door that connected the two studios. Yves heard his wife swearing as she went from window to window trying to get them closed.

The wind kicked around all sorts of debris outside. Yves was trying to protect his wet painted canvases. His own paintings were all over the walls; some even leaned against the room's partitions. He brushed some dirt off a window sill, away from a wet canvas.

He hadn't seen storms like these in ages. It appeared a battle was being waged in the sky. The only other time he'd seen clouds like these was during monsoons in the Indian Ocean. Those daily storms; you could set your watch by them, he thought. Suddenly, lightning surged through the clouds and branched out like a tree. Thunder grumbled across the sky.

"I'm here dear," Kay whispered near his ear. And with shared breath, said, "I got my window closed just in time. No harm done."

"Good girl," Yves said smiling at his wife. "Please hand me that pole with the hook so I can get my upper windows shut." She handed him the pole and he pushed the windows closed with loud thunks. Silence ensued for several seconds; then suddenly another flash, more thunder rum-

bled and shook their small structure.

"That was close," Kay said, shivering. She turned to go back to her studio. She wore a presses khaki skirt that just covered her knees and a wide leather belt held in a rumpled white cotton blouse. She sported a matching khaki sport coat that had stretched out side pockets from years of hands tucked in. She had on short white socks and brown leather orthopedic shoes that klunked along the paint spattered hardwood floor. Her left arm presented a small black wristwatch with a black leather band; her favorite from an earlier time. She headed for their door. Yves caught her by the tail of her coat. She somewhat lost her symmetry.

"Wait," Yves pleaded. "You haven't seen what I've done to my painting yet. Come see—come see." Yves again sat on his short tri-legged stool in front of his painting. Kay returned and stood close to her husband, scrutinizing the changes he had made. She took a drag on her cigarette then blew the exhale to the side as she carefully considered the words she would use. She felt the steamy warmth of his back. He loved it when she stood close and she knew how it affected him. It was one of their much loved shared secrets.

"I like what you've done to those sea-like objects," she said thoughtfully. "And, yes, I do agree with your rendering of the blueness. It is sky, isn't it?" she inquired, tongue-in-cheek. She could barely keep from hiding her half-smile. Kay wrapped her husband in a good warm hug and whispered, "It's wonderful. One of your best." Whenever she said this, she meant it.

"Oh, one of my best?" Yves said with just a little pride. He was always amazed when anyone liked his paintings.

In 1922 after seeing a Giorgio de Chirico painting in Paris, Yves came to the decision right then that he had to develop some painting skills. So, with no schooling or instructors to follow, he set out to find his own way to paint. To find his own path, his own style. This is why he always felt uncertain with each new endeavor. This sensitivity meant he would abort many paintings, cover them with new gesso and begin again. It took many years of repainting and exhibiting his work to convince himself that his paintings were worthwhile. And yet the feeling still lurked deep within him. He understood the feeling needed to be there to make him outdo his previous undertakings. He was never quite sure of himself.

"Yes, it is. What are you going to call it?" she asked.

"Um...," he thought a second, "Imaginary Numbers, I think." He waited for her response. It was a brief moment, just long enough for him to think she didn't like it, however he waited anyway.

"I think that's a fine title," she said, hoping he would let her go. She needed to finish an area of canvas.

"You really think?" Yves asked, his eyebrows shooting up in surprise. He liked showing mock astonishment.

"Yes, yes I do," she said. "Now can I go back to my own work?"

"Of course," he said. "Call me when you've completed changes in your painting. By the way, what are you calling yours?" He would often have a counter title.

She paused, "Hyphen," she said after a time.

"Hyphen, why Hyphen?" He knew it gave her pleasure to ask and to be ready for a different offer.

"Because...that's what I want to call it," Kay said playfully tweaking his nose. "And don't try to talk me out of

it." Then she slipped back into her own adjoining studio and shut the door behind her.

Flash...boom! Yves jumped, startled. The storm clouds were directly over the barn. Suddenly the rain and snow mix began pouring from the dark sky. The downpour had a thundering of its own. The limbs on the big old oak drooped under the assault of heavy rain and snow. In his studio, everything felt damp to the touch; even some magazines that were stacked in the corner were warped from past rains. Brand-new canvases leaned in another corner of the room, needing mere splashes of white gesso, so his ideas could burst forth like dreams.

Yves Tanguy turned back to his painting. This was routine; he'd done the next few steps a hundred times. Yet it was the most important and difficult task in painting—the finishing as he called it—cleaning up the details. He couldn't explain his technique because it was more of a feeling than a knowing. He had to feel when a painting was complete, that is, nothing more could be done to it—nothing more could be put in or taken out. His ability to terminate, to stop before ruination was a delicate hard learned task. He needed to stop before spoiling the painting. Fiddle too much and, well there goes another canvas to the stack of work that had to be redone.

He stopped listening to his friends' opinions years ago when they said he was too persnickety. He needed to feel this for himself, for that raison d'être, he picked up his favorite palette with oil colors smeared entirely over it—those night-colors of blues, greens and red-browns. He began painting once more.

A while later Yves heard his wife exiting the side door of the barn. "See you anon," Yves called. "I guess I'll do

without blue today..." His voice dangled off as she slowly drove away in their black '48 Ford—the tires making crackling sounds on the cold wet gravel.

Due to the thick moist air, his nose stuffed up. Yves sneezed. He blew his nose in his handkerchief then shoved it into his back left pocket. Yves shook a cigarette up from the pack and lipped it out. He searched around for a book of matches he had somewhere. He found it and ripped a match out and when he scraped its red head against the rough, it popped, then burst into flame. Yves sucked the flame into the end of his cigarette. He drew a deep breath and let the blue smoke swirl in his lungs. As he let his breath out, Yves set the cigarette in an ash tray and turned to another painting in the beginning stage. Each painting began as a complete drawing. The shapes were rendered in charcoal and graphite and given shadows to reflect the direction of light. Each fragment of a drawing, each contour—every implicated mark of color had to make sense to him before he could go further. Then, over time he filled the drawing in with the colors indicated, producing his surreal, unrestricted inner realities. These irrational visions made little rationale to most viewers, but made perfect sense to him. His mental pictures of the coast of Brittany, a favorite place in his youth, what with those wide windswept beaches, was held in his memory so he could add fanciful metaphysical objects of his own design.

His L-shaped table was strewn with odds and ends and the drab tablecloth had been paint-stained for years, mostly with greens and browns. Two jars filled with all sizes and shapes of brushes grew like bushes, out of the table. The air in the studio smelled strongly of raw linseed oil, Dammar varnish, brush cleaner and turpentine; it was one

of Yves' favorite scents, for it was the perfume of his industry and hard labor.

A metal shelf standing against one wall was stacked with lacquer jars and Japan dryers. A cardboard box in a corner was filled with hundreds of half-used paint tubes. Nearly every oil color of the rainbow was in that box. An old dented aluminum garbage bucket sat in the middle of the room. He wasn't such a great shot as debris was scattered all around it.

There was one tall, three-legged wood stool leaning against the wall for the infrequent invited guest who would want to watch him paint. A package of soda crackers lay on the table so Yves could munch whenever he felt hungry. An art calendar hung crookedly on the far wall; it was turned to January 1955.

He had married the American artist Kay Sage and moved to Connecticut some years before. The critics called them both Surrealists. Yves' subject were organic marine like landscapes, while Kay's paintings were analogous, hers had an architectural, scaffolding, structural feel.

They'd bought property on Old Town Farm Road that had a barn as an outbuilding and converted it into two studios for themselves. The couple kept their studios side by side. A cupola sat up top to vent the fumes from their painting. There was a rustic stone and wood picket fence facing the road and a small lake waited out back.

Because they developed similar artistic styles, they could help one another by criticizing the other's paintings. They worked off each other. An idea Kay came up with often showed up in his work a year later. This happened both ways. This pairing in life, paring in paintings became a subtle way of communicating between the two. They echoed

each other.

They had two registered blue-eyed, Seal-Point cats, one named Moto Crème De Koko and the other Moto Sapphire Belle. The cats were great company and often got into the paints, leaving colorful paw prints on the floor and furniture. Kay would chase the cats trying to remove the paint as she knew it was not good for them. Yves at times would paint his cats into the landscapes.

Yves still wore his lightweight winter clothes. The dark baggy pants suited his lifestyle and the sport coat with a white shirt and dark tie was kept spotlessly clean despite his vocation. He dressed for warmth. As he aged, his circulation faltered and his feet were always cold. He wore thick drab socks and brown leather shoes that were kept clean as well.

He was over six foot in his youth, but now he was shorter. He lost most of his hair in mid-life, but that didn't bother him nor Kay, but those age spots on his bare rosy scalp appeared far too soon. His eyes were set too close together for his tastes and his elongated nose ended with that bulb at the tip. He had pale skin from years of avoiding the sun and his elfin ears reflected his child-like attitudes, while his half smile always favored the left side of his face. Yet people become accustomed to their own outer shell until age changes them. The haggardness of his outward show cautioned him that someday his life must end—how soon, that was the koan. Yves didn't dwell on that question very much. But occasionally the mirror reminded him, like his carny pictures, those four-ups, making strange faces with his hair all askew.

Not every day was like this cold wet and gray day; as a final point the wet snow stopped and droplets dripped like

tears from the oak branches. The clouds broke apart with bright sky and sunshine, again lighting and enthusing his studio.

Some erstwhile friends had visited him earlier in the day, leaving cold sweet coffee in half-filled cups. His coffee was not the best, but real friends don't make comments, he believed. He rounded up the mugs and dumped the black gunk into the sink. He glanced out the window, sighing. His paintings always drew him back.

As he worked on his painting throughout the rest of the afternoon, Yves Tanguy, grew sleepy and he, with certainty, put down his brush. Because of his failing health he walked slowly over to his aged brown couch and sat down. He studied his painting and said to himself, "I like Imaginary Numbers." The title spoke volumes to him. He thought a long time with reference to his latest work; thinking of titles was not easy. He had no preconceived notions of what a title should be. Whatever came to mind was fine with him. Sometimes Kay would help with suggestions.

In this one painting—land bridges crossed the seas. The biomorphic countryside in the picture needed names. He gazed at it thinking of places, people and events. He really wanted to concentrate on the canvas; instead, he fell asleep, his thoughts turning into the sometimes. Koko had jumped up on the couch beside him and curled up to keep him warm. Belle retreated to Kay's studio.

The cool air woke him. Night had claimed his studio but a few twinkling stars shown through the window. There were no lights on. Mr. Tanguy stiffly rose and made deliberate tread across the darkened room. He didn't need any lights because he frequently walked around in the dark and

knew the placement of everything. He stepped toward his latest painting. This time he forgot the small stool he always used. When his foot hit the stool it threw him off center and he toppled like a falling tree. But instead of crashing to the floor he floated in a manner not unlike weightlessness. O that a second seemed like an hour. He felt himself fall toward the painting and he dreaded the thought of ruining his perfect effort.

The seconds passed slowly like honey from a jar. The stool he kicked floated mutely out in front of him and pushed against the paint stand. The moments stretched thin. Now the stand began tumbling while the brush-cleaner cup oozed its contents and turpentine seeped through the air. In slow-motion he saw Koko jumping off the couch heading for the kitchen. This in sum happened as he fell toward the painting.

He recognized his painting clearly in the evening star light. It was too real to be a painting. The bizarre landscape took on a life of its own, more three-dimensional. It was like a mental landscape. He floated closer and closer to the painting. His feet were level with his shoulders and he was falling head first into the freshly painted canvas. He could sense the impending disaster. The thought of smeared paint sickened him.

Yves thought he was close enough to feel the moist, sticky paint. Except he felt nothing. Something strange was going on. He was falling through the canvas. The paint slowly seeped into him. The darkness of the room became a warm brown glow. He seemed to be floating. He calmly gazed around and realized the room he left was now sky with a strange land far below him. He hung there on the brink linking his ordered life and the inimical chaos to

come. He drifted around not knowing why. And then, without warning, he fell.

The wind whistled in his ears and his eyes watered. Yves thought he had been falling for several minutes. The landscape grew closer. He saw lands and seas the likes of which seemed to be familiar. He realized right then that his nous had created this strange place. What's happening, *jamais vu*? He wondered.

The sea-forms loomed nearer—he knew he would soon fall into the dark water below. The ample atmosphere was warm and the sea sizeable. As Mr. Tanguy fell, he saw waves, brown waves purled with purple caps. How strange, he thought. Oceans were supposed to be blue with white caps. Suddenly he remembered painting the seas brown. Yet he had not painted any waves. Where had they come from? He felt the cool mist caress his face just before he hit the water.

With a sudden jolt, he plunged in feet first, then sank into the gritty, turbid muck. His bald head popped up like a fishing float, breaking the surface of the brown consommé murkiness. He felt swirls of sand scratch at his body. Then Yves sputtered, gasped and swam for what he hoped was a shore line.

Two

"What is thisss?" Sathedra said, spitting and hissing the last word. "Something out of the sky again?" She stood at the small dirty window. The last time this happened a great foul, stinky wind kicked loads of things into the air—books, trees and yes beings blew and flew. But there had not been any weather disturbances lately, not since she learned to control the violent outbursts from King Solanum. This was strange, she thought. She hadn't foreseen something dropping out of her sky, and she witnessed most incidents before they happened. This one must have been triggered by an outside force. She did not like unknown happenings. Did she feel any danger? Possibly, a little. Given that, she shouted at one of her half-witted querulous spuds.

"Guard!" She paused to breathe then shouted again. "Guard! Are you deaf?" She knew the coarse mouthed guard was far enough away that her knife-sharp voice, not the muttering utterances of her subordinates, would diminish and be hard to hear. Once again, she shouted. "Guard! You better get your polluted carcass in here!" She cracked her knuckles as she waited.

The futsy, thick-lipped sentry skidded into the chamber and stopped in a low bow. "Forgive me mistress," the sentry said panting, dripping saliva. "What is your wish?" He stared at the tiny puddle formed from his drips while the seconds slowly ticked past. Through his teeth he sucked saliva back into his mouth, slurp. His grubby leggings

reached to his knees and his short dirt-stained midnight-green pants billowed out like a bloated corpse. His thick overcoat was long enough to cover his creaky knees and his steel poked out the back waiting to bring blood. The top of his flat hat boasted a big red "S" stamped on it. This was an expression of her power over them. He waited for the longest time. She wanted this infelicitous grub to wait even longer.

"Place double guards around the castle," Sathedra the Sorceress commanded with a black venomous sneer. "Now!" She was always impatient and full of contempt with the slowness of these pathetic goobers. Yet this one was the least stupid. He owned no name.

She could take no chances; anything new demanded to be regarded with suspicion. And someone falling out of the sky from nowhere was indeed suspect. She wanted to know how he fell and what he was doing in her Land of Sath. This might be threatening.

"Your wish will be carried out," the sentry said, sneaking a peek at the sorceress. Then his head snapped right back down, face banging the floor, splat. He knew it was ill-stared, but his mates dared him to peek at her. He felt the hot sting of her anger burn into the back of his dirty neck.

"Do not measure me. Keep your eyes to the floor as you leave," the sorceress demanded, paying him no more attention than a dust mote. The squaddie slowly backed out of the room with his nose touching the floor. He shut the thick wax door as he left and a boom echoed through the castle.

All the guards she'd drafted were required to learn the rules: Do not lay eyes on the sorceress. Obey her, but do

not, do not gaze upon her. This was the way she liked it. Maybe that meant many lonely days, but that was as it should be.

Sathedra enjoyed the returning silence. The stillness of her province gave her an unmatched feeling. All was mostly right in her realm. But it hadn't been that way in the past. There had been strife in the land, with the Curiosa people hating the Curds, and the Curd people hating the population in Lilium.

One day long ago, a young Sathedra sent a carefully crafted message to the ripened, portly Magician named Magus in the solitary Chicane-City and pleaded him to give her control of the area. He said he would, but only if she could learn the modes of his dark ways. Sathedra agreed and visited the old guy to learn the magical laws. Sathedra spent a year with him and during that time she met Luci, the not very lovely and truly unwise ruler of Gehenna. Gehenna, that special place where the *very* wicked are sent after death.

Sathedra was unimpressed with Luci, but she didn't let on. Sathedra came from the land of Bones, which was a prison and Luci looked at her misdeeds, then accepted her with some concern. Although Luci was small in stature, she demanded respect even though she did not deserve it. Luci's dark underscored eyes, half toothed smile and her cheekiness, made it hard to find friends. Luci's disgruntled nature made it hard to teach Sathedra anything. Luci left most of the teaching to the apparatchiks, Magus.

Sathedra become skilled in the unnatural. Unpolitics, nonhistory and apophilosophy, those topics in the opposite world of Gehenna, were also major subjects the old man taught her. Much later, when Magus thought Sathedra

had progressed enough, he presented her with a cheap metal crown. With a scant eye, Sathedra thanked them suspiciously and left to start her tyrant ways.

With her new dark knowledge, Sathedra added flesh to her own bones and made herself come across a lot better looking than Luci, more mature to be sure, as Sathedra was older, now more filled out. Sathedra liked her own manner—the long dark tresses tickled her new etiolated shoulders, and her large brown eyes cast back from the mirror with a new brand of authority.

After a time, she was given say-so over the citizens in a section of the Ogre's land. It held no name back then, consequently she named it after herself, the Land of Sath. It was part of the Ogre's Kingdom, just up-region from the Shadows and Notions and over from the Not-Quites. The Ogre King, Crag, had through his solipsism, trouble controlling his subjects. While he lived underground, Crag in his past, collected gemstones of all sorts and arranged for a splendid mineral palace to be built up top. It was put up with great hardship and grievance from his community. He treated them as nulls. Yet the people knew that the Ogre King wouldn't use it much given that he was a stink and rarely surfaced from his underground home, and anyway, this area held such a diversity of inhabitants, he exhibited trouble ruling them.

Still, Crag did not complain overmuch. He got what he wanted out of the transaction with Sathedra. To get that headache off his back pleased him. In this way, the venal Ogre was happy. The old Enchanter, Magus, was reckless and barely kept his word. But now, at last, the land was hers to have power over.

The first thing she did was create lands separated by

bodies of water. There were land bridges of course, connecting the separated areas. This was considered necessary to enhance trade. She commanded every poles-apart faction to go and live in the different regions. This calmed the hot-headed citizens. Then Sathedra conscripted many of the young children. She transformed them into her guards and servants, not the nicest thing to do, but necessary for her purposes.

She taught the smartest guards and servants what was required, then all the rest were instructed by the sharp-witted ones. Nonetheless, this action created a void between her and the rest of the Land of Sath. But she truly liked the separation and she would do all in her power to keep it that way.

She enjoyed not the Dark to create tangible things, but, the power to transform objects. She transformed Crag's mineral palace into a new exclusive castle for herself. She chose candles—candles of all sorts—big fat ones, tall thin ones and many odd-shaped candles. The interior of her castle was laced with tube-like tunnels and you could get lost easily because the tunnel walls were opaque. These candles would protect her from her nemesis, King Solanum, in the up-region. He hated fire.

Sathedra endowed one candle with the capacity to hold her power from which she could draw. The candle was located deep inside the castle and while guarded by a red wax orb, a force shield also protected the power flame from being blown out.

In the chamber of making, she gave birth to her Reds, Blues and Greens. It took months to grow a wax globe in her belly and when ready, it surfaced, then pushed off from her abdomen and floated aimlessly until she prepared

it with her incantations. She had been busy at first, breeding hundreds of wax orbs of different colors, but finally settled on red, green and blue.

After they budded from her, she gave these wax spheres a different task. The Reds were for investigating and included the power to destroy if necessary. The Reds gave off a whine that ranged from a low pitch while on patrol to a raspy beeping if it detected a belligerence.

The Blues were sent out to keep watch on her land close to her castle and the Greens kept an eye out in areas farther away. Sathedra controlled hundreds of wax spheres that floated around her land. They spied on and controlled the lands and people. No sphere was ever allowed to venture outside of Sath. She didn't want too many to know of her forces.

One limitation the old Magician and Luci insisted upon was that Sathedra couldn't leave her castle or else she would revert back to her skeletal state so, Sathedra, for that reason, attuned the orbs, sending them out to do her bidding. There were hundreds of Greens floating across her lands. Fewer Blues were needed to protect her castle and no more than two Reds at a time roamed the countryside seeking aggression. Even with all her power, she still was a prisoner. *But this is better than Boneland*, she thought. Her lands were all she cared about. She wanted everyone to have the basics, but only the best for herself.

"But why," Sathedra hissed as she peered through the almost clear, thin transparent mica window of her honey colored wax palace. "Why has this person fallen out of the sky?" She stared at him while he tumbled, splashing into her Sathedra Sea. After that she could not see what was going on. She turned away from the window and reached

over to the Pool of Seeing. After chanting a few chosen words, an image faintly appeared on the dark, calm water. It was of the fallen man and he was swimming to shore and yes, someone was there to help him, a crystal cat. She scrutinized the cat sitting on the shore as it stared at the man in the water. Then the image faded; even her seeing powers were limited. The pool was blank once more. This was a sour note to her day.

"Now I must send a Red to keep an eye on him." With a few colorful select words and a puff of foul smelling purple smoke, a labile red sphere was located and dispatched. "Keep close to him and report back to me," Sathedra ordered. "Ah, Power!" She repaired her smile.

A small bird fluttered around her window then perched on the sill, peering inside. It pecked on the mica window goading her, but when Sathedra moved over to the window the little bird flew away. She thought King Solanum may have sent the bird. Sometimes he did that sort of thing just to taunt her. She didn't have many visitors and the little bird would have been a pleasant but captive guest.

On this day Sathedra the Sorceress was wearing her preferred floor length cape. It was royal purple. The fringe was cream-colored fur which gathered dust balls from the floors. Gems were set along the robe's margin and as she walked sometimes the stones would clatter on the hard wax floor. Her gown was made from the webs of those children she distorted into her own nest of spiders. They spun delicate satisfying patterns of pink roses. It was her rose gown.

She was not tall, but her demeanor made her seem that way to her people. Her dark-brown hair cascaded down from under her crown and traced back and forth on her

shoulders whenever she strode the dark halls of her castle. Her crown was made of that cheap bronzy metal. It didn't fit very well, but still displayed many images of candles and the words, "Sathedra of Gehenna."

Her complexion was drab from the years spent in her dark, candlelit castle. Her hands, too, were pale with blood red painted fingernails that would tap and click on whatever she touched.

Late afternoon was the time for Sathedra to make her day to day tour of her realm. She sat on a wax bump positioned next to the pool and she uttered a few words. Wavy images formed in the water. Her subjects had always been less than enthusiastic on the subject of her laws. They agreed there was peace among the different divisions, but at what cost? Their privacy was invaded by the Greens and their children forced into servitude for the good of her land. This had to be, she told them.

She glimpsed over to the home of King Solanum. They suffered from fungus growth and wood-eating insects. From what she heard, they still had the problem. One day, King Solanum would come to her for help with that fungus and those wood-hungry bugs.

Sathedra incanted some other words and the image changed from Lilium to the Deadly Lilipond. The pond was covered with a deadly fog—that is, deadly only to Sathedra. King Solanum despised her for removing him from her staff. *But, he read my spells and after all, theft is theft,* she thought, *and my spells were hard-earned.*

"I must find Say's book before anybody else does," she said. She spoke a few more words and the image distorted back to a view of Lilium. Most of the area was shrouded in an intense fog. She couldn't steal a look into any of its lo-

calities. Her Greens couldn't get into his bug pit either.

His power holds strong, she thought angrily. *Solanum has strengthened his will.* She probably would never have control over his land. His region was far away in the up region, pushing farther into the Ogre Kingdom. Her parallel chose that area to be as far from Sathedra as he could.

Other much-repeated words brought muddy-white Curdland into near focus. Queen Creamy was another sub-ruler who, as always, complained after something. Most of the time it was concerning the subjugation from Sathedra. Yes, Queen Creamy appreciated the cool winds Sathedra provided, but the queen didn't like how her young were taken away, ill-treated, then years later brought back depleted of their vitality. There were many half-filled and close to empty Curds. Some must be sacrificed for the good of me, Sathedra would argue and Sathedra always won her arguments.

"Where is Curiosa today?" Sathedra muttered. More carefully selected words happened from her bright red lips and the pool's point of view shifted, overlooking Ann Thology's Appellation City. She seemed the happiest of all the sub-rulers, if you could call it happy. Even her land was scourged by insects, those creepy-crawlies that ate at her people. She benefited from the most control over her lands, and she cooperated in some measure with Sathedra. Lately though, Ann Thology's problems were the pests finding new inroads to the pages of her folks. Sathedra had no idea nor cared what kind of bugs were harming the population. Perchance nits nibbled at Ann's nation.

It was getting dark outside and the castle's candles were not yet lit. Five of the light-minded, pusillanimous guards started their rounds, lighting the wicks. The guards delib-

erately, knowing it annoyed her no end, chattered and laughed loudly.

"Get all those candles lit!" Sathedra the Sorceress roared down from her window. "I don't want any darkness on this of all nights!" The raucous guards hurried off around a corner.

An entire day of solitude usually made her quite tired. As the night came over, Sathedra retired to her sleeping chamber. Here she considered herself safe for the night. All racket was filtered out. Inside the chamber was a single bed surrounded by many candles. It wasn't a bed as humans would use as it was made of wax and it molded to her every curve. Sathedra changed into a lavender silk nightgown and sank into the warm wax.

She thought about Sath and its natural direction of happenings. But when this man fell out of nowhere did he set in motion a different destiny? "I must remember today. Something's changing. I can feel it in my bones. I must remember..." and she soon was lost in a nightmare world of her own making, animating the impending.

Three

Old Scratch the cat was out on one of his meanders. He'd had many jaunts since he'd left Crystalum in his youth. He was on his way to Curdland to enjoy the Cream Festival that happened every year at this time. In years past, there existed all sorts of delights for his taste buds. He didn't have to eat, but the smoothness of the cream was more than he could resist. Old Scratch was getting up in years and his body sometimes creaked, especially when it was cold, though the nights lately remained unusually warm. There were times when his whole body moaned as he toddled along.

He was made of crystal. He always said it was the finest crystal in all of Crystalum. That was his opinion. His facets were smooth, but his edges were a bit worn. From a distance you couldn't see any of his flaws, but if you were to get nose-close or loupe him, you would see the tiny chips on the edges of his facets. Looking into him you could see, with close inspection, blebbies, his occlusions. They crisscrossed his interior lattice like needles piercing ice. When light shone into him, dull distorted rainbows emerged. As he walked along, the chimeras danced around him like unwell fairies.

Scratch was in an ornery but improving mood despite the fact that he was returning from a short linger with his family in Crystalum. He hadn't stayed long seeing as the cold there always got the better of him. He grew stiffer as the visits got longer. His mother and father lived alone

now. His siblings had given rise to their own families, and kindles of high-spirited crystal kittens scampered close, a bit too much caterwauling for an old cat.

Crystalum was ruled by Spinel. He ruled with a firmness that some enjoyed, but many abhorred. There was little crime. But when someone did commit an offense or even a personal affront, they were sent off to stand before the callous Ogre King. Some offenders were altered and sent to the Land of the Bonepeople, while others were incorporated back into the Grand Lattice, depending on the misdeed. In other words, executed.

Old Scratch left one cool afternoon as the sun's rays began their descent on the landscape. He needed to leave because his family was getting on his nerves. This happened many times in the past. He knew his limits. Scratch then desired to hit the road.

He traveled with a pouch around his neck filled with his toys—balls of blue yarn—soft fuzzy multi-colored playthings and a cat-nip scented leather mouse. Keeping on the move was in his structure, that's why he set out, heading straightforward, to the down region of Curdland.

As he trotted past Lilium on the causeway leading to Curdland and the festival, he suddenly heard a startling thunderclap, coming from nowhere. He thought it might be a Green as they sometimes made that sound. There were no Greens around; he stared into the sky and squinted his eyes.

"My, my," the old cat said as he gave attention to a stranger falling from the sky. "Not again." Old Scratch knew that whenever someone new plunged into Sath, things changed. It always happened. Scratch was used to change, but there were others who disliked it. And no one

could predict what the variations might now be in their lives. "Sath better brace itself because this looks big."

The human tumbled and spun. Scratch sat on the edge of the Sathedra Sea and watched the foreigner fall into the murky brown water—kersplash. Oh, and now surface and begin swimming toward him. The man did a variety of swimming strokes—breast stroke, the crawl and the dog paddle. Waves splashed over his head at times and he disappeared. Then he bobbed up like a discarded fishing cork.

"Do you need some help? Should I throw something?" Old Scratch shouted, his clear paws cupping his mouth.

Yves bobbed up once, sputtering, "Help me!" He was awash and floundering. After swimming for a few minutes more, he felt the sea floor rising under him. He stopped dipping under the waves and bounced off the bottom until he could tip-toe his way to shore. His time in the Merchant Marines paid off; his swimming maneuvers saved his life.

Old Scratch sat on the shore. He had a dislike of water. Actually, Scratch didn't do anything until Yves was something like two feet from shore because what was there to do? If Scratch swam out to get him, surely he could have drowned. Scratch got down as close as he dared, snatched the man by his shirt collar and pulled him onto shore. Mr. Tanguy was soaked and covered with grit; he could hardly keep his breath as he hadn't exercised much in his later years. And this swimming, well, it took it out of him. He hadn't been swimming since he was in his 30's.

He could barely pull himself along onto the nearly flat shore. Yves felt helping tugs as he crawled onto the hard wet sand. He collapsed right there on the beach—thump. His clothes were rucked and sticking to his skin. Rivulets of water ran from his shoes and fingers.

Old Scratch was two foot tall on all fours and four feet tall when standing on his back legs. Old Scratch dragged Yves further onto the beach and propped him directly against a rock. Mr. Tanguy's head hung limp. Old Scratch understood at a glance that Yves was cold from the water so he turned to gather some wood. *A fire should warm him*, Scratch thought. Old Scratch trotted over a dune to gather some dry sticks. There were many to choose from so he picked the shorter twigs knowing they would burn best.

As Yves gained awareness, he raised his head, looked around and did not see his studio. It took only a second of seeing water and beach for him to realize that he was not where he thought he should be. He let out a primal scream; the kind of ear-splitter that comes from deep in your viscera. With his adrenaline pumping double, he screamed a second time, but nothing changed. His shrieks were lost in the coming evening gloominess. He tried yelling again but his voice cracked and he began coughing.

Old Scratch heard the screams; he scurried back to see what was wrong. Mr. Tanguy was still sitting against the rock in a daze. The old cat walked over to him, setting the fire wood close to the man and began making a fire.

"You all right?" Old Scratch asked.

"Aaaaaah!" Yves jolted himself upright. "What...who...aaaaaaah!" He started to rise and run, but Scratch snagged his pants cuff with a claw and held him back.

"Hold on there," Old Scratch said. "You shouldn't be going anywhere." Scratch's claws held firm in Mr. Tanguy's pants.

"Get...get away, let me go!" Yves shouted. He was clutching at the sand with his fingers, but couldn't get free.

"Okay, I'll let you go, but I think you'd better sit down

and be still. You might provoke some attention." Old Scratch looked intently around and saw no orbs approaching. *Don't need that right now*, Scratch thought.

Yves scanned around and saw nothing recognizable. He nervously sat by the rock again and stared at the cat, who held out a paw, catching the last rays of the sun. The murky light passed through the cat's paw, acting like a magnifying glass. Smoke poofed from the sticks, then flames appeared. Yves sat there dumbfounded, staring at the crystalline cat and considered the wrongness of it all. He'd never seen a cat build a fire. The cat mumbled to himself at the same time.

"Cat," Yves said with a startled abstract expression, "can you talk?" Yves had pulled his knees up to his chin.

"Of course I can," the old cat came back indignantly. "I've been talking ever since I was a kitten. Would you quit looking at me like I was some sort of a freak!"

"But…you're talking!" Yves kept on incredulously. The old cat glared at him and said nothing. Mr. Tanguy's mouth dropped open.

"I don't know, but bugs can get in if you leave it open like that," the cat said. Scratch blew on the glowing embers, making them hotter.

Yves shook his head as a fly buzzed him and he posthaste shut his mouth. By this time, the cat had gotten the fire going quite well. Mr. Tanguy closed in and warmed himself by the flames. The flames flickered orange and gold off his face and the surrounding area was suffused in a concentrated yellow. The fire crackled and popped, sending red embers into the sky. Scratch put a few more sticks on the fire. The flames died back at first, giving off more thick smoke, then the flames soared higher, letting loose

more heat. Yves held his cold palms as close as possible to the flames. Smoke issued high into the darkening sky. Yves leaned near the smoke breathing it in, hoping it might get into his lungs and relieve some tension. It only made him cough. *Could use a cig right about now*, he wished.

Crickets began their eisteddfods in minor chords. That was an odd sound to Mr. Tanguy. Yves rubbed his eyes as if to erase this mental picture. It was no hallucination. Yves shook his head to get the sand and moisture out of his hair. Using both hands he pushed his hair back over his ears. He wiped his hands on his wet pants, trying to get the sand off.

"My name is Yves Tanguy," he began, hoping the two of them could make a better unveil.

"My name is Scratch," Old Scratch announced, "and your name is...eaves...tan...gee." Old Scratch slowly pronounced his name as best he could.

"Well, you're close," Yves said. "You got my first name accurately, but my last name is Tanguy. It rhymes with *oui*, you see."

"I think I'll call you Yves for short," Scratch decided quickly. "No need to complicate things."

"That will be adequate." Yves seemed irritated. "Sure could use a smoke right now." He checked in his pockets, remembering he left the pack of cigarettes in his coat that he lost in the water. *Be soaked anyway*, he thought.

"But I'm not a freak!" came Old Scratch's belated response.

"I didn't say you were," Yves said. "I just commented that you could speak." Yves could feel the annoyance eating away at his edges. *How long has it been, an hour, a day. No way of telling here.*

"Well, I'm not," Scratch retorted defensively. Scratch had been chastised in his past. Sometimes he felt different from the others, but that didn't mean he was a freak.

Yves sat straight-spine listening and checking around, seeing nothing since it was dark. He asked Old Scratch, "Where in blue blazes am I?"

"This isn't Blue Blazes. You are on the shore of the Sathedra Sea, in the land of Sath, in Gehenna."

"Gehenna? But…," Yves interrupted, "that's just…"

"Just what?" The cat said with a significant air of defiance. He couldn't figure what this Yves was suggesting.

"Oh…nothing," Yves said, turning away. He massaged his temples, thinking it would be better not to discuss the subject of afterlife. Best not know too much, yet.

"Just to let you know, across the sea is the land of the Curiosa people," the cat said, pointing over in the direction of the water, "and far in the up-region is Lilium." Old Scratch saw Yves was looking a bit tired and confused. His clothes were just starting to dry from the warm fire. "Why don't you get some sleep and I'll tell you all about this land in the morning when you're more rested and can see straight. Heck, if I had fallen out of the sky I'd be right pooped. Right now I have to get this fire out before the guards of Sathedra see it and send a Green or maybe even a Red to investigate."

"Who…are the guards of Sadeathera?" Yves asked with a yawn. Old Scratch was toing and froing from the water's edge with paws full of water to douse the flames.

"Her name is Sathedra. I'll tell you all about her on the morrow; now get some rest," Scratch said as he finished putting out the flames. The fire hissed and bubbled as steam rose into the gloom.

Yves leaned back against the large rock, feeling better. He looked into a multi-hued sky and saw clouds drifting. They were a bright orange with magenta swirls. As each minute passed, the clouds changed shapes making color shifts from pinks to yellows. The clouds then lost their color and turned gray against a shadowy burgundy sky. A flock of blue crested sand peepers swooped along the shoreline snapping at insects on the fly. There was a constant background buzz from bugs everywhere. Most were in the air, but others tickled the sand among the tall reeds and bug ridden mosses.

Yves still wondered, *Where am I and who is this Scratch? Who are the guards of Sathedra?* The questions nagged at him. They kept him awake for a while. Eventually though, Yves laid on his side in the sand and was able to find some snooze. He jerked once or twice, dallied with the perhaps, then calmed down. Flies found a resting place on his leg.

Old Scratch watched the man nod off, then noticed a hollow in a rock that'd been warmed by the sun. He crawled into it curling around like a pill bug. He, too, wondered who was this man and where had he come from and what was he to do with him? Scratch thought a minute and concluded he must take the man to see Queen Creamy since he is in her province. It seemed the right thing to do.

"Yes, that's what I shall do," Old Scratch held to himself. "Now I must rest. I'm sure tomorrow will be a demanding day." With that said, Old Scratch fell asleep in a flash.

The chilling night passed on around them. Tens of thousands of bugs noiselessly trekked across the beach looking for mates and eating anything smaller than themselves. The crickets in the grasses chanted madly their mu-

tating minor melancholy harmonies. As in all times past, the stars circled across the sky and waves reached against the shore, drowning out the mutterings of the land. The regimented land lights on the far shore, reflected in the smoothing water. While the night progressed, the lights died out one by one.

Yves dreamed deeply of flying paint and crushed canvases—of falling and water, then not quite drowning. Slowly Yves became aware of himself as he let the outside world in. He felt the warmth of the early sun on his skin. The heat felt good.

"Strange, the sun doesn't come into my studio in the mornings." Then he remembered. "It was simply a dream. I must have wandered into the sitting room during the night and fallen asleep on the couch. "Entre chien et loup," Yves said with a laugh. He quickly sat upright and looked around. His laughter stopped when he saw the brownish body of water.

"Oh my," Yves said with certified concern. "I'm not dreaming." He shook his head with puzzlement. Rubbing his eyes didn't help either. The purple waves were still breaking on the shore.

It was a peaceful, pinkish morning. The horizon was a powder blue off to the right and white over to the left. A haze floated over the sea until a breeze whispered it away from the shore. There was a hush upon the land—no machinery sounds, no animal sounds and the fire had gone cold. It was that in between time when the night animals have gone to sleep and day animals have yet to wake up. The land slept.

The shore was lined with dreary, moss-looking plants. *It looks like Irish Moss only mostly dead looking*, he thought. The

sea slurped at the mat of brownish moss and almost kept it moist. The near-dry moss gave way to other scraggy plants that Yves could not identify. Tree branches were twisted and gnarled, pointing in directions of way off places. Far across the brown water Yves saw what seemed like mountains, but not quite like mountains because they were organic in shape, something like living forms—parts of arms or legs—akin to the mountains in his paintings. Kind of biomorphic. *How could this be?* Yves mulled to himself. Then he watched as one of the shapes changed colors. Before his eyes, the shape changed from a yucky brown-gray to a brighter flesh tone. *What happened?* he thought.

He stood creaking his knees, then put footprints down to the water line. He made a left turn and began a rickshaw trot down the beach. He was seeking a way out of this situation. After several hundred yards of running, he made an about-turn and pumped back past the camp. Yves covered in a minute a short distance before he realized this wasn't a way out either. He slowly backtracked to the dozing cat. Old Scratch was still heavy-eyed in the rock hole when Yves arrived. Old Scratch slowly stirred to see Yves bent at the waist, staring right at him, nose to nose.

"You're still staring at me. Don't you realize I'm just a cat?" Scratch said, stretching. He twitched his crystal whiskers then wiped sand off his leg with a crystal paw. The side Old Scratch slept on was still plastered with sand. Bits fell away from him as he moved around.

"Oh, merde! You're transparent!" Yves suddenly realized. "What are you made of?"

"I'm made of crystal from the mountains in the upper district. What are you made of?"

"Just flesh and bone." Yves stared at his hands to make

sure. He started to wonder. *After all, Gehenna is that special awful place. I'd better ask again to be sure,* he thought.

"Scratch," Yves began yet again, trying not to look too concerned. Yves was shaking some sand off his shirt and pants.

"Yes...?" Old Scratch said suspiciously.

"You spoke of the different people around the seas last night. Will you now tell me where I am?"

Old Scratch sighed, frustrated by the man's ignorance. "I enlightened you last night. You are in the province of the Curd people. Curdland is ruled by Queen Creamy. I'll be taking you to her soon. She should know what to do with you." *This is a troublesome person,* Scratch thought.

Yves held scores of questions animating in his head. But he made a curlicue gesticulation with his finger and asked, "Is this actually Gehenna...and...why is the sky pink?" He knew the name Gehenna meant something awful, something like a hell where the depraved are punished after death. It was beastly, that much he remembered. He said nothing, only kept an eye out for anything more unusual.

"Yes, this is Gehenna. It has been Gehenna...well, forever. Now the sky is pink because it is pink in Curdland. It's blue over in Lilium and it is white above Curiosa. Each land has its own sky tint. The people of each country select a color and then they ask the sorceress to make it be that way. If the people do terrible things or revolt, the sorceress can change the color to something the people hate, which happens more often then you might think."

Yves broke in, "This sorceress, tell me about her."

"You certainly ask lots of questions," Old Scratch grumbled.

"It's the only way I can investigate this weird place, isn't

it?" Yves said.

Old Scratch continued on as if he was telling the story for the thousandth time. "Her name is Sathedra, and she lives on that island right over there, to the other side of the Dark Road." Scratch pointed to an island. Yves saw the island and he was taken aback that it was made of what appeared to be melted wax. Yes, puddles of paraffin. And on this island there appeared to be a candle castle. Most candles were yellow, others blue and a few green ones. Then he noticed that others were shades of pink and red. A few wicks were burning, but most were not lit.

"Sathedra lives on the island and yes, it's made of wax and those are candles. She is protected by her guards and her orbs. Actually, she selects the choice first born of a few families and turns them into her guards. They and the Blues, patrol the island and the Dark Road of Sathedra to keep out any strangers. She lives alone, I think.

"Invaders have attacked the island, but they all have fallen victim of her traps. There are animals and many pitfalls. Just she and the guards know how to get around them. The Dark Road is cold and icy. Sathedra lights the candles at night to keep herself warm."

So far, all of this made no sense. But because he was in a flight of his imagination it was acceptable, or so he hoped. If he'd been in Woodbury standing beside the pond out back, none of this would be correct. He'd be optimistic and getting coffee for himself and Kay.

"Get down!" Old Scratch shouted suddenly.

Yves looked at Old Scratch. "C'est quoi ce bordel?" Scratch had crouched down.

"Down! And don't move!" Old Scratch was pulling on Yves' shirt sleeve. Yves squatted beside Old Scratch. This

was Scratch's standard routine. Be still and quiet.

"Why?" Yves asked. "I don't see anything." Then his eyes skimmed over the dunes and he heard a vague drone. A red orb rose like the sun. It was shiny, red and a perfect non-pedal sphere. The landscape mirrored from the bottom and a perfect sunspot reflected off its top. The whine reached its apex and changed to shrieking beeps. It slowly moved toward Scratch and Yves.

"Don't move and it won't see you," Scratch said. The sphere circled them twice and then seemed uninterested in the area. It moved off. Its sound changed back to a soft whine and Yves thought it would be safe to stir. Yves stood

"No, don't..." Scratch spoke too late; the sphere started toward them again.

"Run! Take cover!" Scratch shouted. Scratch was already scampering and dove behind a small dune. Yves just stood there staring, not knowing the danger. The red orb came within reach, checking the area again.

"Look out!" Old Scratch cried. A jagged bolt of fire shot out from the red orb and hit straight at Yves' feet. Sand flew and caught him in the face. Yves brushed the sand out of his eyes as he staggered back. Now all he could think of was finding some cover; that thing was coming in closer and the screeching beeps hurt his ears.

Stepping farther backwards and covering his ears, Yves' heel caught on a stubby bush and he stumbled, falling on his backside. The sphere grew closer. The screech was deafening. The ball blasted the bush right between his feet. He felt the heat sear his ankles. Out of desperation Yves spotted and seized a rock and let it fly. It bounced off the red orb and left a deep dent. The sphere shot again, but

this time its aim was off; it's fire hitting somewhere inland. The thing started hissing and spinning. It was like a fireworks display as it hit the ground. The orb bounced down the beach toward the sea and exploded just a few feet from the water. There it sat on the wet sand, in pieces like a shattered egg—silently smoking.

Old Scratch stepped over to see if Yves was all right. "Are you hurt?" Scratch asked.

"No, not bad. What is that thing?" Yves asked, acting a bit bewildered.

"That was a Red. And you killed it. Sathedra won't be happy with you." Old Scratch headed down to the water's edge to look it over.

Yves followed. "A Red?...what the hell is a Red?" They stood around the dead orb, kicking the loose pieces around.

"A Red comes from Sathedra's castle. I'm not sure what it is, but I've never seen one act like that."

"You mean you never saw one act this way before?"

"No. They usually just come and go innocent of any problems. But we don't throw rocks at them, either," Old Scratch said.

"Until now," Yves said, sounding unyielding. "If one attacks again, no two ways about it, I'm throwing rocks, sticks or anything I can find."

"If you see a Green, please don't do anything. They say the Greens are Sathedra's eyes. Hurting any of the balls is a sure way of making Sathedra really mad. All things being equal, I think you are in big trouble already. You destroyed this Red; she will be after you."

"Do you think we should get out of here before another Red comes?" Yves asked, worried.

"Sounds good to me," Old Scratch said. "I think we should bury this thing first. I'll dig a hole and put the shards in and cover them. You mask our camp." Yves trudged back to the cold fire, kicking some dirt on it. He spread broken twigs and leaves over the ground to conceal their habitation.

Scratch dug in the sand and with his paws, produced a hole deep enough to secret the pieces of Red. He walked around bringing together all the bits of the sphere that were scattered hither and yon. He found one doohickey that must have been inside that thing and threw it into the grave, too. Yves came back to the hole and before Scratch shoved sand in covering the evidence, Yves fix his eyes on the pieces of Red. *Looks rather like alizarin crimson,* he thought. *Did I use that color to make these spheres?* With sweeping arm movements, Scratch pushed sand over the dead Red and the sand once again, expressed a natural texture.

The sun was climbing higher in the sky and Yves' clothes were dry. He shook sand and grit out of his sleeves and pant cuffs. He'd lost his sport coat last night in the water.

"Are you...are you cleaned up and feeling all right?" Old Scratch asked in a hurry. "We should be on our way."

"I'm as clean as I could ever be and I feel...well, a bit sore in places. That attack left some sore spots, but I'm ready." Yves rubbed his derriere and his right elbow.

"Good. Let's be off before any more of those things show themselves."

The pair set out with Scratch leading straightaway toward the over-there and in a while they approached a road marked, by a signpost, Whey Way. "Yep, this is it," Scratch said looking far down the road. "It'll take us right through

the Creampeople and on to Milkolopolis. That's where Queen Creamy lives. All we need to do is watch out for those damn balls. They're probably on alert because of you."

"I hope I'm not in too much trouble. After all that thing did attack me and I was merely defending myself. How many of those things are there?"

"I've seen one or two Greens a day. They never bother me. Their noise gives them away so I have plenty of time to stand real still and they pass on by," Old Scratch said. "Since Sathedra would be hunting for you, maybe you'd better appear like something else."

Yves got the idea. "Oh, you mean like a tree...or a rock?" Yves dug around in the weeds for some twigs and held them in the air above his head. "Like this?"

"Put your feet together and stand straighter," Old Scratch said as he walked around Yves. "Yep, you plum disappear," Scratch said with a chuckle. "I think it might work."

"If we see one, please make me stand frozen," Yves requested. They walked on side-by-side keeping careful watch. After a time, Yves remarked, "Scratch, this road is purple."

"Uh-huh, so?" Scratch thought that this man sure didn't know much.

"Guess I've never seen a purple road before."

"Well, you have now. The road is this color because it leads to the royal city. Each road leads to a certain place. Depending on where you are going, the road will be a particular color. This road, for instance, going the other direction, is brown." Yves turned to see. The road was a raw umber brown behind him, but purple in the other direc-

tion. As fast as Yves swiveled his head back and forth, the road changed colors. He couldn't see it change, but it did. *Looks like I used Mars Violet on that road when I painted it,* he chuckled to himself.

Yves was dizzy from spinning around, and for that reason Scratch steadied him and they started out again. Scratch explained. "You see, brown is toward the poverty stricken people of Curdland and toward the rich, it purples"

"Oh...okay," Yves said, semi-believing him. *I suppose I should expect anything from here on,* he thought.

While they walked along the purple road, Yves remarked at the oddness of the countryside. "I have never seen anything like this in my life," Yves said. "The thing is, the trees are so, damn, I don't know. The hillsides seem to be like...my hills! I mean, like I might paint them." Old Scratch just shook his head, wondering what Yves was talking about. Did it really matter—it might.

The purple lane wound around each petite hill and into ravines, making S-curves over and over through the countryside. The land was dotted with a few forests. They were randomly placed; some of the copses were dense while others were small and sparse. Some trees stood alone, others stumps. In between the trees, grasses grew stubby and seeds hit the rhythmic winds. *All these colors, on my pallet?* Yves was thinking.

The trees still showed a purpling tint and sure enough, as Yves turned around, the same trees took on a brownish shade. This was hard for Yves to take in. Had he created such a place with no more than the strokes of his brush?

The trees were not tall, in fact Yves could reach the top and pluck any fruit that might be there. Yes, most looked

like fruit trees.

At one point Yves saw a tree appear suddenly—out of nowhere. "Hey, what just happened," Yves said, his eyes blinking.

Scratch commented, "I see that occasionally. They show up and sometimes they disappear. Never figured that out. Most times things just change. Like their color or their shape. Seems like someone is messing with magic." Up ahead, right before his eyes, the purple road changed from straight to a meander, then back to straight again. *Strange*, Yves thought.

"Scratch, I'm getting hungry. Is there somewhere I can eat?"

"Oh, sure," Old Scratch said. "You can have anything you want. Just wish for it and you will see it appear on the tree." Old Scratch pointed over to several trees lining the road. Three were quite short and one was tall.

"On the tree...you said on the tree?" he asked slowly, again—not believing him.

"Go over to that tall tree and make a wish," Scratch said impatiently.

"A wish?" You want me to make a wish...at that tree?" Yves said, scratching the back of his knee, wondering what the heck. Not the usual thing to carry out.

"Yes, just do it!" Scratch said sharply.

Yves gave the tree a measure and thought of an apple and sure enough a red dot appeared as if was dabbed in with vermilion oil paint, then morphed into a crisp apple. Yves picked it and ate it with much pleasure enjoying its piquancy. Having done that, he again eyed the tree and wished for a crab salad, but nothing happened. Old Scratch cackled. "I forgot. The trees will give you exactly

one wish. You must pick another, then wish from that tree."

Yves noted a shorter tree and wished for the crab salad and yes, it appeared as a blob of lettuce green, crab white and dressing pink. It slowly altered into a cold, fresh salad with rich, thick tasty chunks of crab, Thousand Island dressing and a fork.

"Um," Yves said, munching on the greens. "This is the tastiest crab salad I've ever eaten. But what if the land runs out of trees to wish from?" Yves was mentally counting the trees. *That would be an awful thing to happen*, Yves thought.

Old Scratch answered, "Many of us here don't eat. Look at me, I am made of crystal. I enjoy food, but I don't need to eat. Sunlight warms me. That's one of the deciding factors why I traveled this way. It was too cold for me in my homeland." Old Scratch pretended to shiver. "It's not like we have the choice to be born in a particular place," Old Scratch said. "Don't get me wrong…Crystalum is beautiful. It's ruled by Spinel, not too far from the Land of Sath. Crystalum is rather small, but it has its majesty. Every kind of crystal can be seen there, from amethyst to zircons. When the sun shines on the land, there is light scattering as you have never seen. An outsider might be blinded by the dazzling display." Old Scratch covered his eyes in mock blindness.

Yves stood there rapt, listening. "Oh, wow."

"Most of the Crystal People settled there can tolerate the frigidness. Not me." Old Scratch continued, "I sought warmth. I needed to leave my father, mother and my litter mates. Now I wander happily. Curiosa is still my favorite place on account of the sunny nature of everyone." Old

Scratch paused a second. "We still need to get you to Curdland, though. Come on, let's keep going." Down the road the two set out, following the purple trail. Yves was feeling more relaxed, as it was.

Some time passed before they came upon the first settlement. The houses were strange. They appeared to be large cylinders sitting tall on their flat ends. There were small doors at the base and little windows reaching up the curved sides. *The houses are painted white, flake white with a dab of sienna and each includes old wood for a roof.* Yves was mixing on his mental palette, *umber and mars black*. The roof was pointed and the house presented itself reminiscent of a rocket ready to soar. Old Scratch explained that the taller the house, the richer the people were and the sweeter their milk. The fuller the bottle, the more clever.

Yves was confused by this, but as soon as he saw the first Creamperson he realized what Old Scratch meant. Here was a bottle shaped woman and she was more or less atrophied of what may have been soured cream, *lead white and a tad of yellow ochre*, Yves supposed. The closer they got to the woman, the more rancid she winded. The whole countryside encompassed the smell of that bad cream. When she moved, her contents sloshed around inside.

Old Scratch said, "You see, these are the unfortunate people of the land and they cannot afford ice to keep themselves fresh. The air will become fresher and sweeter as we go farther up-region. The air gets cooler, but also the cost of living is higher. So much more in fact, most cannot afford to live there." Yves noticed that the air he sucked in was so sour he could taste it.

They walked up to her and Old Scratch asked the woman how long it would take for himself and Yves to travel to

the castle of Queen Creamy. He asked just to demonstrate to Yves how the people here spoke. He knew full well the answer and what would happen.

"If you travel fast," the woman began, "it will take you just a day, but if you travel slow, it will take you a day and part of one night. If you travel just in-between that speed it will take one day and a smaller part of the night. Now if you take the short cut across the fields, it will take you most of a day. If you were to travel slow, it would take you a day and one night, but if you were to travel fast, it would take you barely part of a day and if..." With that, Old Scratch pulled Yves away and headed on along the road, shaking his head as he spoke.

"I should have known better than to ask a woman like her," Old Scratch said. "She has too much to say and not enough brains to stop."

Yves glanced over his shoulder to see the old woman still giving directions and pointing her arms every which way, even as the pair rounded the first bend.

"How long will she be gibber-jabbering like that?" Yves asked, concerned.

"Who knows?" Scratch replied. "They've been known never to stop and go on yammering forever."

"What a horrid thought," Yves said, "to have such a thing happen. Have I created this?"

"Created what?" Old Scratch asked.

"Well...uh...this land. It seems like I have dreamed of this place," Yves said slowly. "But not all of it. Not you, Scratch. Not the little details of the landscape. Anyway, I know these colors."

Old Scratch seemed annoyed when he said, "You did not create this land. This used to be part of the Ogre

King's domain. It was his until it was annexed by the corpulent Magician of Gehenna and given to Sathedra the Sorceress. The Great Magician has ruled for longer than I know. Yves, you did not create us. We've been here all along."

"I'm sorry, it was a foolish thought. I am not a creator. I just sleep and paint what my mind reveals. That's all I meant. Do you forgive me for being crazy?"

Old Scratch, perfectly at ease, at first appraised him, then forgave him. It was in his nature to forgive. Scratch always passed along forgiveness as it came to him.

The two of them walked on the length of the purple road toward the land of fresh air and sweet people. The land become flatter and cattle roamed the farmlands. Yves could smell farms. Some had cultivated fields, others lay fallow. Hedgerows separated plots. Birds flew by, bugs zinged the air. The air grew sweeter as they drew closer to Milkolopolis. The farms turned into suburbs and after a time, Scratch and Yves saw the milk white city as they topped a hill. It was laid out like spokes in a wheel.

"Milkolopolis," Scratch said pointing a crystal claw. "See that palace near the center of the city?"

"Is that where we're going?" Yves said excitedly.

"Yeah, we should get there by the afternoon," Old Scratch said.

The palace was the biggest building in the city. It was a mass of those cylinders all placed on their ends with the same type of roof that Yves noticed in the poorer part of the land. The castle was surrounded by a wall. There were roads leading in and out of the city. Train tracks led from the outlying farms and Yves viewed a small black steam train chugging its way toward Milkolopolis. From this dis-

tance the city seemed to be clean. A few smoke stacks spewed out clean white steam and the buildings were freshly painted. There was a deep ground hum coming from the city, more to be sensed with your total core—like the sounds of life.

"That hum's not coming from the city," Scratch said. "It's a Green! Grab some sticks!" Yves darted to the edge of the road and broke off some twigs and stood there. Old Scratch stayed in his tracks and scarcely spoke with slight lip movements.

"Don't budge this time!" Old Scratch whispered.

"Okay!" Yves put his arms in the air with the twigs in his hands and dug his shoes into the ground like they were roots. His dirty pants and shirt did look like a trunk.

The Green came into sight on its way from the city. It glided along just a few feet off the ground and the hum got louder as it approached. The shiny wax Green slowed as it passed Old Scratch, then it stopped. Its hum changed to a buzz and it circled around Scratch. Then it withdrew, moving to a funny looking tree. It rose to eye level, stopping in front of Yves' face. Yves glimpsed himself in the mirrored green surface. *Oh my,* he thought, *Cerulean blue and Bismuth Yellow.* He held his breath. The sphere then changed sounds again and slowly departed. Yves waited until it was way out of sight.

"Scratch...Scratch? Is it safe yet?" Yves whispered.

"Wait a second," Scratch mumbled. Scratch waited until he couldn't hear the hum. "I think it's all right now."

"Do you think I fooled it?" Yves asked of Scratch.

"I think so. If we don't have any problems with the next one, then I would say you're probably safe."

"Good...then let's get down into town," Yves said impatiently.

Four

Yves was exhilarated as they started downhill toward the city. He was taking big steps, kicking up purple dust and Scratch's feet were, in effect, a blur.

"Wait! Slow down!" Old Scratch sputtered as he ran through the dust, keeping a sidelong eye out for more Greens. "It'll still be there if we walk slower."

"Yeah, but I want to get there, now!" Yves peeked back over his shoulder and saw Old Scratch gasping for breath. "All right. I'll slow down." Yves ambled along with his hands in his pockets, letting Old Scratch come up to him and keep astride. Old Scratch was half running to keep along side Yves' slowed pace. Yves kicked aside a dried clot of dung that lay in the path.

They approached the city side-by-side. It hubbubed and swarmed with get-up-and-go. They passed many houses, crossed several canals and wound their way through herds of brown and white cattle. A few of the cows disappeared as if being erased, to be replaced with rocks or more trees. This troubled Yves. His painting was changing. *This is not the way I work.*

Closer to the city the towns folk were friendly. "Hello, how are you today?" many asked, walking on by.

"Hi, we're fine," Old Scratch said time and again.

"Bonhomie," Yves piped up. "What's going on?"

"Must be the festival," Old Scratch replied. "That's another reason I brought you this way. I was coming to the festival anyway."

"You're going to leave me here and go to a festival?"

"No, no," Old Scratch said. "I wouldn't do that to you. I thought we could see the queen and maybe hit a little of the celebration. I'm sure we will have enough time." Scratch led on into the city.

"Well, we'll see," Yves said. "Remember, I want to get home. Kay probably is missing me already and has the cops out investigating my disappearance." Yves looked around hopefully.

"Cops?" Old Scratch asked. "What are cops?"

"You know, the police, the enforcers of laws."

"Oh, you mean the guards, like Sathedra's."

"Same thing," Yves said, dubiously.

"They'll have a hard time finding you here."

"I know," Yves sighed mournfully, "this would be the last place anyone would try to find me." Yves came across fairly woebegone.

Scratch and Yves, after some time, made it to the city center and located the palace. The palace walls were formidable. They walked right up to the heavy brass door, but it was shut. It was ornately hammered with panels depicting scenes from the history of Curdland. The ten-foot entrance, from top to bottom, contained eight panels. Each showing different events from the current government. *Kind of Windsor Yellow,* Yves assumed.

They knocked. Rap...rap...rap... There was a drawn out silence, then the door opened a creaky crack and Yves stared into the face of a doorman. He was shaped like a milk bottle and wore a white coat with edges trimmed in braided gold. He wore a funny hat, that at first glance, Yves thought it was a turban. It was white and also trimmed with gold. Poking out one side of the hat was a white feather.

"What do you want?" The guard made a puffing sound as he tried to blow a flinder of feather away that hung from the corner of his mouth.

"We wish to see Queen Creamy," Yves stated firmly.

"You're not going to spoil on us are you?" The guard sputtered making a raspberry sound, then removed the feather from his lips. "We allow none in who may go bad."

"Do we look like we come from Curdland?" Old Scratch asked, exasperated. "Please let us in. We come on an urgent matter."

"Well, all right," the security man sheepishly replied. "But you can't be too careful you know, what with all the people trying to better themselves." He then solemnly and slowly opened the door all the way to let them enter. The duo stepped in and walked past the doorman.

The palace's interior was as white as its outside walls. Milk could not have been whiter. *Like that new Titanium White I tried last month,* Yves considered. Stairs lead all over the place and the floors were made of white pseudo-marble with golden veins painted on it. Paintings of what must have been past rulers lined the walls. Yves began counting the paintings but stopped when he reached fifteen. There were more portraits along another hall, but he couldn't see all the way down. Old Scratch and Yves stepped to the middle of the entry hall. Their footsteps echoed off the high marble-like ceiling. A guard met them and asked them their business. This guard was a tall, thin milk bottle with a paper cap holding in the sloshing milk.

"We need to see the queen," Old Scratch said.

The sentry pointed, "Climb those stairs and the guard there will help you further." Then the guard turned his head and bellowed, "A crystal cat and an I-don't-know-

what are approaching you." His words bounced off the walls of the great hall. The visitors climbed step by step to the top of the stairs where they met the second guard. This upper guard stood stiffly at attention speaking to them while gazing arrow-like at the blank wall ahead of him. He was a half-filled fat bottle with a metal cap crimped to his top.

"You will have to wait for awhile because the queen is taking her daily milk bath, and she loves to take her own sweet cream time." He paused then shouted, "Two more to see the queen." This time the last words echoed longer. Many Curdland folks turned to stare. "Please," the guard said more quietly, "have a seat over there." He pointed to a long seat designed for more than one person next to a large planter filled with some green curly shrub. The two strode over and sat on a milk-white bench and waited. They were glad for the rest. Yves knuckle-rapped the wall, then the bench. They retained the hollow thump of fakery.

As they observed people pass in front of them, Old Scratch named the ones he knew. One was Princess Namilky, the queen's daughter. The princess slowly strolled past with a cadre of her friends. They were all dressed in finery; apparently feathery hats and flowery shoes were the rage this year. And anything golden was always in fashion. A few boys, the hangers-on in her party, stumbled over each other trying to get Namilky's attention. Up-nosed, she paid them no mind, continuing her stately pace, chatting with her clique.

"What a fair maiden and so loquacious," Yves observed. "Why are some of them partially filled with milk?" He had forgotten.

"The amount of milk inside each person will tell you

how intelligent they are," Old Scratch answered. "You remember when we asked directions from that feeble old woman back there?"

"Yes." Yves nodded his head.

"Well, she was nearly empty and sour, wasn't she? From that you ascertain she was not very smart. That's why I was sorry I'd asked her the way and how far it was. Now, do you see?"

"I think I do," Yves said, eyeing those who had varying amounts of milk in them. *Most of them are less than half full. That seemed about right.* Yves smiled at the thought. *Many of the people I know back in Woodbury are less than half full, too.* He leaned back against the imitation marble and nodded off for a nap. He could still hear the commotion around him, but pretended not to notice.

In the bathing room the queen was having her daily milk bath. The dazzling room was deserted except for one attendant who stood behind a sheer curtain. The queen needed being away from everyone. It helped her think. Her best ideas flashed upon her when she relaxed in the warm, soothing milk.

The room was painted light blue, the color of a robin's egg, and accented with white fixtures. One chair was centered in the bathing room—it was always for the queen. Light poured into the room through a skylight high above. It helped warm the room. The only time she ever missed her bath would be during the height of Cream Festival. Though not today, she genuinely desired time for her bath.

The festival! It was an annual event that brought many from all over Curdland to show off their inchoate ideas. In years past, many half-baked ideas concerned cattle and how they could be moved from one place to another to

take advantage of the best grazing fields.

Apparently new thoughts were hard to come by given that they required thinking of different projects, then formulating a new strategy born out of the old concepts. Each contestant had to perceive the identical surroundings differently. That was true thinking. Not many Curd folk could do that.

The hopefuls were erecting their displays in the queen's auditorium. This year she easily accepted 30 entrants. She would choose the winners and present him or her with the annual stipend and big blue ribbon. The winners would proudly wear the ribbon and live off the money. Hopefully, some of those winnings would go to future research. The queen was obliged to give out the awards even though she thought many displays were trivial.

Queen Creamy let the soft milk soak. She'd been in the bath for an hour and the milk was getting cooler. It felt a bit uncomfortable and the bubbles soon disappeared.

"Lak, I am ready to get out now," the queen called out. "Please bring me the blue towel with the soft edges."

Silently Lak gained the towel and sat it on the steps beside the tub. Lak was a worker from one of the farms. She'd shown promise in the ways of care giving. Few Curdland citizens contained the gift of giving, that's why Lak was immediately promised an education, a position and wage. Others such as Lak were helped along with their talents as well. Their obligation was to work for the queen and their lives could be easy.

"Thank you Lak," the Queen said. Lak helped her dry off and get into a shear gown. The lightweight cotton gown was worn while the queen walked to her dressing room. Other workers there would help her into her daily

dress that the common folk would see. Queen Creamy stood in the warmth of the skylight, soaking up the warmth that streamed down.

She sauntered out of the bathing room, down a hall and out into a brightly lit courtyard. She was the lone individual around this time of day. Everyone else knew to keep away and let the queen be alone. She left the courtyard after a few serene moments, then made her way to the dressing room. Her attendants there held her favorite dress ready. She slipped into it. The dressing process took no more than a few minutes because the milky maids were all so skilled. The queen took a long look at herself in the huge floor to ceiling mirror and smiled. "If they're ready, I'm ready," the queen resolutely announced.

Scratch and Yves were still dozing when the queen came onto scene.

"All rise for the queen," one sentry sounded. His voice ranged high in pitch; he sputtered the word, "Queen." His face flushed crimson. Old Scratch and Yves stood straight with a snap of their knees. The queen suddenly rounded a corner and entered the reception area. Her dress sailed behind her as she hurried across the floor. She carried her gold orb with a "C" standing atop it. That was the emblem of her state. Today she wore her work-a-day crown, which was a plain band of gold that circled her brow. It, too, was engraved with an elaborate "C" which faced forward. The Queen of Curdland stopped abruptly next to one of the guards and whispered something in his ear. Then she sped off down another corridor. Several attendants tried to keep steady with her as she flew along. Yves and Old Scratch saw she was filled to the brim with sweet cream.

The guard walked over to them. "You must come back

this evening. The queen will see you then."

"Any special time?" Scratch asked.

"Be sure you are here after today's festival events. The queen will be busy officiating."

"Good," Scratch said, "now we can see some of the festivities."

Scratch and Yves left the palace and headed for the festival. The air was heavy with aromatic odors—the smell of food cooking. Seeing the stature of Yves, the crowd much like a zipper, parted forward then joined together seamlessly behind. They made their way to the staging area of the festival where the auditorium was filled with thousands of Curds who filed back and forth among the booths discovering items for sale. Trash and foul smelling milk-soaked rags filled the spaces between booths. The scum of hustlers and hawkers confused the air, selling handmade trinkets, hats of all sorts and lots of food.

"Wait a minute Scratch," Yves said stopping at one hat booth. Scratch halted and turned to see Yves talking with the hat salesman. "I like that one with the broad rim. Can you make it fit?" Yves was rubbing his head.

The salesman, wearing a red beret and standing behind a low counter, considered Yves' head, took some measurements and asked, "Yes, when would you like it?"

"Better make it later today, before we see the queen," Yves said.

"You two are here to see the queen?" the seller asked excitedly. "Then by all means I will have the hat ready. Would you like a feather in it?"

"Yes he would!" Old Scratch broke in.

"I would?" Yves peeked at Scratch. Old Scratch gave Yves a furtive side glance with his eyes. "Uh...oh...a feath-

er!" Yves turned to the merchant, "Yes, I would like a feather."

"What color would you like?" Old Scratch asked.

Yves scanned the colored feathers, kept his own council, then made his decision. "The pink one," *magenta*, Yves chose. "The one next to the end," he said pointing.

"Pink! Yes, that's a wonderful color," the merchant said. "Your hat will be ready by the time the sun sets."

Yves reached into his pocket and came out with a few quarters, two nickels and a dime. The dealer scrutinized the unique coins and smiled as he kept one eye on Yves. "I'll take...that one." The merchant picked out the dime and seemed happy as he inspected the front then the back.

"Thank you," Old Scratch said. "We will be back."

"That hat will keep the sun off my head." Yves rubbed his balding pate as if it hurt a bit.

The two moved into the hurly-burly that pushed them along in waves. They passed more booths of commodities, then in a short time, drew closer to a section of food booths. They could tell because of the drifting aromas of smoked meats and grilled vegetables.

"It was certainly kind of the queen to see us," Yves said. "She seemed awfully busy."

"Yes, I believe she is busy," Old Scratch said. "Come on let's find you a booth here and get something to eat."

"She's as busy as I am hungry," Yves said, seeking a nice place to eat. They walked down an aisle to a stand with smoke curling around the cook. "I don't have much money," he continued. "They won't like me very much."

"Don't fret about money, remember, I'm a cat. I will offer my services to rid the place of mice. I do this all the time whenever I come into town."

Yves came across a bench and table between two booths then sat down. The table and bench was painted white and the paint was flaking from years of use. Scratch made the arrangements with the cook and scurried around finding mice and rats. A few minutes later Old Scratch brought the furry animals to the owner and held them elevated by their tails and showed the cook the wiggling squeakers.

"Please, have whatever you and your friend want," the cook said, disgusted. The cook grabbed the rodents by their tails and carried them to a covered waste can. He lifted the lid, dropped them in and slammed the cover back down. He walked away wiping his hands on his smoke stained apron.

Old Scratch returned, sat down with Yves then they both ordered some dinner. Yves chose a large chunk of salty, orange-colored cheese, grilled tomatoes, a vanilla custard and apple juice. Old Scratch ordered a small bowl of cold, sweet cream and a vanilla custard, too. Scratch sat, lapping it with relish. His crystal whiskers were crusted with dried cream and custard smeared his nose. Time passed quietly as they ate.

The two felt pleasantly full. Yves leaned back against a wood partition, with his hands behind his head. "That was tasty," Yves said, belching.

"Yeah, you wolfed that right down," Scratch said, grooming his face with a crystal paw.

Yves gazed at the pink sky. *Looks like Quinacrid Magenta and flake white I mixed a weeks days ago,* he remembered. There was a haze from the cooking and the sky displayed orange and custard yellow clouds. The colored clouds were reflecting a warm tint into the crowd. Yves noticed, here

too, parts of the clouds were dulled away to be replaced with smooth, brush like streaks. He was less concerned.

Yves lulled into a nap. An ocean roared in his ears. Sea birds flew by his merchant ship. The wind was filled with fresh salty mist. He watched the bow of the ship rise, then fall. A crashing spray came up over the bridge wetting the decks down to amidships. He faced into the wind and heard the hissing of the sea as it passed on its way astern.

"Yves...hey, Yves." Scratch shook his friend's shoulder. "Come on, we've got to get back to see the queen." Scratch was already heading out into the thinning mass.

"Is it late?" Yves stood big and walked into the sparse crowd, rubbing the top of his head. "My hat! Let's not forget my hat!" he exclaimed loudly. They made their way back to the hat dealer and tested it for fit. It was a little snug, but all right.

"You look quite stylish," the merchant said, then added as if to cement the sale, "and it will stretch as you wear it."

"Thank you," Yves said as he turned his head right then left, watching the pink feather swish in the air. Passers-by had to duck to not get swiped.

The afternoon was practically over and the two travelers made their way back to the palace. Yves stood a head above the tallest and the hat made him seem even taller.

They arrived at the main gate and the door opened before they could knock. This time the guard let them in without question and they were escorted right to the chamber where the queen's dinner was laid out for her.

"In here and be silent," the guard ordered them. "And remove your sun-hat." Yves obliged.

They entered the room and remained silent. Yves was surprised that the room was made of dark wood, *somewhat*

like Burnt Umber with Lamp Black striations, he remembered. This was certainly different from the rest of what he'd seen. One must get tired of the banal white and gold.

When the queen entered, she was surrounded by her staff. Some sort of dinner was being served, but Yves didn't recognize what it was. They waited for the queen to make herself comfortable and speak the first word. One of her staff leaned over and whispered something in her ear while pointing at Yves and Old Scratch.

"Well, speak!" the queen spoke sharply. "I am waiting to eat my dinner." The queen picked a bit and tasted it.

At first Old Scratch just turned his face up at Yves, then back to the queen, "Queen Creamy," Old Scratch began, now bowing so low that his nose touched the floor, "my name is Scratch and this is my companion Yves Tanguy. I call him Yves for short. He landed in the Sathedra Sea from where I do not know. I pulled him out. We have traveled to seek your wisdom. What should I do with him?"

"Yes," Yves added, also bowing very low, "I did fall, but not from the sky. I fell against my painting and passed clean through. I landed in a gritty sea." His voice quavered, not knowing what she might say.

"That is not an unheard-of way of traveling," Queen Creamy said as she slurped from an amber goblet. "People come and go around here in all sorts of ways." She paused and studied him. "The distress in your voice tells me you would like to go home. Am I right?"

"Well…yes," Yves said quietly.

"That seems quite impossible." The queen continued, "Since you cannot fall up, you cannot go back the way you came." The queen thought for a while longer. "I cannot

help you. I think it would be wise for you to go and see Ann Thology, in Curiosa. She would more than likely have much more awareness of this than I. In fact…I have heard of a book of knowledge that tells of spells for making things happen. But that might be a myth." The queen's company nodded their approval. They all thought the queen made a wise decision. The queen raised a hand to hush the murmuring. All grew silent and faces became unmoving.

"I'm sorry I could not have helped you," the queen said as she picked at her next bite of her meal and popped it in her mouth. She directed a smile at the cook and nodded her approval.

"Oh, but you have been of great help," Old Scratch said. "If Ann can help us find that book, then Yves could get home. We must go to the Land of Books," Old Scratch announced. "We'll see Ann Thology and find an answer to this riddle of Mr. Tanguy. May we take our leave now?" The queen told them to leave and the pair made their exit from the white castle. They were met at the front gate by another well dressed guard.

"Be safe," the guard said politely as he let the two out, then shut the door behind them.

Once outside the walls the travelers wandered a bit then hit upon the pink road which Old Scratch knew would lead them to Curiosa. Down the road they paced. For a while they marched along until Scratch grew tired. After all, Old Scratch had to control twice as many feet.

Toward starlight, Old Scratch noticed his companion was looking tired. "Yves, if you need to rest we can stop anywhere." Scratch wanted him to be healthy and rested.

"That half-burned log over there," Yves said pointing

into the darkness, "that will work." Yves headed off the pink road, looked around for safety, then got down on his hands and knees and cleared away a few sharp sticks and wet pebbles. Yves smelled the blackness of the burned wood, then snuggled against it. "Don't know why I've been extra tired of late. Do I seem…too tired?"

"No, not really," Scratch answered. "Any new experience will be difficult for you, like trying to outrun your shadow. It will wear you down."

"That must be it," Yves sighed. Old Scratch sat next to him, cleaned himself for a while, then he too, rested. Old Scratch curled up at first, then rolled onto his back, stretching his back legs out straight. He relaxed and allowed the night to overtake him, too.

Sathedra sat back in her wax chair, stunned. She acted as if she'd been struck by Solanum's lightning; her ears rang like a tin bell. A Red was destroyed while making a trek along the Sathedra Sea. None were ever hurt before this… why did this happen? The Reds could act autonomously, but they were instructed to record and transmit the events preceding an incident.

The record showed a person there in the sand dunes with the moss covered shore to his right hand. A crystal cat of some sort was diving over a dune, taking cover. Sathedra couldn't make out the person. He was too far away. But it was a being somewhat like herself. He was in possession of a head, two arms and two legs.

A bolt of energy lit the pool of seeing so intense that it made Sathedra squint. After that, the image was dazzling, overly bright. The personage fell backwards, made some movements and then the image started to spin. Then the

pool blanked out. This was the third time she'd viewed the record, but still it made no sense. She arose from her wax chair and paced the room. Had the Red malfunctioned or was this being in fact a threat? One of her Reds was gone; that's all she could ascertain. She owned three Reds yesterday, and now, she had two. It would take months to grow another Red. When she dispatched the Greens to hunt for the missing Red, they uncovered nothing. There were no traces in the sands of the person, animal or her Red.

"This is not right. I saw him fall into the sea and he was helped by a cat. But now there's nothing. They must have covered their tracks well. I will contact all my Greens in that area and they will find those two. She turned to the dirty window and peered out the best she could. "You are out there somewhere. Yes, we will find you!" she said brutally.

Yves and Scratch slept as the Greens began their search. Two Greens were in the vicinity and they investigated the slumberous pair. The Greens hovered and moved back and forth trying to make out the scene. One moved in very close, nearly touching Yves on the leg. The Greens saw a log and two boulders beside the road. One rock was like quartz and the other was made of some organic material. It didn't fit any given descriptions, thus the Greens left.

Yves stirred, opened one eye and saw the departing Greens setting like two green moons, over a far hill.

"Scratch...did you see that?" Yves whispered.

"Yes, I did. We were lucky this time. They didn't detect us." Scratch took a deep breath and nuzzled closer to the log. Yves relaxed again, too, trying to find that nod off.

Five

Morning arrived and the sun shone warmly on the snoozing pair. The sun's rays struck the crystal cat's facets and scattered dull distorted rainbows around them. Old Scratch was the first to wake; he kicked at Yves until he woke. Old Scratch sat up, peeked around and stretched his paws out to gather in all the sunlight he could.

"Seems like it's always warm and sunny here," Yves said, yawning. "Never too hot. Even the nights are not too cold…I'm hungry." He pushed to a sitting position and breathed the air, his hair was all mussed and he rubbed his tummy.

"Go have something to eat," Old Scratch said. "I'll wander around until you are finished."

Yves stood stiffly and struck out, hunting for a wishing tree. He sighted a tall bushy one and wished for some breakfast. He wished for biscuits with butter and jam and when they appeared, he gorged himself until he could eat no more. Old Scratch wandered off checking the countryside. Scratch wanted to make sure they were not being pursued by any of those orbs.

"Don't see any," he muttered to himself. He listened carefully. "Don't hear any either." Without hesitation, Old Scratch scampered, straightaway, back to Yves. Scratch was old but he could still have fun. They got back on the pink road and continued walking toward the land of books and the Curiosa people.

Several hours passed and the well-worn Whey Way nar-

rowed down to just a few feet, with Shoddy Sea to their right and the upper Sathedra Sea on the left. It was just wide enough for a cart to pass. Old Scratch and Yves kept themselves great company along the way. They nattered of lost old friends and family members. They even guessed they could become good friends someday.

All of a sudden they heard a bubbling, gurgling whimper coming from the edge of Shoddy Sea. They craned over to see what was making such a burble. When they peered over the bank they saw a white duck and discovered it was pinned under a large log. Most of the log was underwater and the duck's neck was just long enough to keep its head out of the water. It looked like the duck was in a lot of distress as its head flopped down and went under the water, then back up for air.

"Looks like you need some help," Old Scratch shouted as he slid down the slope. Yves followed.

"Oh boy, do I ever!" yelled the duck when its head was out of the water.

At the water's edge Yves shouted, "I'll lift the log and you pull him out. Ready...?" Yves lifted the log. "Pull!"

"Got him!" Old Scratch shouted back.

Yves dropped the log with a splash and Scratch pulled the duck up the embankment and onto the pink road with Yves following right behind. The duck, after a moment or two, with some effort, stood on its two legs.

"Oh thank you, thank you. I have been under that log ever since the log cart came by...now...that was a week ago," the duck said, panting. Its wings hung low.

"You've been under there for a week?" Yves remarked.

"In fact, yes. I was on my way back from Curdland where I was visiting some of my relatives," the duck said,

trying to catch his breath. "I was going to Lilium when the log rolled off a cart and tumbled onto me while I was getting a drink. I was pinned in the water. The driver didn't even notice."

"You look a bit bent out of shape," Yves noticed. Indeed, the duck was twisted. His white feathers were soaked in mud and the duck's feet were facing one way and his body was going another.

"Oh, so you know your way around this land?" Scratch asked as he walked around the duck.

"Yes I do," said the duck, ruffling his wet, muddy feathers to dry them.

"Then will you help my friend here? He fell from the sky and is trying to find his way back."

"Yes, I see your problem," the duck said, tilting his head and putting one eye at the sky. "Since you appeared out of nowhere, you certainly would have a problem getting back…well, back the way you came." The duck paused, thinking, then shook his head. Muddy water flew off in every direction.

"Hey, watch it!" Old Scratch yelled as the water splattered on his faceted body. Yves stepped back too, brushing the spatters off his pants.

"Oops! Sorry about that." Then the duck continued. "I think the people in Curiosa could help you."

"Yes, that's what Queen Creamy suggested," Old Scratch said. "I really do want Yves to get back home."

"What's your name?" Yves asked, staring down upon the soggy screwed-up duck.

"Gabby, Gabby the Duck," He answered. "And I'm sure I could be of some help."

The three of them discussed the plan, then decided it

would be a good idea if Gabby came along. With that figured, the trio set out for Curiosa. Yves carried Gabby for a while seeing as he was still too twisted to walk.

Yves got to thinking, "You've got trains here. Are there any automobiles?" Yves asked.

"Automobiles?" Old Scratch scratched his crystal head.

"Yeah, things you ride in and go places," Yves said.

"Oh, you mean Thimble-rigs. Those run around in Chicane-City, not out here. But that's a nice idea. It would be good to ride instead walk sometimes," Scratch mused.

The road separated the two seas like a causeway, and the water levels were different. The Shoddy Sea, to their right, appeared about twenty feet higher than the upper Sathedra Sea on their left. In a short time, the road widened out. There was a row of trees along each side of the causeway and Yves wished for lunch. "Gabby," Yves inquired, "would you like something to eat?"

"Sure," Gabby replied, "I'll wish for some cracked corn."

"Help yourself to that tree over there." Yves said as he wished for some fish and chips. Scratch wished for a bowl of warm milk and bread.

They all headed down to the water's edge and sat on a pile of pink granite rocks. Gabby pecked at the corn, Yves ate the fish carefully because it was hot and Scratch tore the bread into bite-sized pieces with his sharp crystal claws, then soaked them in the milk. All three sat in surreal silence, together, eating.

"Scratch, when does the sky change from pink to white?" Yves asked. He was ogling the sky and wondering.

"Well, you do have a good memory. The skies change at the boundaries," Scratch said. "It's like a dome of color

with fuzzy edges. The color does not change abruptly. It's gradual, but with good eyes you can see the change."

"So that's why the horizon comprised of different colors that first morning I was here?" Yves said.

"Yep, in the mornings and evenings you will see the colored boundaries the easiest," Old Scratch said. "When we get close to the border, we should see the sky change then." Scratch turned to the duck, "Gabby? You've been quiet." Gabby was picking at his food.

"I just like…peck—peck—peck…to listen…peck—peck—peck…to what people have to say," Gabby said in between bites. "I'm almost… peck—peck—peck—peck—peck…finished."

Yves looked over at the duck's feathers. "Gabby, will you be able to walk?" Yves asked.

"Yeah, I think I've finally straightened out." Gabby stretched his neck way out and ruffled his feathers. He was dry and regaining his white duckness.

When all three had finished their meals, they climbed back to the pink road and set out, once again, for Curiosa. The road widened out and the seas on both sides receded far behind them. The sky made its gradual change from pink to white and the landscape changed from unexciting green to a black-brown desert. There were biomorphic-shaped mountains that bent this way and that. All the landscapes seemed familiar to Yves. *I must have painted them that way,* he thought.

Yves momentarily stopped. "Let's see," Yves muttered inaudibly to himself, "those green trees over there, that'd be Sap Green and that desert ahead, Umber and Ocher with a bit of white. "Gabby," Yves asked, turning up his voice, "when will we get to Curiosa?"

"Late afternoon," Gabby answered, shaking his feathers to put them all back in their proper places.

"I guess that's why we've been seeing the landscape change from rolling green hills to brown mountains," Yves commented.

"Come on Yves, I think we should keep going," Old Scratch called out.

They continued walking along at an average walking speed for a man, a crystal cat and a duck. Each maintained his own stride. Yves had the longest, Scratch second longest and Gabby the Duck the shortest. This meant Scratch and Yves chose to stop once in awhile to let Gabby get closer to them.

The three were not alone on their sojourn. On their trek they met Curiosa people going in the opposite direction. *Maybe they are going to Curdland for trade,* Yves thought. *The people look like books with nibbled edges. Something is eating away their pages. They look sad, too.*

Halfway through the afternoon, the three travelers came across quite a sight. It seemed to be a giant bipedal insect and it walked on its hind legs. The closer they got, the more it appeared like a spider. It stood twice as tall as Yves and was hairy. The hair on its head splayed out in all directions like rays of a starfish. The spider was dressed in a stylish red silk suit and sported a black bow tie. On his feet were shoes made of insect bodies. He also had a elongated, fuzzy, coiled snout. Nevertheless, the trio bravely walked near to the spider. Scratch was the first to speak.

"Hello," Scratch said in a shaky voice. He had not seen spiders like this.

"Good afternoon," the spider made answer, formally in a low guttural voice.

"My name is Old Scratch. This is Yves and that's Gabby."

The spider paused, shifting his weight from one foot to the other, then replied, "My name is Diddlespider." His voice sounded as if it came from belch.

After an ensuing opaque moment of silence Yves said, "Mr. Diddlespider?"

"No, just Diddlespider," the spider interrupted, staring hard at Yves with all eight of his black beady eyes. This made Yves feel uncomfortable and his veneer grew sober.

Suddenly Gabby jumped erratically, flapping his wings. "I remember you now!" Gabby shouted. "You walked right past me when I was stuck in the water. You didn't hear me call for help and you were going toward Curiosa."

"You are correct," the spider said, coolly. "I'm just returning from Curiosa. Sorry, I guess my mind was elsewhere then. I didn't hear you crying for help. I was thinking about the battle between the bugs and the Curiosa people. They claim the bugs are eating the pages out of the books. Of course, this is not true," the spider said importantly.

"When books are old, the pages dry and fall out, and they blame us. The bugs revolted and now the guards of Appellation City are putting the revolt down. I was sent to Curdland by the bugs to find help, then come back and try to reinstate the bugs back into the Curiosa society. I admit, I have not done well. I haven't brought anyone back to help yet." The spider slurped air through his clacking mandibles. "Say, would you three like to help a good cause? I can take you to Appellation City and maybe you could help us." Diddlespider clasped six of his hanging hands.

Yves took Gabby and Scratch off to one side to confer with them on the matter. The three formed a small huddle, Scratch facing away with Gabby and Yves fixed on the spider.

"Do you think we should let this spider come with us to Curiosa?" Yves asked in a whisper.

"Sounds like he *is* trying to find help," Gabby piped up.

"I vote for letting him come along," Scratch said, raising his paw.

"As do I," Yves said. "It doesn't appear like he wants to hurt us. I vote yes, too."

The Diddlespider seemed cautious as the three conferred. He was getting impatient. He began tapping one foot and crossing his six other arms. The little legs of his bug shoes flailed all over. His snout uncurled then twirled three times before sucking it back in.

The three broke their huddle and Yves paid heed to the spider for a prolonged pause, then said, "I think it would be good of you to accompany us to the city in Curiosa," Yves firmly told Diddlespider. "We would be happy to let you travel with us. We could use the extra protection. And when we get to Curiosa, we will see if Ann Thology can help me. If there is time we will argue your case." Scratch and Gabby nodded in agreement.

"That sounds fair," the spider said. "Maybe I have made a difference. I think the bugs would be pleased with me, having sent you three to plead our case."

The spider started down the road, then turned and beckoned the trio to follow. The three chased right after Diddlespider, kicking up dust as they dashed to go on.

"Awful dusty," Yves sputtered, kicking in the raw-umber dirt.

"It's this way because no rain is allowed in Curiosa," Old Scratch said. "The paper would mold and disintegrate."

"How do these scraps of plant life grow here?" asked Yves coughing from the dust.

Old Scratch carried on, "You will only find dry land plants and they are not much good for cultivating. The community of Curiosa doesn't provide food products. Remember, they are the holders of information. They have a depository where vast amounts of wisdom is stored."

"Do you think that place will have that book we seek?" Yves asked hopefully.

"We would have to ask," Old Scratch replied. "Maybe."

The four travelers continued on down the road until they started climbing a steep hill. They tromped on a dusty, switch-back trail that was rocky in places and lined with dry brush and an occasional tree. After climbing for twenty minutes, all were out of breath. It was a punishing incline.

"Whoa, time out," Yves said gasping. "I need to rest. This climb is getting to me."

Old Scratch turned around to see Yves doubled over, puffing air. "We'll meet you at that rest area there ahead, in the shade," Scratch told him.

Scratch, Gabby and Diddlespider tracked along further and waited for him. A few minutes later Yves made his way to the shaded rocks and sat down with a groan. The climb was steep and he was grateful for the mid-way rest.

"Much further to the top?" Yves wheezed.

"Naw, just a few hundred yards more and we will be at the crest," Old Scratch said turning his face up-slope. "We all could do with a rest. How about you, Gabby?" Gabby's beak was open and his wings drooped in the dirt.

"Wish I could fly over the hill," Gabby said.

Diddlespider hung onto a tree branch with most of his arms and leaned downhill. "I'm fine," he said with a silly smile. There was a faint dusting on his diddle-fur. A few minutes passed and their gasping sounds subsided. Yves took his hat off and was fanning himself and the others. The cool breeze felt good.

"Time's a-wastin'," Scratch reminded them. Grumpily they began to climb again. The trail leveled out and the summit was in sight. Scratch moved way forward and stood at the pass waving his arms side to side over his head to show the others how close it was.

"Show off," Gabby snorted.

"I agree," Yves responded.

Before long they all arrived at the summit. There in front of them and a few miles across a dusty flat, stood the city where many Curiosa people lived. Diddlespider began explaining what lay before them.

"It's called Appellation City," the spider said, waving his many arms back and forth. "To the right, up-land is where the queen lives. Under the whole city is that cache that the cat mentioned. There must be millions of books under there. Actually, it's the storehouse of their old folks. They are carefully guarded and no one is allowed entry in fear that some might be stolen. To the left, down-side is Paperback Land. The destitute live there because it is awfully expensive to live in the up-land. These people live in cubical houses and of course, fire is forbidden given that the whole city and inhabitants are made of paper. Their homes are heated by sunlight during the day and luckily the heat stays around until morning comes. It never rains. Sathedra sees to that. Not everyone is happy though. Take us bugs;

we have been persecuted for a long time. Just because we are different and have different ideas, we are vituperated, blamed for most of the natural disasters." The spider dabbed a few of his tearful eyes.

"One time," Diddlespider continued, "the city was almost destroyed by a mysterious fire. The lightning bugs were instantly and falsely accused. Lightning bugs don't start fires. It just sounds like they can. Now I ask, does this sound fair? It sure doesn't to me."

The spider sniffed. "I know you three can help because you see, no bugs are allowed to see Ann Thology. If you could get in and convince her, she might see we are not at fault for every tragedy."

Yves advised the woeful spider that he might be able to talk with Ann Thology, but still, his main concern would be his own welfare.

"You see," Diddlespider went on, "the Curiosa people have become paranoid. If they see a bug, they step on it. It's their way of solving the problem. Never mind who the bug was. Just kill it and be rid of it. It's said millions have perished this way since the troublesome bugs started eating the books. Most of the naughty bugs have been destroyed. But the torment continues for the rest of us. Even those who are friends of bugs have been cursed. You see, it's not even safe for you to be seen with me. I may never get back to Appellation City, but that's all right, I have work elsewhere." The spider drew himself larger. He was listening to something. "What's that?" the spider said. There was a harmony of hums coming from the direction of Curiosa. The humming got loud very quickly.

Yves reached for some twigs and took his tree stance. His sleeves bunched to his elbows and he chose a listing

position. Scratch stood immobile but Gabby and Diddlespider gaped at them in disbelief.

"What are you two doing?" Gabby asked. Then he saw the three Greens and the one Red. They were approaching with the Greens in front and the Red in back.

"Shut up and be still!" Scratch hissed at the top of his whisper.

"I will not," Diddlespider said. "I have nothing to hide."

The green spheres moved to surround the four and the Red floated around Scratch and Yves. It was trying to work out what Scratch and Yves were doing.

"It's Sathedra. She sees us," Yves said.

"What does she want with you?" Gabby asked.

"Oh...I killed one of her Reds," Yves said. "I bet she's upset." Without delay, this Red started that screaming beeping and let a blistering beam go that burned off one of the twigs he was holding. Yves made a fast assessment of the smoldering stick and took a double-take just before he dove for cover. He rolled into a dusty hollow just as the Red let another blast rip the air. Scratch was already hiding behind a tree and the other two achieved hiding places, too. The Greens moved back to let the Red finish the job.

"Scratch!...Gabby!...Diddlespider!" Yves yelled. "Find a rock or something and throw it at those Greens. I'll aim for the Red." They all started scrounging around for weapons while the Red aimed several more blasts at our heroes. One burst scorched the tail feathers right off Gabby and another hit Scratch in the front left leg, sending him spinning into the woods.

Yves was shocked by the sight and he got to his feet to run after Scratch. Three short burst hit him as he dashed. He felt his body vibrate like he was being electrocuted.

Yves crumpled to the ground. He held his sight, but could not lift a finger. Diddlespider was the only one yet unaffected. He gathered several rocks and was poised to throw them when the Red downed Yves. With all his strength and his many arms, Diddlespider let loose a barrage of rocks. With rapid fire accuracy, he hit the Greens all at once and they were sent spinning out of control, hissing and bouncing through the trees.

This left the Red. It hovered for a eye blink, then ascended to gain a height advantage. It was out of reach now, safe from the salvos of Diddlespider. But the Red's range was limited too. It circled the area once and Diddlespider got his claws readied with more rocks. Suddenly the Red dropped, firing at Diddlespider. It missed by a silken thread. At that same time Diddlespider hurled all the rocks he could at one time, then hid behind a tree. Two rocks hit the wax Red and it plummeted to the ground. It "whooshed" and spun as it collapsed into a pile of broken wax.

Old Scratch recovered and rabbited full tilt back to the scene. He held a rock ready to toss, but dropped it when he saw Yves sprawled out on the road. Scratch charged over to him.

"Oh, no...Yves, can you hear me? Can you move?" Old Scratch was beside himself.

Gabby ran to Scratch and took in the sight of Yves lying in the road. "Is he all right?"

"I don't know. He's breathing and his eyes are open, but he can't seem to move." Old Scratch shook him. Yves moaned. Diddlespider joined them.

"He looks awfully blanched," Diddlespider said with concern. Yves limply lifted his right arm and rubbed his

face with his hand. He was feeling to see if he, even now, retained a head.

"My side hurts," Yves finally said. "Oh great, now I can feel things." He reached for his ribs and winced. His shirt had a hole in it and his skin felt roughened to the corium, his deep skin. Suddenly he became aware. "Where are they...are they gone?"

"Yes, they are gone," Diddlespider said, pointing to the pile of red wax. "It melted in a few places."

"Diddlespider did you chase them off?" Yves asked.

"I guess you could say that. I supposed now I've borrowed trouble, too."

"Yeah, you might say that," Old Scratch said. "I think we should bury that thing and get out of here." Yves was feeling more normal now, his color returned. He stood and walked around on wobbly, undependable legs. Scratch, Gabby and Diddlespider dug a hole on the side of the road and shoved the fragments in and covered them.

"We've killed two Reds. Think Sathedra is going to be mad?" Yves asked of Scratch.

"I'm sure of it now!" Old Scratch exclaimed. "Please know, Diddlespider, I'm not blaming you. You had to do what you did. In reality, we all are grateful."

"Yes, we are grateful," echoed Gabby. He turned and observed his bare, smoking featherless tail. It was quite a shock to have his tail feathers burned off. Violence was not unheard of, but one rarely saw it.

Yves brushed the dirt off his pants and peered at the small ragged hole in his shirt again. He put a finger through the opening and felt the skin. He flinched. The pain increased and the darkened skin began flaking off.

"Oooo! This is going to hurt for a while," he said. It was

as if he suffered an electrical burn, caused by lightning.

Old Scratch finished covering the scene and Gabby gathered his tail plumage. Diddlespider stood tall and kept an eye out for trouble while Yves got his strength back.

After some time Diddlespider said, "Looks like things have settled down. I can leave you now. I don't think you will be bothered by them for a while."

Scratch and Gabby moved over to Yves and Diddlespider and they all stared at the spider. "What? You're cutting out so soon?" Scratch and Gabby said in unison.

The spider came back, "I thought I told you that I was not going back to Curiosa. I have duties elsewhere."

There was a persistent silence. They assumed the spider would remain with them longer, but as Yves thought, it was probably good they parted.

"Well, thanks for your help and we will do what we can when we see Ann Thology," Yves assured the spider. They parted company. Arms were waved and good-byes were said. Diddlespider spidered off across the countryside with a feeling of a job well done.

"Another Red destroyed!" Sathedra was in a rage. "What is happening? This isn't in my plans for Sath!" Her Reds were not supposed to go around attacking her subjects. They could if provoked, but only if attacked. If aggression was encountered, she was to be contacted by the orbs, then the Reds were given specific instructions concerning the hostility. "I send them out curious, but they strike instead." She was seething.

"This is happening because of that person." She wondered what other things might change. This was not the best of anomalies for Sathedra. She asserted tight control

over her spheres until now. No one ever hurt her Reds. And now she had precisely one Red remaining. She would have to take great care to safeguard its existence. She knew now that all future events would be changed just because of this individual.

Sathedra contacted her sub-rulers. Spinel agreed to keep under observation anything strange and Queen Creamy said that she would be alert to anyone that fit that man's description. King Solanum suggested they meet in Curiosa and discuss their problems, but Sathedra knew what he was thinking. He knew that she couldn't leave the neighborhood of her castle without destroying herself. He would never stop trying to trick her. Solanum would never be of any help. Ann Thology, as always was easily persuaded and soon acquiesced. If she saw this person, she would hold him until he could be transported to Sathedra.

Sathedra then withdrew to her chamber of conjures and began the growth process of the Reds. It took five months to create a Red. She was worried as she gave voice to her spell.

Ann Thology was feeling chipper. She took pleasure in announcing to her public that she'd finished another year's covenant with Sathedra. Their sky would remain its lovely silky white color, the dry winds would continue through the Athenaeum and fire would continue to be outlawed.

Ann was a collection of stories that were based on historic rulers. Between her covers, stories were written pertaining to young kings who didn't know how to rule and old monarchs that were too baroque to actually govern. She held arcana about the kings and queens in far off lands. From these accounts, Ann learned how to govern

her people with compassion. Although lately, pressures were upon her to conform more with Sathedra's laws and this bothered her. Ann could hear the polyphony of Sath starting to become dissonance.

Ann was preparing for another session with the common folk who needed her advice. This happened once a week. Tomorrow she would sit for a full day, listening to their complaints. They needed her for this because she was the final arbiter in many conflicts and they knew she would be fair.

Ann knew the bugs were getting into everything. She ordered round-the-clock watches to keep the nibblers out of her sight. This night in contrast, despite this fact, she was awakened by chewing sounds. By the time the aides arrived, the little chewers were into her gowns.

"This close! This effing close!" Ann Thology indicated with two fingers pressed together. "Any closer and I would personally throw you into the bug pits!"

"Your m-majesty...," one lieutenant stuttered. "They m-must h-h-have come from under...g-g-ground."

"I don't care where they come from," Ann snapped. "I want a guard with me even when I sleep, is that clear?"

The officer shrank away from her words. Then Dick Shinary, Ann's erudite and trusted prime minister, arrived and ordered the watchman to leave the queen's private room at once. Dick waited for them to shut the door.

"Ann," Dick Shinary assuaged her in a calm tone, "you mustn't be too hard on the guards. They may not have the acute hearing you have. But I will impress the guards to be more alert to the bug sounds." Dick stopped talking and listened. There were some scraping sounds behind him.

"See what I mean!" Ann shouted, pointing to something

scurrying from the closet to the dresser.

"Just a minute," Dick said, peeking behind him. He saw several insects darting. "Guards, in here, now!" Several sentries rushed in and started chasing the scurriers. One bug sped under Ann's bed. The guard dove right after it.

Ann gave Dick a "See what I have to endure," face.

She tried to communicate with him using head movements and facial expressions. Dick deciphered that she wanted the guards out of her room. But before he could give the order, several more ham-fisted guards bashed in and began chasing bugs around. Some bugs were cornered. One guard rose from the floor holding a Black Screamer. It screeched and thrashed its legs all the while it was being removed. Ann sat on her bed holding in an eruption. Her face was turning red as she held her breath.

"Something must be done!" She exploded. "Dick, get everyone out of here!"

"Yes ma'am," Dick said, coming across a touch helpless. "Out everyone, out this minute."

Each guard ultimately got to the door holding a bug. They held them proudly, showing all who would take notice. They were brave bug hunters.

"I am grateful for your help," Ann said to Dick after the guards left, shutting the door. "But we need to keep after this cursed infestation. What a scourge! My people are after me to stop this infernal plague and now the outbreak is after me." Ann stared nonplussed, right into Dick Shinary's eyes. "We must do more!"

"We are doing all we can. We have sent out couriers to find help, but none have returned. We have put a bounty on every bug salvaged. The bugs are being thrown out of the city by the millions. There are daily bug hunts. Every-

one is schooled in insect removal." Dick threw his arms over his head in mock surrender. What more can we do?"

"As usual, you are quite right," Ann said, resigned. "What can be done, is being done. I can't expect miracles overnight. But I want you to see to it that pressure is put on everyone to continue the eradication."

"Yes, your worship," Dick replied, bowing before he took his leave.

"Where are you going?" Ann Thology asked coyly. "I want you to hang in here. I need to rest and I want you to guard my slumber."

"But your majesty, as much as I'm at your beck and call, others can watch over you."

"Tut...tut," Ann chided. "None of that now. Sit over there and keep the bugs away." Ann leaned back, rested on the soft pillows and closed her eyes.

Dick took a seat in a corner and minded Ann as she drifted off into fitful slumber. When she was deeply asleep, Dick walked to the door, opened it a crack and whispered instructions to the guards to remain outside and keep themselves silent. "No raucous bug hunts," he commanded them, then silently, he closed the door. It would be another sleepless night for the Prime Minister. He, give or take a few sleepless nights, was used to it. It was just as well, Ann needed his protection.

Six

Appellation City grew larger as they moved nearer until it was all Yves could view from up-land to down-land. The city was walled in by a vast yellow paper fortification. Along this outer surround there were drawings of short and tall trees, with images of bushes placed along in-between to give the landscape an overgrown aspect. On the outer columns fake stones were painted. It gave the walls an impenetrable impression.

There were a few small entrances along the fortification, but only one large main gate showed near the center, giving the walled city a symmetrical feel. Yves decided this was the gate to use. The weary travelers proceeded to it and gave a knock. The lookout sentry peered over the crest and asked what they wanted.

"We have come to see Ann Thology and ask her advice," Yves announced, gazing up at the guard. The guard was shaped like a book. He was a copy of the "Brown jackets' Manual," the book of rules and regulations that governed his line of work.

His face was positioned at the top portion of the book spine and he was clutching a spear in his right hand and held his left hand over his mouth, as if warding off a cold.

"Go away!" The guard shouted with a muffled voice. "The queen is not seeing anyone." The guard waved his left hand as if sweeping bugs away from the gate.

"Can't we just enter the city to visit?" Yves asked. "It seems to be a very nice metropolis."

"No, you may be infested with bugs," the over-looker yelled. "We have to control the infestation." Then the guard tossed a batch of bug parts over the wall, raining down on Yves, Scratch and Gabby.

"We are not infested," Yves said, dodging the hurled insect bits. "We feel top notch." Yves turned to include Scratch and Gabby.

"You may be in good health, but you might have all sorts of creepy things crawling around on you. You are out there; that's why you are not allowed to enter the city. New rules!" the guard snorted.

"New rules? That's preposterous!" Gabby shouted to the guard, flapping his wings. "Not everyone is afflicted."

"Look at me," Old Scratch said, showing some crystal teeth. "You can see right through me. Do you see any bugs?"

It was a regular shouting match for a few minutes. The three shouted insults at the sentinel and he whooped indignities and bugs right back at them. You see, this was the sole way the city could get rid of the bugs; they threw them out. Piles of dead bugs and bug parts were piled all along the outside wall.

"Push on," the lookout shouted down, "or I'll call for more help!" With a bookish lack of expression, the guard showered more nit bits from his height. Yves gathered his travelers together and suggested to them that they could wait until nightfall and then find footing over a lower portion of the barrier. Scratch thought that was a good idea and so did Gabby.

All the while, they sat outside the gate until it started to get dark. The guard changed and a new sentry peered down to keep an eye on them. More bugs were dumped at

the turn of the watch. Some discarded bugs were dead, but many were alive and those scurried away.

Yves decided it was not a good idea if every single undesirable element was eliminated. He'd seen the majority do that to too many ethnic groups. The entire thrown out just because of a few objectionables.

The three, after that, pathed along the defense until they saw a low point. There they sat until dusk. They cut a few branches from wishing trees, then attached them to Yves' belt. Nighttime soon happened and the trio started scaling the wall. Yves lifted Scratch high over his head and then Gabby got on top of Scratch. Gabby was able to reach the top edge where he peeked around and then called back down.

"Looks like it's all clear." Scratch jumped and Gabby caught his crystal paw and helped him climb the rest of the way. Yves pushed a wishing tree limb up. Scratch and Gabby caught hold and braced themselves. Yves climbed the branches, scaled the wall, then pulled the tree limbs up and reattached them to his belt. One by one they dropped noisily to the ground on the other side.

"Who goes there?" It was one of the inner guards, a larger one this time.

Yves thought quickly and without delay said, "We are the feelings of the great queen that rules your state. We have been out surveying the land and discovered things about the people. We are returning to reveal what we have learned." Yves glared at the other two, shrugging his shoulders. *What else could I say?*

"If this is true," said the guard, "then why don't you float along like my thoughts?" The guard was now staring down at the crystal cat. Scratch turned to Yves with a

frightened demonstration.

Yves replied, "You see, we have traveled far and we are tired. It takes more energy to float than to walk." Gabby and Scratch rolled their eyes back into their heads in disbelief.

The guard thought a minute and said, "Wait here while I confer with my prime." The guard disappeared into the darkness. From their obscurity the three travelers could barely hear part of the conversation. Out of the dimness came words such as "What?"—"floating thoughts?" and "dreaming again!"

The guard returned mumbling as he dragged the speartip on the ground behind him. "I guess you can pass. He wouldn't believe me. Move along." The guard resumed his mechanical marching off into the darkness.

Our three were relieved that they had fooled the guard. Yves couldn't believe that the guards hadn't ask the important question of why they were climbing over the wall and not using the front gate. *Funny things have happened in the half and half,* he thought. "I hope this is a dream," he said aloud. They continued their walk into the city, dragging wishing tree branches behind them.

"My guess is," Yves said, "it's that tall building over there. Yes, we will find her there."

"Good guess," Old Scratch said.

Many Curiosa people hurried back and forth. They were heading home after work while Curiosa children played in small troops. Curiosa mothers were sweeping book dust off their porches with straw brooms, while some of the adults were calling children home for dinner. Some were thin books and some were fat. Yves made a mental guess that *the fatter the book, the smarter they were.* He made this ob-

servation because it seemed to follow the pattern of this whole land.

Since night was upon them, the travelers stopped to rest. Yves noticed an alcove behind a staircase of a public building and they settled in. They arrived like the homeless, passing through the city.

Yves pushed the branches into the ground and wished for a bowl of sliced pears, bread with cheese and a pot of hot tea. Gabby wanted his favorite, cracked corn, but this time mixed with barley. Scratch wished for sweet cream and cottage cheese.

Much later with bellies filled, the three friends snuggled together keeping their warmth among them. After a time, the bustle of Appellation City grew peaceful. Only the slight breeze whispered as paper bits, those torn out pages moved their way, earnestly searching for their home chapters through the alleys and lanes of the city. Most passersby shrugged the three off, but a few would stop to gawk. Some Curiosa children would ask impertinent questions of their parents and they would shake their heads as they walked away, leaving the three to a quiet sink into a secure shadow. Old people who could not sleep and nocturnal intimates were the only ones who noticed them.

Morning arrived with a sudden blast of sunlight. The warmth first woke Scratch. Next Gabby awoke, stretching his neck and fluffing his white downy feathers. Lastly, Yves stretched awake because it was such a tiring night and he too, laid there, soaking in the sun.

They listened to the hustle and bustle of the city life once again. Curiosa workers pushed carts filled with goods and buyers would come out of the houses and buildings to check their wares. Curiosa children chased each other,

playing, completely ignoring the Curiosa teachers trying to get them into school.

But it was time to set out to find the residence of Ann Thology. They gathered themselves together and down the street they strode, passing many different store fronts. Old Scratch stopped several times and asked Curiosa merchants for directions. The Curiosa people kept pointing toward the largest building; to that end they ventured on. Yves led the bleary eyed little band with Scratch behind him and the duck behind Old Scratch.

Some of the streets were narrow with tall buildings while a few avenues were very wide with short squat store fronts. But still, the largest building was Ann Thology's. It loomed over their heads as they drew near. The walls of her keep wore that fake painted guise, too. From a distance it appeared to be stone, but when Yves saw it really close, he simply laughed. *It's faux stone painted with white, umber, sienna and a bit of magenta.* Yves mixed it in his mind.

They ascended ten steps to the front doors. The double doors were inscribed with many important-looking book titles such as "The History of Gehenna" and "Of Rhymes and Reason"—but alas, the doors were shut tight. Yves knocked anyway. A guard pulled open the tall door.

"Yes?" The guard inquired with a rough sticky throat sound. He was an older book and slightly threadbare. His covers were tattered as if he'd been through many hands. He was "Principles of Door Keeping," and he asked, "What do you want?" The old book hacked once clearing his lungs.

Yves tried to ignore this. "We wish to meet with Ann Thology and see if she can help us," Yves pleaded, peeking past the doorman. Yves saw other Curiosa people gathered

inside. They were each and every one in different states of disrepair. Some rag-tag and some owned brand new dust jackets.

"She will have time for you, but you will have to wait your turn. Please come." Coughing again, he opened the door wide and stood out of their way.

"Thank you," all three of them chimed in unison. And in they stepped. They felt quite lucky to get in this easily, but how hard could it be to get past that old guard.

They were led past a clutch of Curiosa people and on to the chamber room where Ann Thology sat. She was at the far end of the room, leaning forward and listening intently to the city folk who offered their complaints.

Ann Thology was a wise-looking book. Her binding was maroon leather and her cover lettering was pressed gold leaf. Her interior pages were made of the finest cream colored bond paper and they were trimmed with prized gold paint that reflected brightly.

On either side of her stood other Curiosa dignitaries of high rank. One of them was Dick Shinary. He was Ann Thology's best advisor, born into the rank and privilege. His parents were part of a vast encyclopedia of knowledge. He was the single one of his siblings to climb this far. His brother, by a hair's breadth, made it to carpentry and his sister had passed on to the Great Curiosa Collection in the Athenaeum a few years back. He missed her. But Mr. Shinary knew one day he would see her again. Given that, he kept faith.

Dick Shinary was a book of words. He contained every word known. In his youth he'd collected words and kept them lovingly in his word sack. When his parents felt he had accumulated as many words and named places he

could, he was sent to the Curiosa printers and the contents of his word sack were typeset and bound into his, here and now, form. His grasp of words was astonishing and this made him a natural for high office. Ann heard of his accomplishments and at once wanted him for a high position.

The wait line snaked around inside the chamber and our trio was shown to the end. The inside of this chamber was painted with faux tables, chairs and fake window dressings. There were painters in one corner discussing how to restore a portion of a facade that had peeled away while other artists were covering over drawings of plants.

On another section was a faded painted map of Curiosa and its surroundings. In the center was Appellation City with a lake in the far upper left corner. Small red dots indicated where hamlets were located. The map looked familiar to Yves. It was a portion of his own painting. This gave him an odd feeling. Could his brain be doing this to him? Having queued, Yves organized his mind as to what he would say.

The line crept ahead in fits and starts, little by little along like a giant worm as it advanced across the huge room; it was a real stem winder. Hours passed before they were in front of Ann Thology and Yves removed his fancy magenta hat. The three stood there, staring at Ann, sitting on her high throne. Behind her hung the golden emblem of her rule. It was a large gold painted "B," signifying "Bookland"—the name that was chosen before her rule. The lower belly of the "B" had a crack in it. Under it was inscribed, "Books Hold Wisdom." Ann Thology leaned down to hear Yves.

"Ann Thology," Yves started, "I'm from a far off place.

I am unable to find a way to get back. My friends here have helped me up to now." He acknowledged Gabby and Scratch, then continued. "And now I am putting myself in your hands to help me any way you can." At this point, Yves dropped to one knee, spread out his arms and bowed his head in fake submission.

Ann thought for a while. Then with a nod she instructed her prime minister, Dick Shinary, to prepare a meeting room for the three strangers. "Have them wait there until I can give them a private sitting and discuss their problem," Ann Thology commanded.

The line moved as the three stepped to one side. The prime minister led Scratch, Gabby and Yves into a smaller meeting room right behind her throne.

"Remain right here and wait for her," Dick Shinary passed on to them as he slowly closed the door. The three sat down and waited for their meeting. The room was rather small. The seating arrangements were odd—for a duck, a crystal cat and a man—but not odd for Curiosa people.

There were curious couches on which Curiosa people could sit. Basically everything was made of solid paper blocks and book leather. Yves liked the smell of the room. It reminded him of the library at Lycee St. Louis, in Paris. It had that same bookish bouquet. *What would Matisse think of this?* Yves chuckled to himself.

A real window across the room included paper drapes that diffused the sunlight as it entered. Old Scratch went right over to the sunlight shining on the floor and sat. He stretched and a pink crystal tongue pooked out of his mouth. He finished his reach, but left his tongue hanging out. He glared back at Yves and Gabby. They were snick-

ering between them.

"What are you laughing at?" Old Scratch shouted.

"It's just that you come across rather silly," Yves returned.

"Silly? First I help you and now you insult me," Old Scratch complained and he started sulking.

"Oh, now, come on Scratch. It was only your silly tongue hanging out. We're sorry, aren't we Gabby?" Yves directed his eyes at Gabby and had a hard time keeping a straight face.

"You can call me the buffoon, but someday I'll be the one laughing." Scratch laid back down in the sun and pouted.

"Sorry Scratch. Really we are," Gabby said.

When the overly long public audience ended, Ann Thology made her quick exit. Dick Shinary and the others of the court followed in her wake. Ann stopped.

"Dick, you continue with me," Ann said. "Please, the rest of you...be on with your business." The company broke into twos and threes and wandered away. When the hallway was empty, Ann resumed the slow walk. The prime minister knew she wanted him to walk with her and discuss something.

"Prime Minister," Ann began, "this is the man that Sathedra contacted me about, isn't he?"

"Yes indeed," Dick said, "are you going to hold him?"

"Heavens no!" she voiced. "If she wants him then we certainly don't want to help her. What would you do with this Yves?"

"Your Majesty, the matter of this lost man must be handled carefully. I'm sure Sathedra knows that this Yves is here and we know that Say's book with Sathedra's spells

has been lost and Sathedra can't find it. This book may contain magic to help him get home. Solanum may know of it because of his recent power gain. I for one would like to know where he has acquired this strength. Since Solanum's cleverness is similar to Sathedra's, I think you should send Yves to see him."

"Your wisdom is impressive. You have won my favor once again." Ann Thology patted Dick on his spine. "We very well may find more on the subject of Say's lost book if we send him to see King Solanum. But, what if the book is recovered and finds its way back to Sathedra? Wouldn't she have more power? We don't want her to have the supreme dominion over us, would we?"

"Of course not. Ann, the probabilities of Sathedra getting the book back are equivalent to Solanum getting it. Or for that matter, we could very well finish with it."

"Ooo..., do you think we might get the book? It's hard to imagine the power and spells that might be learned from between those covers."

"Ann, we should only hope that Sathedra doesn't get it back. Because if she does, the oppression will multiply."

"Should we tell them of the book, or should we keep it to ourselves?"

"Oh, no no," Dick said in a rush. "Tell them nothing except that King Solanum may be able to help."

Ann smiled, "Indeed, that is what I have decided."

The two walked on in silence, down the hall of simulated cabinets and clocks, back to the meeting hall and into the small room where Yves, Scratch and Gabby sat.

"All rise!" Dick Shinary commanded. The three jumped to their feet and Scratch scampered back to the main table when he saw Ann Thology standing close behind her

prime minister. Dick stepped aside and Ann Thology walked thickly into the room. Ann sat at the end of the meeting table with Dick standing at her side. Dick motioned for the three to sit. Everyone was hushed, waiting for Ann to begin.

"I have considered your plight," Ann began, "and I have concluded I cannot help you in this matter. But King Solanum, in Lilium, would know more of these things than I. He knows of the power of Sathedra and you will need that kind of information to get back to whence you came." Ann stood, ready to leave. "Is there anything else I can help you with?"

Yves thought a second. "I hear you have a library under Appellation City. Could we see a sample of your collection of books?" Yves inquired with a hopeful visage. Gabby and Scratch fixated on Yves with questions in their eyes. They couldn't believe that he would delay his own progress.

"I think that can be arranged," Ann said. "But we call it the Athenaeum. Would you like to see it right now?"

"Yes indeed!" Yves said. "This would be a good time."

"I will escort these three to the Athenaeum," Ann declared. "Mr. Shinary, you will attend to your other duties."

"As you wish." Dick bowed calmly. "By your leave?" She nodded and he left the room.

She led them out a side entrance of her palace to a natural stone staircase in the back of her building that was quite unlike the other structures that were made of paper, then headed down underground, following a curved vertical surround, like the inside of a cylinder. The cold stone was gray, flecked with white quartz and covered with a patina of old green growth. The stairs were worn smooth with

foot depressions on each tread recording their years of use. The way was dimly lit by battery lamps and there seemed no end to the stairs, or any boundaries to the depth and space. Down, down they spiraled, coming to a heavy black iron door. It showed evidence of hammering and the hinges were rusty.

Ann placed a key in the lock, turned it and there was a resounding, echoing clack. The door opened with a full deep metallic screech and the space on the other side of the entrance was as dark as a cellar, lit by a solitary small battery-operated lamp sitting on the guard's table. From what Yves witnessed by the dim light, the inside of the cavern walls were made of rusty-colored sandstone. Yves could just make out the light and dark alternating, parfait strata. The floor of the cavern was foot-printed dirt and here and there in the floor, he could make out tread-worn stones with nearly flat tops betraying their age. The rock tops adumbrated the presence of stones lurking beneath with massive proportions.

Ann, along with the threesome gathered around the lit table. The lonely guard had already snapped to attention and awaited her commands.

"Run down that aisle and turn on the reading lights as you go," Ann ordered. Without a word, the guard dashed down the aisle, flipping on the light switches. The row of shelves lengthened as he jogged far into the distance and his footfalls gradually grew more silent. After awhile, Yves could hear the guard's feet advancing, getting louder as the guard made his way back up the next row of shelves. The guard, after a time, arrived back and stood at attention, waiting.

"You see," Ann smiled, "these are two of the thousands

of rows that are under Appellation City." She turned to the guard. "Guard, you may stop lighting the rows now. There is enough light. You may sit."

"Yes mum," the guard gasped, dropping heavily in his chair. He was a bit out of breath.

"There must be a million books under our city." Ann offered, focusing her wise eyes on Yves, Gabby and Old Scratch. "All the old Curiosa people are placed here. Of course each one is unique and you should be pleased to know, we are keeping all of them.

"If there is anything you want to know, this would be the place to search. The only problem is, the books are not in any order and there is no filing system that you can delve into. You must know where the book is located, or you may never find it.

"The collection," Ann Thology continued with hubris, "extends out to the limits of our city. You see, it is big and we fear some natural disaster might destroy the books. Like those bugs." She spat the last sentence like she suffered something in her mouth. Wiping her dark leather lips she continued. "They have eaten away at some of my best friends."

"How is such a vast cavern kept dry?" Yves asked tracing his fingers through a profuse layer of paper dust on one of the book shelves. He wiped his finger absently on his pant leg.

"We have a natural ventilation system," Ann replied, waving her arm in the direction of the darkness. "Can you feel that slight breeze? This cavern has an opening in the up-end and one in the down. We asked Sathedra to create a wind to flow continuously to keep the place dry. We have been fooling her for years." She held her eyes intense

on the trio and clasped her hands in front of her mouth. "Do you have any other questions?" Then she turned to leave and was facing the iron door, but stopped when Yves asked her another question.

"Your majesty," Yves began, "if there was a book about Sathedra and her spells, would we find it here?"

"You have heard of such a book?" Ann said, spinning around with surprise on her face.

"Only that it might exist," Yves said. "I thought it might be folklore."

"I, too, have heard of that legend. But if it were here, we, too, would have a tough time finding it. Even if it were in our vast depository."

Yves stepped in front of a shelf of books and removed one. He gave it the once over and slid it back into place and pulled out the next one. He placed that one back, too. "You are right, to search for a text in this multitude would be futile." Yves said. "I guess you have answered my questions."

Leaving the sentry to his darkness, Ann shut the door and secured it. Then the party started back up the stairs. On the way down, Yves counted 352 stone steps and he counted them on the way up, too. They climbed, stopping to rest every fifty steps or so. They passed twenty battery lamps on the upward climb. Yves thought they must have been down hundreds of feet below the city. Their eyes hurt when they climbed topside into the natural light. Our three followed Ann Thology back into the throne room and out through the main corridor to the front door.

"Who is this person in Lilium who could help?" Yves asked again because he'd forgotten.

"That person is King Solanum. He was once close to

the sorceress. He might have the wherewithal to help you. You should go there and seek his advice. He lives across the Deadly Lilipond and the only way you can get there is to cross it." She studied them closely, then said, "I will order my master builders to help you build a suitable raft." Ann took leave of the travelers and strode down a side hall of her palace until she met Dick Shinary. He'd been waiting for her.

"You will have the master builders construct a craft for them," she said. "Those three will help us find that book."

"You are wise." He bowed his head.

"I know," Ann said with a chuckle as she disappeared around a corner.

Dick Shinary looked down the hall at Yves, nodded his head, then ducked into a doorway, leaving the travelers alone.

A lone Green hovered just outside and below a small window in Ann's castle. It, without doubt, overheard the byplay between Ann and Dick. The orb shuddered slightly and sent a message to Sathedra. When Sathedra learned Yves was in search of the book too, she decided to rethink her strategy. If Yves had a chance to find the book, then she must let him try.

"Scratch, what did you think of the Athenaeum?" Yves asked. "Wasn't it huge?"

"Quite," Old Scratch said distantly. He was thinking on the pond and all the horrific things he'd heard. "But, didn't she say something about the Deadly Lilipond?"

"She said we would have to cross it," Gabby quacked, his eyes frowning over his beak with apprehension. Old Scratch recognized that distressed aspect on Gabby's face. Gabby knew what the Deadly Lilipond meant.

It wasn't long after the queen departed that the master builders came into sight to see the three in question. The prime master was a book on the subject of boat design and the others were of carpentry and knot making. Just the kind of information the builders needed to realize a craft.

"Well," said the prime master, "I see you will need a good-sized raft to take you across the Deadly Lilipond. I think we can help you build a suitable craft."

The prime master and his entourage escorted Yves, Scratch and Gabby out the main gate and onto a path that took them clear of Appellation City to find logs from which to make a raft. The way was lined with waist high dried grasses that shed their seeds to the current of air as Yves coursed his hands along the seed tops. They tickled his palms. Old Scratch ran off into the fields once, just to chase a White Eared Grass Mouse that, by its own mistake, rustled the weeds. Scratch trotted back to the path, empty handed and said, "They're more fun to chase than to catch."

By the afternoon, the troupe had journeyed to a forest fringing the Deadly Lilipond. The trees stood tall and waved without a sound in the upper reaches of air. The trees gave the appearance as if they'd been planted in generations past, in neat rows The area was clean and open around the tree trunks. There was a carpet of pine needles, inches deep, that made the ground soft underfoot. "We know you will be crossing the Deadly Lilipond," one builder remarked. "That should be quite an adventure."

"I hope the crossing will be uneventful," Yves said, trying to reassure himself.

"I doubt that," the builder said.

"Stop here," the master builder ordered. "There should

be plenty of wood in these trees to make a raft. I'll mark them with ax cuts and you three will cut them down."

"You won't be helping us cut the trees?" Yves asked.

"Certainly not. We are builders, not cutters," the prime master said with uncomplicated self-importance. "Now, you three start cutting. My assistants will help you get going." He repaired off into the forest, chopping marks into large and a few small trees.

Yves turned to Gabby and Scratch. "Let's not argue here. We need to get across that pond. Ann Thology was good enough to give us these builders; we better use them."

The Deadly Lilipond was just yards away from the forest's edge. Yves peeked over and glanced at the pond. There were grasses and reeds along the shore; *looks like I used Oxide of Chrome for that green, and well—here too, it's no more than water painted with Prussian Blue. Why is everyone perturbed*, he wondered.

Yves seized an ax and started chopping on a labeled tree. Old Scratch and Gabby grumped, but they grabbed a two-man saw anyway and together with some difficulty, began sawing on a marked tree.

Zitt—zott, zitt—zott of the saw and the thunk—thunk—chunk of the ax extended on for a while and the ground around the trees became piled with sawdust and wood chips. Our three began to suffer tedium.

"Don't slow down," the prime said, "there are still more to cut."

"That's simple for you to say," Gabby said puffing, "you're not doing the work."

Yves told Gabby to calm down and keep sawing The smells coming from the sawing and chopping reminded

Yves of the wood he'd cut no more than a month ago. The wood gave off a sharp resinous smell. He loved the smell of sawdust.

Several more hours passed and after that, the builders stopped the weary group. There was enough wood for the raft. Gabby was the first to find a tree and sit. Old Scratch and Yves, found soft places in the grass, too. The prime master brought out some plans, put them on the grass in front of Old Scratch and Yves, then stood around pointing and instructing his assistants. From a pile of cut timbers that were heaped this way and that, a square of large logs were lashed together to form a frame.

"It is nice to see them working now," Yves said.

"Yeah," Gabby said.

"Agreed," Old Scratch said, huffing and puffing.

As per plans the builders put smaller logs across to make a floor. Everyone worked quickly since they knew what they were doing. If Yves attempted making such a craft by himself, it would have fallen apart as soon as it was moved.

Before the day was gone, the builders lashed the logs together and propped a lean-to in the middle big enough for the passengers. Then they struggled to get the craft down to the water.

When Yves saw the pond again, the great expanse awed him. The surface of the pond was blue-green with yellow lilipads and blue flowers. A fog settled in and now he could only see part way across. He noted the color of the water far from shore. It turned to the most beautiful light aqua he'd ever seen, *like Cerulean Blue with a bit of white,* he reflected. It sparkled like an inimical jewel. There wasn't a ripple.

"Are we really going to cross this pond?" Gabby asked, putting his beak down close to the water.

"I hope we do," Yves told the duck.

"I hope we do, too, and safely," Old Scratch added.

"I assure you, even Ann Thology would be safe on this raft," the prime said giving it a solid kick and throwing left over extra rope and cord onto the vessel. The craft shook, then creaked back and forth like it was in an earthquake.

Yves commanded everyone push the raft into the pond. Beautiful waves were effectuated. The pond normally was blue-green, but when it was agitated, the color changed to a brilliant dichromatic red/cyan.

Yves asked, "How does it do that?"

"That's the blood of its victims that fall into the pond," one of the builders explained. "The pond eats every part of the person except the blood and the pond gets redder over time."

"And the pond gets nourished," another builder added. This made the trio gulp and Gabby jumped back from the water's edge.

"Don't be slapdash and you will be fine," the prime master assured them.

"Thank you for your help," Yves said. "I'm sure it will be an okay craft, I mean, the way it is built." Scratch and Gabby just shared a glance.

The Prime waved at his group to follow and they headed back toward Appellation City. Yves turned back to the raft and shook his head. He certainly held doubts.

Yves carefully crept onto the small craft. He was followed by Gabby and then Scratch. The raft tipped a bit, but then righted itself. They carefully slothed around the craft looking it over. They snatched the poles and proved

their length by putting them into the water.

"This boat sure seems small now," Old Scratch remarked.

"And tippy," exclaimed Gabby.

Yves directed Scratch and Gabby to push the raft away from the shore and stop fussing around.

"We'll pole along until nightfall and then stop and rest until tomorrow morning," Yves instructed. With a great push the raft slowly started across the deadly pond.

Three green orbs, too quiet to be heard, appeared from behind trees and floated down to the water's edge to observe the travelers dwindle into the foggy distance. The Greens could go no farther.

After poling for a while and twirling in several circles, their course straightened out. The atmosphere became warm and moist. They had moved into the new climate. Lilium proper was thick jungle and always covered with a fog that made everything moist. Droplets of water formed on the raft. Yves reminded Old Scratch and Gabby to be careful because wood was very slick when wet. Yves made fast a safety rope around each of them and secured the ends to the center of the craft. Now, if one of them lost his steadiness, the rope would catch and not let them slip overboard. "Don't want anyone to get hurt," Yves said.

The fog grew thicker and the temperature rose. It was very warm and misty and the fog hissed as it moved around them. The fog seemed to be moving in great banks that would open, then amass over them again. Yves could only see fifty feet in any one direction. He wondered how they could stay on the right course. He become aware of a shadow and observed that even in fog there was a direction to the light. Knowing this, he determined that they

were on the right course. Pretty soon they drifted into nighttime.

"Hold the poles," Yves ordered. Both Scratch and Gabby stopped and swung their poles back onto the raft. The forward movement ceased and they sat nearly at rest on the water. The only movement was the rocking of the raft by the passengers and that sent rippling messages, out from each corner of the raft, to be received by the far off shorelines.

"Lets all get some rest now," Yves decided. "Gabby, you sit on the spar and Scratch, you get inside the lean-to and I'll look out for trouble for as long as I can stay awake."

Gabby climbed to the spar and roosted while Scratch pill-bugged in the lean-to. Yves sat down and began his defense.

He pondered his situation. *Will I ever get back to my studio in Woodbury, Connecticut? What will Kay do when she finds me gone? Or am I in reality gone? Am I in a half-here? A pinch will tell me.* "Ouch!" *That didn't work.*

This was no fantasy. He was real. He was hungry. Scratch the crystal cat was genuine. Gabby the Duck was tangible and the pond looked deadly real. Yves tried to stay awake, but in the end he slumped down and drifted into a deep, thick, natural sleep, occasionally smiling, the kind of rest he enjoyed back home.

The night circled above the mist and white throated Evening Stingers swooped and flapped in and out of the fog, snatching insects that ventured out into the cool air. Soon the birds with a hiss of wings, flew back to their aeries with full bellies, to feed their nestlings. The night grew quiescent again and the stars left no trace of their path.

Her orbs were everywhere except in Lilium. They could not follow the travelers into the fog, either.

"They have gone into that blasted mist," Sathedra resentfully spewed. "Poor Ann, she knows of the book and she is helping those three get across the pond. I will deal with her later," Sathedra cackled.

She couldn't fault the stranger for trying. He was making progress. She glared again into her Pool of Seeing, following his trail. He'd passed from Milkolopolis to Curiosa seeking advice and was much closer to finding the book than she had ever been. Sathedra again wished that she could leave her castle and gad free. Someday, peradventure, she would figure out a way. Perhaps not, but for now, it was essential for her to wait it out.

Would the stolen secrets ever be hers again? If the three travelers made it across the Deadly Lilipond, would they find their way? Not even Sathedra could find the palace of King Solanum. The fog and mist made it impossible for her to see into his kingdom—besides that, she couldn't resist the allure of toying with the three travelers anyway.

"Spin...spin...spin," she incanted. Sathedra passed her white finger around the edge of the Pool of Seeing. The trace of her red fingernail made ripples. The faster she whirled her finger, the faster the water in her basin spun. The fog on the Deadly Lilipond start to spin as well. Faster and faster she whirled the water and faster and faster the image in the pool spun. "They must be having a grand ride," she said aloud. Even Sathedra was getting dizzy.

Her guards, tending the animals and traps far below, lifted their faces toward the tower and heard her rare laughter echo into the night.

Our three sailors on the Deadly Lilipond slept. Their

craft slowly started to drift and then spin, a whirlpool formed. They were being drawn in. They awoke when the raft gyrated.

"Scratch...Gabby! Wake up!" Yves staggered to his feet. The raft was spinning and he was having a hard time standing. Gabby woke and flapped his way down to the deck while Old Scratch stirred. Yves was pulling in the ropes to make them shorter so no one would spin off.

"What's going on!" Old Scratch yelled. He clawed deep into the wood.

"We're being sucked into that whirlpool!" Yves shouted. "Hang on tight!"

"That goes without saying!" Scratch shouted back.

Gabby flew into the lean-to and huddled beside Old Scratch. Yves sat down and held onto the ropes. They were not being drawn down but simply spun round. Red water splashed onto the raft giving it a pink color. If it hadn't been for the ropes they would have been thrown off. Suddenly the raft up-ended, nearly turned over, then was thrown out of the whirlpool landing fifty feet away with a "ka-whomp." On the way down to the water, Yves lost his hold and was thrown free and he landed in the water right beside the raft.

"Yeee...ouch!" The pond water already began to eat at his skin. "Get me out of here! Grab the rope and pull me out! Hurry!" Yves shouted.

Scratch and Gabby got hold of the rope and pulled with all their might. Within seconds, they hauled Yves back onto the raft and started wiping the bloody pond off him. Had Yves been in the pond much longer, he would have been in real trouble.

"Ooooo...it feels like I got a sunburn," he said hissing,

rubbing his arms lightly with his fingers.

"I think you will be all right now," Scratch soothed.

"You think...doctor Scratch?" Yves shot back.

The raft leveled itself off and, in the dark, the waters calmed down. Our three sailors huddled as one, eyes wide and excoriating skin, until the fog settled back into its thick motion. But they eventually fell asleep again, bunched together in the middle of the raft.

Interlude

At this point in Yves' papers, not only were there the description of the raft dream and falling in the water, but there were some sort of words—to me, an unknown language. More like pictographs than words, like maybe a made up language meant only for his eyes. What the meanings were, I could not tell.

Now, back to the story.

Seven

The thick morning was slow in coming and Yves relished in the extra rest. Scratch was awake with the first light of day as it filtered through the dense fog. Gabby came around last. The water made slapping sounds on the logs as the raft tipped from side to side. Except for the water sloshes, it was tranquil. Even their voices were absorbed by the mist. Each noticed items were askew and Yves' clothes were still wet from the dunking that happened during the night.

"Everything is wet!" Yves complained to Scratch and Gabby. "That was some storm last night, wasn't it?" He continued feeling that fiery sensation and he knew that he would experience that sunburn peel in a few days. He looked at his arms and legs. They were as pink as those poodle skirts he'd seen a short time ago in Woodbury. *Sort of like light Rose Madder, but with a sting,* Yves thought.

"I can remember dreaming of being dizzy," Gabby said, ruffling his downy white feathers, sending tiny droplets flying. "We must be thinking about the storm we lived through."

"Yep. I'm sure it started something spinning around in your head," Yves said. He was sure of this. He, too, felt uneasy as his mind had engaged in odd half-times in the early morning hours—similes of time ticking away. He could not pin down any power to slow the time, as a result, it sped by faster, with clocks ticking, chiming...bonging in a

cacophony of clock sounds. *Like a noisy collage,* Yves thought woozily. The burn was making him feel more tired. He would have to fight the sick feeling.

"Check the raft over real good," Yves continued. Yves was resisting the crossed-grain pressure his burned body was exerting over his overall mood. "Gabby, you examine the cabin. Scratch, you and I will be sure the logs are lashed together properly." In spite of everything, they took to their assigned duties and reported the raft was secure. It was just wet.

Broken plants were scattered here and there on the water and hanging from the push poles. The pond appeared as if it had been stirred. The night before, the plants in the pond were evenly and naturally placed; this morning the plants were scattered every which way. A few were in clumps, exposing open areas with no vegetation. Sticks and bits of this and that floated in the deadly pond. It smell like a ripe cesspool.

"That whirlpool must have generated a lot of energy to cause this much damage," Scratch said.

"I think there was more happening here than what was natural," Yves replied with concern. "From the appearance of the water and vegetation there must have been quite a wind, too. How did we survive the whole thing?"

"I'm surprised that I woke at all. I could have slept through anything," the duck said. Gabby was right. New muscles were felt and indeed, they were altogether quite tired.

"Yves, can we rest awhile longer?" Gabby asked hopefully. His wing feathers were tattered and his bright white plumes had changed to a light gray tint. "I can hardly hold my wings up." Gabby raised his wings, then let them drop

again.

Casting back at Scratch and Gabby, Yves said, "Hey, I hurt just as much as you do, but we have to keep going." Yves was hoping they wouldn't rebel and refuse to work. He would be in big trouble if he lost his companions.

Gabby's plans were to come to Lilium to help the Lilifolk combat the wood-eating bugs and fungus. He planned to fly over the forests and locate pockets of infestations. That was his strategy. Well, as soon as his tail feathers grew back.

Yves ordered the manning of the poles. Although this day's distance wouldn't be great, the day ahead would be a challenge. Scratch and Gabby grumped, then took hold of the pushing poles and sank them deep into the muddy bottom. The craft moved slowly through the fog once again.

In the middle of the gray afternoon Scratch smelled land. With his nose twitching in the moist air, he walked carefully around the raft, trying to locate the shoreline. He stopped at one corner, sniffed right, sniffed left then right again. "That way!" he said decisively, pointing into the dense fog bank. The pace of poling picked up and the raft moved in the direction of the unseen shore.

After a while, Yves sensed the presence of dense undergrowth, too. The shore seemed to be there. But he couldn't quite see it. It's like when you believably see something before it's visible. He imagined it to be there in the fog. Then it really was—then it evanesced again. Presently, there was substance to his vision. He espied big green broad-leaf plants, trees and lacy ferns. The leaves on the trees and fern fronds were without air. The ecosystem was truly dense with plant life and Yves studied the shoreline for a landing that would be suitable for the raft.

"Over that way," Yves commanded. The crew pushed the craft in the direction Yves indicated. A small white sandy shore appeared and they pushed frantically for it. After not quite two days of poling, they came to the land of the Lilipeople. The raft dug into the soft white sand and they jumped out onto the thin white beach. It was warm on their feet. Rolling in the warm sand sure felt good on their sore bodies.

Then the trio rested for a bit. Yves lay on the sand and gazed up through the trees. It reminded him of the tropical forest he'd seen while he was in the south seas. *Let's see,* he began thinking, *that would be every green I have in my pallet. And this white, I don't think any white I could buy would be bright enough.* Of that he was sure. But these trees did not stir. There was no breeze and the half-tone forest was silent. It would have been way too easy to rest the day away. Fighting that, he propped himself on his elbows and looked at the resting pair.

Scratch was sprawled on his back, sticking his legs in the air. He wriggled deeper into the warm beach. Gabby dug into the warm dry sand with his wings, then flipped some sand onto his back. When he shook his body, the feathers allowed the sand to pass through. With this vigorous shaking, the sand cleansed the grime out of his plumage.

"It's time for us to start the search for King Solanum," Yves said, noticing a path leading away from the beach and into the dense foliage. "Let's follow that path. It must lead somewhere."

"It could lead to trouble," Gabby said, shaking more sand out of his feathers. "And trouble is what we don't need."

"The path seems safe to me," Old Scratch said. He was

looking as far into the jungle as possible. Scratch absorbed as much heat as he could from the sand—it felt positively good.

"Okay, you two, let's get going," Yves ordered. The three adventurers set out.

The path was lined with jungle and in many places the growth crossed their way. After a while, the trail turned to jungle, too. Without a bearing, the three now pushed through the undergrowth. Yves pushed ahead of them, clearing the way. After an hour, Yves heard something like habitation sounds. With that, they kept struggling along through the jungle. The sounds grew louder.

"Shhhhhh," Yves whispered with a finger to his lips. They strained to listen.

"Sounds like workers," Old Scratch said.

"They give the impression of being pretty far off," Gabby guessed.

"Yeah, I think you're both right," Yves paused and they listened again. "I'm sure it's safe to continue."

"After you," Scratch said.

It wasn't long before they came upon a barricade of trees. It stood a hundred feet in the air and there was not a single space between the trunks. It gave the impression of being like an army fort from the old west, except this thing was living.

"What in the world is this?" Yves said, perplexed. "Who would let trees grow this way?" He stood there, eyeing the trees. *Maybe someone made the trees grow this way,* he thought. "Any ideas how to get over this?" Nobody answered. After that, Yves decided to take charge again. "Has to be a way through this somewhere. Scratch, you start knocking on the wall down that direction," Yves pointed to the right,

"and Gabby, you start pecking on the wall over on the left. I will check the wall way high. Gabby, have you ever seen anything like this before?"

"Nope," Gabby answered. "This is the strangest thing I have ever seen. I sure hope we can find a way in." Gabby wasn't sure if they'd find a way.

Scratch turned his direction and Gabby reluctantly waddled the other way. Yves started investigating far above the ground for a way in.

After a while. Gabby returned back to Yves and reported no luck. In fact, Gabby waddled down only a short distance and hadn't pecked at the wall much at all. He held his doubts. They started looking for Scratch and while doing so, Yves put Gabby up on his head and made him peck along higher than Yves could reach. There were no hollow sounds or secret passages. *There must be,* thought Yves. They walked a half mile until they saw Scratch returning toward them.

"I've found the way! I've found it!" Scratch called. Yves hurried toward him. Scratch was obviously excited.

"It's an odd thing, but there is an invisible passage," Old Scratch said, pointing a crystal claw down the divider. "You can't see it, but when you feel into it you pass right through."

"What a stroke of luck," Yves remarked. "How far is it from here?"

"It's ten minutes of walking," Old Scratch figured.

Gabby maintained his suspicions. "I'll believe it when I see it," he said.

"Gabby, why do you doubt Scratch?" Yves asked.

"Because ever since I've been with you two, we have gotten into some sort of trouble."

"Come on, I'll try to keep us out of harm's way," Yves promised. He wasn't sure how, but he would sincerely try. His body couldn't take much more of this punishment.

The three footed on down the blockade and when they arrived at the supposed way in, Scratch showed the unbelieving Gabby the passage. It showed the same facade as any other part. The bark seemed normal and when Gabby peered at it he said, "Looks solid to me." But when Yves pushed his hand through, sure enough, his hand disappeared as if the wall wasn't there.

"Oh my," Yves said with surprise, jerking his hand right back. It didn't seem to hurt his hand, though.

"This is remarkable. Scratch, you go through first and come back as soon as you get there," Yves ordered.

"Yes sir," Old Scratch said in a military mien, giving his human friend a quick salute. The cat walked right through and disappeared. A few seconds later Scratch's head popped back through. "Seems safe to me," Old Scratch said, acting as if his actions were nothing. He pulled his head back and disappeared once more.

"Gabby," Yves said, "you're next."

"All right," Gabby said in a way that cast suspicion on the whole situation. "Here I go." And in he pushed. Part way through, Gabby felt the uncontrollable urge to flap his wings and call out a "quaaaaack." Then Gabby was gone. Yves was alone and he didn't like the way that felt.

"I'd better get this over with," Yves muttered. "In I go." And then there was no one in the forest. For an instant Yves felt displaced—out of body. Then he discerned no sensations. Much like fainting.

When Yves got to the other side he was glad to have feeling back. Scratch and Gabby were waiting for him.

Suddenly the three were surrounded by guards that exhibited the bearing of humanness except they were made of vegetable matter.

Their hair was green leaves, their bodies a trunk and their arms and legs—branches. They walked and talked, and Yves twigged what they were saying.

"Stand still," one picket commanded the trio, "you have entered the city illegally. What are your names? What are you doing here?"

Yves sighed. *Here we go again.* "I'm Yves Tanguy. This is Gabby the Duck and that is Old Scratch the Cat. They are helping me to find my way home. We were hoping to meet with King Solanum. He might have some answers for us. You see, Ann Thology in Curiosa sent us and helped us cross the Deadly Lilipond." He shifted uneasily from one foot to the other.

"You have crossed the Deadly Lilipond?" one guard asked. "Few do that and live." He turned to the other guards, "You two hold them here. I must communicate with headquarters." The two other guards stepped over to our travelers while the sentry in charge planted his feet into the ground. He sank down roots and his legs became as solid as a tree. His representation was animated while he transmitted his information. In a while the report stopped and the sentry uprooted then walked over to the three.

"Are you for or against Sathedra the Sorceress?" the sentry asked.

"Against!" Old Scratch said in the blink of an eye. He knew alliances meant a lot.

"Well, in that case," the guard said, "we must take you to Caylyx City."

They motioned them to press on along ahead of them

and they were off to Caylyx City. The road they were forced to walk was cleanly cut out of the forest. Yves could scarcely see but a few meters back into the dark woods. In among the trees, Yves spotted other Lilians with their legs stiff as stumps rooted in the ground, sending and receiving information, too. Others stood in their places serenely. When Yves turned his eyes up he saw blue sky and puffy white clouds. *That's nice*, he thought, wistfully, *just like home.* Then they were led into the city and Yves could not believe what he saw.

The natives were made of plants and that included the city. The largest buildings were made of what looked like tall redwood trees standing packed together; rope bridges crossed the gaps between the trees. Root steps lifted people to elevated doors. The canopy was sparse which let light filter down to the ground. There were doors in the trunks, leading into different levels. The openings were linked with limb-ladders and catwalks circling the trunks.

Lilipeople were being moved up and down in wooden lifts that were powered by laborers in squirrel cages. Ropes were wound around large spools and these connected the lifts to the spinning cages. When the workers in the cages treadmilled to the right, the lifts rose. They turned around and ran left to lower the lifts. There must have been hundreds of lifts, each going up, then down and up again, moving townsfolk about.

The mist that hung in the jungle was much thinner here because of a breeze. This kept the fog high around the tree tops, which sometimes disappeared into the clouds.

The travelers were led to an inclined walkway, then into a large tree and shown into a dark waiting area lined with ebony wood doors. Many grim guards stood stiffly at at-

tention, making the place come across like a penitentiary. Other guards stood about with no pressing duties. Then a door was opened and the three were pushed into a small cell. The door slammed behind them with a reverberating bang; then silence.

"This is supposed to be a friendly place," Old Scratch complained, wiping mud from his crystal paws.

"Oh look," Gabby said delighted, "a puddle!" He waddled over and dabbled his bill in the shallow, muddy water.

"So much for Caylyx City," Yves said.

The dungeon was dim and soggy, with dank walls. The floor was moist and in some places, Yves could squish his shoes right into the floor. A drizzle seeped through the air and droplets of moisture dripped from the ceiling making splat sounds.

Yves, Gabby and Scratch paced around the water, circling it many times. They were thinking of ways to escape. The cell walls were propagating. New branches and twigs in the past, sprouted leaves, some green—some etiolated, pale from no sun. *The guards must chop away at the new growth every now and again,* Yves worked out.

He couldn't tell what the vegetation was. It was sort of like elm leaves, but larger. The bark was a squishy dark brown because it was wet—like the color of a compost heap. The leaves owned a dark summer look, like Viridian, and not the green of spring.

The wood acted like a natural sound dampener. The trio's voices sounded flat. This place demonstrated none of the familiar echoes of real life. Isolated light filtered from a small window cut high and its thick wooden bars that diminished the light, looked as strong as steel.

"Climb up and look around," Yves said to Scratch. "Use

those claws, they should be crystal sharp."

"Indeed, they are sharp," Old Scratch replied. "I should have used them on those guards. They would have made great scratching posts." Scratch clawed the air in mock battle.

Gabby waddled into the puddle and was enjoying the cool water on his orange webbed feet. He sat down and splashed water on his back and shook until the mucky beads dribble off.

"Up you go," Gabby said, now standing in the puddle.

Scratch jumped on the wall, digging his claws deep into the wood. It took Scratch just a few seconds to scale the wooden barrier and when he got to the window sill he stopped, poking his nose out between the bars.

"There is a big courtyard and many are selling goods. In the middle sits one person guarded by many sentries. I cannot tell what he is doing there," Old Scratch called down to Gabby and Yves.

"The mist and fog is even in the courtyard. It looks like there are many entrances to the court because people are coming and going in great numbers and they all look the same from here. Wait a second," Scratch's voice extended to a higher, more excited pitch. "There seems to be some kind of disturbance off to the right. The guards are rushing over…they are settling a dispute."

By this time Old Scratch was getting tired of hanging from the sill. As a result he slipped and fell. Yves caught him before he hit the soggy wooden floor. There was a "chink" noise and Old Scratch exclaimed, "Darn, there goes my tail again."

"Looks like you broke the your tail," Yves said.

"Yeah," Old Scratch sighed, "it happens once in a great

while. I'm getting fragile in my old age." The crystal tail broke cleanly off an inch from the tip. It was a nice squared-off break, not rough or jagged. "One nice thing about crystals," Old Scratch continued. "They can grow. It'll take awhile, but my tail will be normal soon enough." Scratch collected the broken bit and put it in his toy pouch hanging from his neck. *I will not leave bits of me laying around,* Scratch thought.

"I guess we'll wait for them to make the next move," Yves said. "It's impossible for us to get out right now. Let's just sit back and relax."

Sounds from the courtyard filtered down into the cell. Yves started thinking of various paintings he'd finished. Did they all have such wonderful places in them like he'd encountered in this strange land? "I'll be careful what I paint from now on," Yves muttered to himself.

"What did you say?" Old Scratch asked."

"Oh, nothing," Yves said with a small sigh. Gabby the Duck, busily paddling in the puddle, was oblivious to Scratch and Yves' conversation.

After several hours Old Scratch put his nose in the air, sniffing. "I smell something funny, sort of...acrid." Yves suddenly noticed it, too. Gabby blinked his eyes rapidly as if they were hurting and flip-flapped his wings. Then Gabby's wing tips suddenly flopped onto the floor. Our three yawned and drooped as they tried to fight it off, but the urge to sleep was too strong. The threesome suspected they were being drugged. The last thing Yves heard was Gabby sounding a stretched-out quack that processed down just like an alarm clock. The cell door opened, muffled voices floated on the air and then nothing.

Eight

Yves was the first to wake and discover he was flat on his back, with his arms and legs restrained to a wooden table. He looked around a white-washed room, alarmed to see his friends strapped to tables just as he. The room was empty except for the three of them and various types of medical looking paraphernalia. His vision spun round and round; he gripped the table's edge to keep from spinning off. Eventually, the dizziness ebbed. The room was quiet enough that Yves could hear his heart beat and the breathing of his friends. Gabby was wheezing through his little nostrils while Old Scratch snored softly, somewhat like a purr.

A few minutes later, both Gabby and Scratch awoke. "Ooooo," Gabby moaned, gazing groggily around the room. "My head hurts. What happened?" Gabby's head flipped and flopped as he searched for his companions.

"Gabby…I'm over here," Old Scratch called out. "Yves…are you okay?"

"Yes, I'm hanging in there," Yves answered. "Any ideas where we might be? I wonder if we're still in Caylyx City?"

"Well…we might be. It seems they wanted to move us here without us knowing where here is," Old Scratch said. "Did I make any sense, you know, what I said?"

"Sure," Yves said, "you made perfect sense, considering." Yves smacked his dry lips. "Obviously, they want to study us."

"I wonder why?" Gabby asked suspiciously. Right then

the door opened and in walked a cluster of sentries followed by an important-looking person.

"Stand out of the way," the leader commanded. "Where did you find them?"

"We caught them slipping through the invisible passage, my Lord King Solanum," one guard timidly answered. The guard hunched over waiting to be punished.

"Good work, you will be rewarded," the king told him. The guard gave face, stood taller and grinned, exhibiting ebony snags for teeth.

"Lord King Solanum," Yves shouted from the middle of the sterile room, "what have you done to me? You can't do this to us!" Yves struggled with the ropes holding his arms.

"We have done what we must," King Solanum coolly remarked. The king stepped over to a tool-strewn table.

"But we have done nothing to warrant this," Yves said, fighting with his restraints again. "Please come here and listen to me." Yves was hoping the king would be curious enough and want to listen. The guards stepped in between the king and the prisoners when Yves yanked violently on the ropes.

The king turned and glared at our three. "Who are you to speak to me in such a manner?"

"My name is Yves Tanguy," Yves paused, "I think." The drug was wearing off, but something, nonetheless, clouded his thinking.

"You think...don't you know who you are?" jeered King Solanum with half a laugh. The sentries started laughing, but King Solanum shut them down with a wave of a hand. The guards shrank back. Now he was much more interested in his odd prisoners. The king strode imperiously in

front of the guards, edging forward to the tables where the three were bound.

"I'm not from this land or any land around here," Yves said. "I'm trying to get back to my home."

"Who are these other two?" the king inquired, looking between the Scratch and Gabby.

"My name is Old Scratch," Scratch said, introducing himself. "And that is Gabby." The duck lifted his head, offering the king a tiny crooked smile, then his head snapped back onto the wood table with a thunk.

"They were trying to help me," Yves broke in. "I hope you might have some information as to how I might get back." Yves rested his head again and stared at the roughly cut high-timbered ceiling.

King Solanum looped around the three tables, studying his imprisoned specimens. "Hummmm," he said, intently eyeing Old Scratch. "I've heard of creatures like you. Never saw one until now. You would be an easy addition to my crystal collection."

"What! You wouldn't dare," Old Scratch protested.

"You be quiet," one guard shouted at Scratch.

"I will, but he's not going to collect me!" Scratch hissed.

The king continued circling them, winding around Yves. "I might be able to help you, but I'm not at all sure I ought." King Solanum started to walk away.

"Wait...please, my good sir...help me," Yves pleaded.

"I must confer with my aides. You must remain here under guard because you know the entrance to the secret city." King Solanum swept from the bland room, leaving several sentries behind to guard the restrained intruders. A few moments passed wordlessly.

"What is this...secret city? Isn't this Caylyx City?" Yves

asked one of the guards.

"Yes, this is Caylyx. But you were caught entering the secret city," the guard stated importantly. "You see, no one must know about the secret city or how to get into it."

Yves believed the secret city was the main town, but he thought wrong. "Guess the secret city isn't such a secret any more, is it?" Yves said, tongue-in-cheek.

"Uh, I didn't mean to tell," the guard sputtered. "You cannot tell anyone. Please promise you won't." The guard shot his companions his worried side.

"Don't be concerned," Yves assured the talkative guard. "Your secret will be safe with us." Scratch and Gabby muttered their agreement; then our trio was silent.

Out in the hall King Solanum and Stem, his trusted aide, spoke in soft tones. "They fit the description of the travelers we heard about over the net," Stem offered.

"You're sure of this?" King Solanum asked. The king hadn't been listening to the land lately. He'd been too busy preparing his new spells to use against Sathedra.

"Believe me, your grace," Stem continued, "Ann Thology helped them cross the Lilipond and they are the ones that killed the Reds. They are exactly what they seem. Sathedra wants them. And if Sathedra wants them, then we better assist them and not Sathedra."

"All right then, we will," the king decided. "They may be able to aid us someday soon."

"Yes, someday soon," Stem echoed, nodding his wood head.

A half hour passed and King Solanum burst into the room, startling even the guards.

"I have decided to help you and your two friends," King Solanum announced. "You came in good faith and I will

return the same. Guards, untie them and bring them after me." The guards jumped at the orders.

King Solanum was out the door, trotting briskly here and there, down one hall, and across to another with our three following. His path seemed devious, as if he was trying get the trio lost. The hallways were lined with windows covered with thin gauze. It was the softest window light that Yves had ever seen.

In next to no time, they were led into a large chamber high in the palace. It, too, showed windows covered in the same type of cloth and a set of double doors led out onto a balcony. This room gave off a woodsy smell, the same as the rest of the palace, add to that the combined odor of roots and earth, Yves enjoyed the scent.

In the middle of the room grew a large wooden table, scattered with loose papers and large books. The books lay open, waiting for King Solanum to return and continue his work while other disturbing contraptions were scattered on shelves like forgotten toys. The room gave the impression of being a workshop where King Solanum might spend time researching the unexplained.

"From this room I control my kingdom and can monitor the other lands, too." King Solanum divulged to the awed troupe. "I hold the single power in the land that can counter the great power of Sathedra the Sorceress. Sometimes I can cloud her Pools of Seeing," the king chuckled. "I'm sure it baffles her. It was from her books that I learned my powers.

"Once, some years gone, I was one of her guards. One night, while her consciousness of the world was suspended, I crept into the secret charming chamber and read her spells. From that day on we have been foes. Yet, she

has more power than I do, but I can at least defend my own kingdom from her.

"You see," King Solanum continued, strutting nearly the full length of the room, "I became aware she cannot live in fog, so I placed my land under a continuous layer of it. She, in turn, created the Deadly Lilipond and hoped we would swim in it. Well, some of us did, but we discovered it soon enough. Not too many were hurt." The king stopped speaking and gave a quick glance at Yves' raw pink skin. "It appears like you have been in the pond, too," he said. "Do you need medical attention?"

"Some cream or balm might be good," Yves said politely. "It would soothe some swollen sore spots."

"I will get you some before you leave," the king said. "Stem, please see to it."

"It will be done," Stem said as he left the room.

The king stepped over to a shelf filled with brightly colored crystals. He picked out a ruby, gazed into it, then set it back on the shelf and returned to his guests.

"Then she changed Crag's mineral palace into a castle of candles knowing that we cannot come near any fire," King Solanum resumed, nudging a small stool with his woody foot. "She has protected herself from us. From what I know of her castle, there is a chamber in which she must go into to sleep. No one can enter the chamber without being drugged into slumber. I have heard she also has a wishing chamber. If you could get into there. I'm sure you could get back to where you came."

This excited Yves so much he yelped. Swiveling to his friends he said, "We know the secret of my returning. We'd better get to her castle and get into that wishing chamber, tout de suite!"

"Yves," Gabby reminded him, "you remember, I was coming to Lilium anyway. I won't be going back with you."

"That's right, I forgot," Yves said, bending over, patting Gabby on his downy, feathered head. "Well, I'm sure Scratch and I can make it on our own."

"There is a woman," King Solanum broke in, "that was working at the castle when I was, and she assembled information on Sathedra, too. She is in the lower part of Curiosa and, she too, lives in a foggy swamp to protect herself. She might know more of how to get into Sathedra's castle. Her name is Say Kage."

Yves turned suddenly and stared at King Solanum. "Say Kage!" Yves said out loud as a wave of awareness spread across his countenance. Was she related to his wife, Kay Sage? What was the connection? Now he truly wanted to go and find her. "When can we leave for Curiosa?" Yves asked excitedly.

"Anytime you wish," King Solanum answered. "Your craft is where you left it and I can rig it for sailing. I can also provide some wind for your transit. Howsoever, you must be blindfolded and taken back to the entrance you discovered."

Right then, Stem reentered the chamber, carrying a small round wooden box that contained an ointment. He gave it to King Solanum. The king opened it and sniffed. "This should do the trick," he said, offering the box to Yves.

Yves accepted the box and tried a spot on his neck. "Ah…lavender. Oh, that does feel better," he sighed.

"Good," the king said. "If you would, please follow Stem and he will get you on your way." Yves put the small

box into his pocket.

"This way, please," Stem said.

Our three were led out of the high chamber and taken to the base of the large building. Gabby squeaked a goodbye as his friends were blindfolded, then he quacked loudly several times in a manner that Yves and Old Scratch could hear him as they disappeared into the forest. Gabby then set out to try to find the Office of Insect Eradication and Fungus Removal.

Old Scratch and Yves walked along for a short distance when suddenly the guard ordered, "Here you go," and shoved them through the passage. The next thing Yves and Scratch heard was silence. They were on the other side. Yves took his blinders off first, then he helped Scratch remove his. They were left in exactly the same place, but this time, when Yves put his hand through the unseen entrance, it wasn't there. His fingers just poked at the wood.

"They must have moved it right after we were pushed through," Yves said. "Guess they really meant it when they said it was important to keep their secret."

The two headed back down the trail that led to the beach. When Scratch and Yves saw the small water craft, it was rigged with a simple sail. Included was a mast, a boom, a dagger board and a patchwork of colorful sailcloth.

"This is some kind of magic King Solanum has," Yves said. They paced to the water's edge and examined the raft.

"Never been sailing before," Old Scratch said. "Do you know how to do this?" Old Scratch climbed onto the raft and scrutinize the setup. Thick hemp was strung from the mast and two cords were lashed to the boom. A rudder was attached to the rear of the raft and the dagger board

was stuck on the right side. Other than that, their trusty raft seemed the same as they left it.

"Sure, I've been sailing before. I've done some day sailing off New London," Yves said confidently.

Old Scratch gave him a subdued face. "That's where you came from isn't it? It didn't sound like around here."

Yves' thoughts turned inward after his friend's reminder. He saw in his mind's eye his home in Woodbury and hoped everything was well. His face darkened and his stare told Scratch that Yves was homesick. Indeed, Yves was remembering his home and friends.

Yves pulled himself out of his reflection. "Let's not dwell too much," Yves said spiritedly. "We need to get this little craft going." Old Scratch sprang back onto shore and together they pushed the raft back out into the pond.

"Come on, let's get aboard, it's safe!" Old Scratch said, leaping onto the raft again. Then Yves jumped on, slightly tipping the wooden craft.

As soon as Yves got on, a strong wind started to bluster. King Solanum kept his word. The wind would blow them back to Curiosa.

"I'll man the rudder," Yves called out. "You start pulling on that rope." Yves pointed at the mast. "Pull that rope and set the sail. Old Scratch did what he was charged and the patchwork cloth took the breeze and billowed out like a full belly.

"Now, tie it on that cleat over there and hold on to those two ropes coming off the lower boom. I want you to control which way the sail faces," Yves ordered.

"Okay," Old Scratch said, not minding that Yves took charge. After all, Yves knew what he was doing. Soon the wind began blowing even harder; the craft started sliding

across the Deadly Lilipond. They created quite a wake.

During the passage Yves creamed himself with the ointment. He removed his shirt, then plastered his chest and arms with the cooling lotion. Then he asked Scratch to rub some on his back. His legs and feet were the last to be anointed with the salve. This led to the welcomed detumescence of his skin. The wind was filled with the resinous scent of lavender and the murmurations of a French tune that Yves hummed over and over again as they sailed on, into the fog, leaving Lilium behind.

It took them an easy three hours to make the transit and they hit the far shore with a thump, leveling a patch of grass and squishing the mud. Safely on the other side, they both hopped onto the shore and left the raft behind. They were on their way back to Appellation City.

Yves' clothes were damp from the spanking pace, but they were drying nicely now. Old Scratch shook himself and droplets of moisture flung in every direction. "We should be back to Appellation City in a while," Old Scratch said.

"Let's hurry," Yves replied. "I want to get back to my studio. I'm getting too old for this kind of stuff."

Down the road the two trod. Their conversation was kept quite general. "This trip to Lilium actually was fun," Scratch said, "and you know, you need new experiences every now and then, just to prove you're still alive. Life is full of new experiences, with different variations everyday. You have to keep your eyes open to them, old friend." Scratch was trotting alongside Yves and looking up he said, "If you look at the world through new eyes each morning, you will see the world like a kitten."

"You are quite right," Yves said. "The world is full of

wonder and strange things. You have never seen my paintings, but you would be amazed how my work creates bizarre and beautiful places. It's all in how you regard the world, I think.

"If you only see ugly, then your disposition will be vile. When you see and absorb beauty in life, then your attitude toward existence will be positive and fulfilling. Outlook is more important than most think." Scratch nodded agreement.

Yves stopped chatting for a minute. He was thinking of a poem he'd learned one time. A friend gave it to him when he was at a low point in his life, crestfallen.

"Old Scratch, would you like to hear a poem?" Yves asked. "It means a lot to me. The title is "Just Try This," I'm not even sure who wrote it. I think it was anonymously written."

"Sure," Old Scratch said. "I'll bet it's a good poem." They stopped walking and Yves stood as tall as he could, as if playing a part on stage. Old Scratch faced him and remained quiet. Yves was unsure at first, but as he got going, the words sprang forth.

"Just Try This," Yves began.

"If the day looks kinder gloomy.

And your chances purty slim,

If the situation's puzzlin'

An' the prospects awful grim

An' perplexities keep pressin',

Till all hope is nearly gone,

Just bristle up and grit your teeth,

An' keep on keepin' on."

Yves quickly curtsied in a small, maladroit, naive way, then sighed. Memories were flooding back into his mind.

The day his friend Paul gave him the poem was as rainy as yesterday in Woodbury.

Yves just learned of Paul's impending death. He knew Paul was sick, but not that sick. Paul gave him the poem after reading it aloud. It was written on a wrinkled piece of pink notebook paper with its top edge torn rough. Paul smiled at Yves and requested him to keep it. Then Yves said good-bye and left his comrade. That was the last time he'd seen his friend Paul alive. Yves kept the poem thumb tacked on his studio divider because he knew what Paul was trying to tell him.

"You hoo…Yves…you in there?" Old Scratch was standing on his hind legs waving up at Yves' face.

"Oh, yeah…sure," Yves said, slowly coming back to reality. "That's it. It's a wonder I could even remember it."

"We need something like that once in a while to give ourselves a boost," Old Scratch said. "Thanks for sharing it with me." Scratch got back down on all fours and smiled at Yves. Now with a lively excitement that Yves did not entirely feel, the pair trotted on down the road, resuming their conversation embracing ordinary things, the kind of talk two friends would have because they knew each other well.

Nine

On the way back to Curiosa, they spotted a jumbled pile of sticks lying by the road. Scratch felt compelled to stop and inspect them. It was a hodge-podge of long and short staves, sort of like there might be two legs, two arms and a stick-like torso. But there was no head. Scratch started searching around for something.

"What are you looking for?" Yves sounded irritated seeing as Scratch had just wandered off in the field by the road. He was nosing in the bushes when he called to Yves.

"I'm looking for a suitable head for that lowly pile of sticks, who obviously lost his...help me, please." They both browsed through the bush-strewn roadside until Yves unearth a large, dried gourd. It had fallen from a merchant's cart a few seasons back. Yves brought it to the stack, popped a hole in the side with a sharp rock, shook out the dried seeds then shoved the hollow gourd onto the stickman's fleshless neck. A face appeared. The thin-bodied stickman suddenly sprang to his feet. He stood a foot taller than Yves and alarmed him and Scratch, making them both backpedal.

"What a relief," the stickman exclaimed. "I've been a pile of sticks for more or less a week now. Lost my head when a Red flew by and shot it off, well, I think it was a Red, maybe it was a Green...I don't know. It snuck up behind me so fast that I didn't have time to turn around. I couldn't believe it...Bam!" The stickman jerked like he was shot. Then he spun around on his stick heels and stumbled

over to the other side of the road. "My head was everywhere, in a thousand pieces it was. There I was, headless, out of control and I barely made it off the road before I completely collapsed. Those Reds aren't supposed to do that...are they?"

Scratch and Yves smiled at each other. "No, I doubt if they are," Old Scratch said.

"Well, what's going on...any ideas?" the stickman asked.

"I think our future seriously changed when Yves arrived unexpectedly," Old Scratch said seriously, "and our past may not be anymore either, making those orbs act differently, too. We probably have a new future as well."

"You mean what we have been expecting to happen, may not?" the stickman asked, looking down on Scratch.

"That may be the case," Yves said. "We even had to kill two of those Reds because they attacked us. I'm sure that definitely stirred the pot."

"Then you have disordered everyone's life," the stickman said accusingly. The stickman then clicked his way back to Yves and Old Scratch. He acted like he was learning how to walk again. He made click-clack...snip-snap sounds as he operated his twiggy arms and legs.

"I guess I have," Yves said lowering his head.

"Don't be sad. You may have done me and all of us here a great favor. How can I thank you enough?"

"You mean, you don't mind me being here?"

"I don't mind," the stickman said. "We may have a brighter future because of you. Now, is there anything I can do for you?"

Yves pondered, eyeing the stickman lopsidedly with some amusement. "Can you come with us and help me get back to Woodbury, Connecticut."

"Oh, that doesn't sound like it's in Sath. Is it in Gehenna?"

"No...no it's not. Have you ever heard of the USA?" Yves inquired.

"Usa?" the stickman asked, tilting his gourd head to one side, eyeing Yves with consternation.

"Now wait a minute," Old Scratch butted in. "I thought you were from Woodbury."

"I am," Yves said with a twinge of irritation. Then he turned back to the stickman. "And, Mr. Stickman, from where do you hail?"

"I am an outcast of Lilium and have been journeying for many years. It would be nice to go back," the stickman said wistfully.

"We were just there," Old Scratch said. "At first we were not welcome, but after a time our intentions were finally understood. It was like he...just let us go."

"Sure, King Solanum can be that way. Sometimes he changes his mind just like that." The stickman snapped his twig-like fingers.

"Would you like to go with us to find Say Kage?" Yves asked.

"Say Kage? Now where have I heard that name?" The stickman shut one eye and scratched his head, thinking.

"She lives in the downs of Curiosa, we're headed that way now," Yves said. "We would like more company." Scratch started to protest but, Yves eyed him and Scratch, with reservation, agreed.

Yves felt if he had more souls on his side he would feel safer making this journey. This was his fourth full day in this land and he was just getting used to it. The unusual seemed normal. Crystal cats, talking ducks, plant people

and now a stickman. Nothing would shock Yves now. *So, what else can happen*, he wondered.

"Well, do you want to go along with us?" Yves asked.

"I'd like that," the stickman said. He couldn't remember exactly where he'd heard the name Say Kage, but he knew she was important. "Just lead the way."

And again, Yves started down the road. Old Scratch followed, with the wooden man right behind the cat. Scratch turned around and asked the new traveler, "What's your name?"

The stickman answered after patting his head with his big clumsy stick hands. "Gourdhead, of course. I've been pumpkin, apple, orange, squash, watermelon and birdhouse. Whatever is up there, that's my name."

After a time of silent walking, the group walked passed the wooded grove where their raft had been built and Scratch heard the hum of those Greens again. They saw five greens coming from the left and for that fact they headed for the forest to their right. Yves peered into the stand of trees and saw a cave. He hadn't noticed it before when they were cutting the wood.

"I think we better take cover in that hole until the Greens have gone." They moved onward to the entrance and when they stood at the opening, Yves caught Scratch just before he was swept into the draft. Yves dragged Scratch off to one side and set him on the ground. Gourdhead lagged behind because he couldn't run. Walk, yes—but run, well, not quite, yet. He tried to run but stumbled, obtained his stick-feet and clacked along as fast as he could. He got to the entrance in time to see Yves setting Old Scratch on the ground beside the opening.

Yves put his arm in front of the entrance and felt the

strong vacuity sucking the air in, drawing like a vacuum cleaner.

"Whew," Scratch said, taking a gulp of air. "That was a close call. This must be the entrance to the Athenaeum that Ann Thology was going on about."

"Yes," Yves answered, "it must be. And with that suck of wind, you may have been dragged all the way through it and out the other end. We can't hide in there."

"Darn! We really need to hide. I can hear those Greens getting within shouting distance," Old Scratch said worriedly. And then looking at the cave entrance a second time, Old Scratch said with resignation, "In we go."

"Guess we better," Gourdhead said, shrugging his thin shoulders.

"Well...all right," Yves anxiously acquiesced. "But, let's be careful."

The three carefully crept into the sucking draft while holding onto the walls of the cavern. The wind blew hard against their backs. Yves' clothes flapped and Scratch's eyes watered. Gourdhead's arms and legs made the wind whistle.

They crawled not quite twenty-five feet into the tenebrous burrow and when it made a slight narrow dogleg to the left, Yves stopped and told the others to stop, too. Scratch clawed into the walls while Yves hung onto an exposed root. Gourdhead slung his stick fingers around a rock on the floor and with watering eyes, faced into the wind.

The Greens moved over near the entrance. One advanced too close to the opening. It was suddenly hoovered in and flew, in a green blur, whizzing past our three. Yves heard the Green smash into stone, deep in the tunnel.

The other Greens backed away from the portal, away from the danger. They called and were waiting to hear from their lost brother. When five minutes passed without an answering resonance, the four remaining Greens caught the meaning that their kinsman was lost. Greens cannot go into fog or into caves because they would lose contact with their ruler. And when they lost contact with Sathedra, the Greens became dysfunctional. The four Greens floated in front of the opening then moved on slowly. The Greens didn't know they had changed. They knew only one thing—move to the down land and find the gathering. Why, they didn't know, but it was very important they go.

"Those Greens can't go underground, can they?" Yves shouted at Old Scratch.

"Don't think so," Old Scratch yelled into the wind.

"I think the Greens have gone," Yves called out. "We can get out now." Gourdhead agreed, holding on tight to the rock. They crawled back out and sat next to the opening. It took them several minutes to catch their breath. Yves licked the salty tears from his lips.

"I want to go back in there and make certain that Green is destroyed," Yves said. "Scratch, you take Gourdhead into the woods and find some vines. I want to use them as safety ropes just in case—you can pull me out if need be."

"You want to...what?" Old Scratch said, looking at Yves with surprise. "Hey!...we only hid in there to escape the Greens."

"Yes, and now I want to check on that Green," Yves said. "Now go do what I said."

Scratch and Gourdhead set out, complaining under their breathing, hoping Yves could hear them. Yves continued sitting off to the side, out of danger. He ignored the pair as

they trudged away grumbling. After awhile, Scratch and Gourdhead returned, dragging a few vines. The three of them joined the vines together, end to end—the viney rope was a hundred feet in length. Gourdhead strapped the vine rope to a tree, then handed the other end to Yves, who tied it around his own waist.

"I want to go as far as this permits," Yves instructed, patting the carefully crafted, rough feeling granny knot.

"Are you sure you want to do this?" Old Scratch asked worriedly. "It looks unsafe in there."

"I'll be all right," Yves assured him. "I've caved before, in France, when I was a kid. I'll keep safe. Just don't let go of this vine!" Yves was emphatic.

Yves carefully stepped into the entrance. The vacuum pulled on him again; suddenly he footed into the darkness. The black gloom was thorough around him; he gulped; he'd forgotten how dark it could be. *Rather like Lamp black*, he thought. Yves felt his way along the damp walls and he stopped in a shaft of light coming from an opening high in the mountain. A few animals in the past had lost their footing and were sucked in. Their bones glowed white in the dim light. Yves fretted a bit and he again patted the vine connected around him. Here, too, he saw the remains of that lost Green. It was smashed flat. This Green wouldn't give them any more trouble. With that out of the way, he decided to press onward. The warren made a few more turns and got bigger. The wind became less as Yves dove deeper into the inky darkness.

Yves made progress to a junction that sprouted in many directions. He developed an uneasy, kind of queasy feeling. He heard a hissing noise behind him and suddenly the vine grew tight. Something was pulling on it. He was hoping it

was Scratch and Gourdhead, but when he turned, he was face to face with Diddlespider.

The two of them stood there for a second, each pulling on the vine in opposite directions, eyeing each other suspiciously. A frisson of surprise like an injection of adrenalin coursed through Yves. He could feel his fear as an extra presence. Both were too frightened to say anything until the realization hit them. They knew each other.

"Oops, What are you doing in here?" Diddlespider asked as he dropped the vine like he'd done something he shouldn't have. "This isn't a safe place for anyone to end up in, you know. This is my haunt. I as a rule, catch and eat the animals that get sucked into my lair. I help to keep it clear of debris so air can flow through easily."

Diddlespider stood there neatly picking bits of bones and flits of fur out of the glistening silver cobweb covering the walls. He put them into a tightly woven tan basket he was dragging around behind him. Diddlespider hadn't eaten a good meal in days. And while at first he lacked the will to fight the urge, ultimately though, he fought the caprice to capture and keep Yves for food.

"I only wanted to explore," Yves explained, regarding Diddlespider with suspicion. He didn't like the way the spider's eyes studied him. Yves sensed a musty smell. *Was it Diddlespider or the cave, I can't tell. Then again it might be both.* "I have always loved caverns and this one seemed unique because of its wind." Yves was trying to keep the conversation going. "A fair wind is blowing even at this point. In other dark parts, the gusts blow so hard they whistle...and..."

"Yes, this hollow is unique," Diddlespider interrupted, his spider jaws opening slightly as if to smile. That gave

Yves the creeps. "And it's mine. You better not tell anyone. A long time before, I had to fight a big shiny black spider for it. Sort of like king of the hill, only I got to eat the former owner. He was good, too," he said, clicking his mandibles.

Diddlespider reached back into a crevice and brought out a handful of bug bits that included a wing, a half eaten abdomen of some black arachnid and a leg. He threw them into the half full basket. Yves trembled slightly. He hoped Diddlespider would let him pass.

"By the way," the spider continued, "did you have any luck in Curiosa helping my friends?"

"No...not really," Yves returned nervously.

"Oh well, it was just a chance," Diddlespider said sadly. "It must be an unstoppable force." The spider gazed off into nowhere. Yves tried to keep this spider's mind off food.

"Looks like you have too much work to do to chitchat with me," Yves said, his voice quivering. "I'd better get back to my friends. They must be stewing...over my situation." *Oh no*, Yves thought, *don't mention food again*. "They've been tugging as if they were trying to pull me out." Yves jerked the vine as if being pulled.

"You may pass, but remember, not a word," Diddlespider warned him off with his six upper spindly legs.

Yves slipped by carefully. "Thank you...sir," Yves said, gulping. "Oh, by the way, there's a dead Green glued to the wall back there." Yves indicated the remains with a thumb over his shoulder.

"Thank you, I'll get it later," the spider said. "You do have something against those balls, don't you?"

"Yeah, I guess. They do have a tough time around me."

"The fewer balls there are, the better. That's what I say," Diddlespider voiced his opinion.

"Whatever you say," Yves said in mock agreement.

"Oops, they're tugging again. I better get going."

"Be careful," Diddlespider said while mindlessly stroking the webs.

This time the vine did grow tight as Yves allowed himself to be pulled away from Diddlespider. He was grateful for the vine because he couldn't remember how he had and gotten this far. He saw dark, side passages he hadn't noticed before and in several spots the route narrowed. The bursts of wind made his clothes flap. He might have been thoroughly lost if he hadn't been tied with vines.

Back at the entrance, Gourdhead and Old Scratch began to wonder why the vine had not slackened sooner. They thought Yves might be dangling over a precipice or something worse. They gave each other the eye, then tugged harder and faster and they hauled Yves out.

When Yves reappeared, Gourdhead and Old Scratch rushed to him and slapped him on the back. They were glad to see him.

"Boy, were we worried!" Old Scratch said fretfully. "We thought you might have been in some trouble. By the way, what did you see in there?"

"See? Oh, I didn't see much," Yves responded, hesitating slightly, untying the vine. "Only lots of bug parts and animal bones and that dead Green. It won't be bothering anyone ever again." Yves didn't want to say too much. He would keep his word to Diddlespider. "I was not in any danger," he told his friends. "This is the up-point entrance to the Athenaeum and we truly should be going. Gourdhead, how long will it take us to get to the other side of

Curiosa?" Yves changed the subject on purpose, *and successfully, too*, he thought.

"It will take the rest of the day for us to make it that far," Gourdhead said. "I know of a place that would be safe for us. When we get there I'll show you. Not many know this place..." Gourdhead's voice petered out as they segued down the blue road toward Curiosa.

Jumping out from a hide, five tiny Vipras scurried onto the road after the three left. The pika-like Vipras' soft red fur contrasted the road. Their spindly double tails formed elegant designs in the dust. There was a brief chittering conversation among them and then the creatures darted away. Birds flew through the clouds above, swooping and swirling. With their clear eyes they saw far into the distance. Clouds were forming over near Curdland, not unlike the war clouds of the past.

Yves was seeing many more things now that he'd been in this land for awhile. The trees were blue going past Curiosa, *that new tube of Phthalo Blue,* he thought, *then the road turns a Cinnabar Red, like the can of paint sitting on the high shelf in my studio.* He noticed there were more than just food trees. Some of them were covered with shoes and a few were laden with socks. Other trees budded gloves on their branches. Yves sorted out how some of the folks got their clothes—*those that wore clothes*, he thought. *Since the Curiosa people were books, they were a populous not needing clothes. They wore dust jackets when they needed to.*

"Why are there garment trees when hardly anyone wears clothes? Yves asked.

"I don't know," Old Scratch said as he turned to Gourdhead.

"I don't know either," Gourdhead shrugged. "But may-

be someone else will know. I'll keep it on my mind."

"Speaking of trees, I just realized I'm very hungry," Yves remarked. "Anyone for a bite to eat?"

"Sure," Scratch piped up.

Yves noticed a new patch of wishing trees and requested a bowl of tapioca pudding, some bread and cheese and an apple. Scratch wished for a caramel custard. Gourdhead chose salted nuts and perched on a sandstone rock, tossing the nuts into the air a handful at a time. The nuts ticked off his face, then they bounced to the ground. Luckily, he did catch a few in his mouth.

"Got some in your whiskers," Yves notified Scratch with a chuckle.

"Look who's talking," Old Scratch retorted, pointing to Yves' shirt spotted with yellow pudding sploops.

In a short time each finished his meal. Gourdhead stood stiffly, crunched his way through the spilled nuts and invited Scratch and Yves to follow him, as he knew the way.

They passed Appellation City, walking right on by. Three lookout guards peered down at the group and tossed dead bugs on them as they strolled by the sentry's post. The piles of black bug parts were even bigger now.

They walked over a high hillcrest and caught sight of the down-end of Curiosa. It was an old-looking part of the land. Way off to the over-there, Yves noticed a swale surrounded by tall grasses and covered with mist, just as King Solanum had said. It was the lone swamp in the area and there was an island in the middle.

They walked on for an additional hour. Yves noticed by the two ruts cut into the ground that this road was used a lot for travel. On their left, far into a mist, they glimpsed Sathedra's castle, sitting there like an exclamation point,

surrounded by her seas and to their right was mountainous terrain.

They walked by two small Curiosa settlements with Curiosa people going about their book business. A few Curiosa children bumped into our traveling three and begged for handouts. Yves couldn't give them anything, consequently the children turned away and left our trio to press on. They came to the crest of a grassy knoll and looked down into a hollow.

"There it is," Gourdhead hallooed, pointing a thin shoot of a finger down the hill to a wooded grove. It was only a small patch of trees in the middle of blue grass. The pine trees stood straight and tall. "There is a small pond and a concavity down there. We can take cover there for the night. I think we'll be safe from the orbs," Gourdhead told them.

They straight away slid down the hill on their rumps, landing at the base of the grove. The trees reminded Yves of the tall pines in the mountains of Arizona, with few limbs below and many above. There was a clean resinous smell in the air. *Oh, how Kay loved the fresh scent of pine.* Yves filled his lungs with the piney fragrance and smiled inwardly then started sneezing. Yves rapped off one sneeze after the other in rapid fire. Yves forgot that pine pollen made his nose plug. After a dozen nose outbursts, Yves blew his nose in his handkerchief.

Gourdhead was first into the stand of trees. Yves followed, brushing the dirt off his pants and Old Scratch scampered right behind. They walked in a ways to the middle of the grove; here they gained first sight of the pond, which was perfectly round and edged by neatly cut blue grass. Yves was the first to look into the pool. His

face reflected back at him. This was the first time he had a good look at himself since he plunged into this somatic illusion. His beard had not grown, but his face sure was different. It was thinner and his cheekbones poked out more than he remembered. Bending over made his nose stuff-up more, "Damn," he quickly put his nose in the air. He let out a few forte snorts to clear his sinuses.

The water plants waved peacefully in the delicate currents and Spiny Sugar fish darted in and out of the rocks below. Yves cupped his hand and scooped a small amount of water and sipped. He discovered it was sweet. There was fruit on a few trees which he might eat if he became hungry.

He walked over to the cave opening, and despite being at risk of receiving pleasure, he turned around and looked up considered the ever changing colorful clouds. They were changing all right, like he was painting them over with different oil colors—with rapid strokes, like a thin application of paint.

Evening approached and the scumbled sky, like watered milk, filled with pink clouds laced with orange feathery fringes that slowly drifted across the twilight. His nose was finally drying out.

Yves ducked down and was the first to enter the cave. It was small indeed, but there was room enough. The cavern was dry with rocks and boulders strewn haphazardly. Yves rolled a few rocks out to make room for the three of them and he was the first to stretch out for a good night's rest. Sailing and hiking most of the day tired him.

Scratch and Gourdhead relaxed near their selected boulders and chatted steadily as regards their respective lives. "Gourdhead," Old Scratch started, "you said you

were an outcast of Lilium. What happened?"

The stickman's eyes darted around and he thought awhile before carefully choosing his words. He was trying to figure a way to explain his mendacity. He decided the truth was the best and only answer. "I was in the employ of King Solanum. I was his security master. With my body shape I could get into all sorts of tight places and eavesdrop on his enemies. Of course, his main foe was and continues to be Sathedra the Sorceress. They have been opponents ever since the rift between them." Gourdhead paused, cleared his throat, then continued. "I'm sure you remember the devastating storms years back."

"Sure do," Old Scratch said nodding.

"Well, those were caused by King Solanum after he left to create his own kingdom. After a time, Sathedra the Sorceress learned to control the great storms King Solanum cast around the land. My job was to find out how Sathedra was preventing the barrages. I infiltrated her domain, but was unable to get chummy enough to learn any secrets. I returned in shame." He hung his head. "While I was gone my subordinates failed to keep the termites out of the city. Many were devoured. I became exiled and here I am." Gourdhead sighed. A tiny tear slipped out of the corner of his gourdy eye.

"That hardly sounds fair," Old Scratch commented, "being exiled just for doing your best. King Solanum must be a cruel ruler. You would be welcome in my homeland anytime, really."

"I have visited Crystalum, but never stayed long enough to get to know anyone," Gourdhead said, brightening. "I think in time I might do that. Tell me more about Yves. Do you know much about him?" Gourdhead glimpsed

over his shoulder at Yves who was by that time, just drifting into slumber. "Does he seem to have any plans to settle in Sath?"

"He's lost," Old Scratch began. "I fished him out of the Sathedra Sea and took him to see Queen Creamy. She mentioned a book that might exist that could help. Then she, in turn, sent us to Ann Thology, thinking she would have the answer. Ann knew of the book, too. We've been to King Solanum also. At least he knows that the book is real. Now we are going to see Say Kage. She'd better know the truth. I think we're getting the old run-around. No one yet knows how to get Yves back to where he belongs. It's sad. And that's all I know."

"Sure, now I remember," Gourdhead said. "That's where I heard her name. It was in relation to some book...and it was about Sathedra. But I have no idea where it might be, either."

"That's why we are going to see Say," Old Scratch said. "She may remember where it is and if it might help."

"I hope for his sake she will have the answer," Gourdhead said, very nearly whispering. "It's rough enough for a person just to live, but without any hope, the result would be dreadful."

Yves stirred slightly, snorted hard, keeping his sinuses clear then turned his face away from his two companions. He was far away. His counter-reality was quite alien to this land. His two comrades continued speaking in hushed words while Yves slept.

The night wore on. Again the stars arched their way from the over-here to far-over there. A few night sounds: Frogs croaked in the pond, wind whispered through the pine trees, and there were distant rumblings across the sky.

Those were menacing sounds, hinting of friction in the land. Old Scratch remembered those sounds from the past. He cringed at the thought of more conflict. Before long he and Gourdhead slipped into sleep, too.

Just outside and near the pond, an inferior figure walked among the trees. He was in a trance, not under his own power. He stopped and faced into the zephyr. Silent susurration reached on the wind, asking questions, giving orders. Without any lip movement, unintelligible words flowed from his open mouth. The trees stirred with the waxing winds. Dust and dirt were swirling around him like a maelstrom. The grit stung his skin and he was alone with the whipping wind. Even the stars paid him no notice. The trivial figure was buffeted by the gusts, then as quickly as the wind arrived, it made one final burst and drove the figure flat to the ground. He lay there in a heap. The night continued on as if nothing happened.

Purple Sickle birds of the night, pirouetted and plunged toward the ground, fanned out and landed gracefully in the lower branches of the trees. The birds rested, then up they flew again to repeat their nightly dance. Down below, near the pond, Bleek frogs hopped, toads toed and Greens hummed wordlessly. There was life in this land, even at night.

With effort, he was able to raise his head from the heap and check around. He was alone. He planted himself in the ground and spread out roots. He was feeling for the tendrils that would send his words. When his roots touched the message-senders his body relaxed.

"There...," he said gently, "...that's the one." He'd made contact. "Soon we will have the book and we can get in to use the trickery against her." Words sped to and fro

through the underground network. "No...not tomorrow but day-after tomorrow afternoon...yes, Say will help. I'm sure of it...no, I don't think...I will preserve it...oh, thank you master...we will succeed...thank you." He wrested his roots, then took a rest. It was dark and thankfully no one was around to see him. "We will succeed," He sighed to himself. "We have to. The future of all Sath depends on it.

Ten

The thin morning light did not come into the den until it reflected off the pond. It bounced right into Scratch, scattering the light in dreary dashes of toneless colors.

"Umm," Scratch yawned, stretching his stiff limbs. "Much cooler and I wouldn't be moving for awhile. Where's Gourdhead?" Old Scratch said to no one. "He must have been up early and wandered off down by the pond." As it grew warmer Yves stirred, squinting his eyes from the intense morning light. He searched around and also wondered where Gourdhead had gone.

"There he is," Old Scratch said, pointing a lackluster paw toward the pond. "He's probably checking the area. We heard rumblings last night and it would be good to know if there are any orbs around."

Gourdhead came clacking back to the entrance. "Gourdhead, what have you been doing?" Yves questioned.

"Nothing, nothing really," he said, adjusting his head. "Just out for a stroll...looking for Greens," Gourdhead added. He sounded sincere, although there was a titch of uncertainty in his answer. "Some Greens have been hovering around, but they didn't pay me much consideration."

"Greens?" Yves said with a startled face. "Show us!"

Gourdhead took them to the area directly opposite the sweet pool and sure enough, there were three dozen Greens hanging around. They appeared aimless, without

purpose.

"Looks like they're waiting for something," Yves said anxiously.

"I think they are," Old Scratch whispered. "Us!"

Without warning, the orbs came to order. They formed up four by nine, then a few broke off and started toward our three.

"The swamp's back this way!" Gourdhead shouted, pointing toward the area they made out from the crest. "The marsh may keep the Greens away." While crouching low, Scratch, Gourdhead and Yves scurried back past the pool and over to the slough. A small foot bridge led over the murky, sour-smelling water.

"To the bridge," Yves ordered. "It must lead to Say Kage's place."

As soon as they scrambled onto the bridge, a mist engulfed them. It multiplied from the water and corralled them with sodden dampness.

"Look!" Scratch said as he turned around. One Green entered the swampy mist. It wobbled a few seconds, then dove spinning and sputtering into the water. The Green then became inert as it bubbled and sank beneath the surface.

"This must be the defense Say Kage developed for herself," Yves said with more confidence, "to keep Sathedra and her orbs away." The mist shadowed the group as they continued along the bridge.

"I have never seen a Green sacrifice itself," Gourdhead said. "It's as if...." Gourdhead stopped when he heard a voice coming through the fog.

"I can see you are not affected by me, so I will leave you now," the fog said in a wispy way.

"Who's there?" Old Scratch demanded. "Answer me! Who said that?"

Too late. The mist lifted and Yves saw that indeed they were out in the middle of a very large marsh. Ahead of them was the island, Say's sanctuary in the middle of this water. The pursuing Greens stopped at the foot of the bridge. Their growing numbers were chary as if they wanted to continue, but were afraid.

The air hung on the three, a fug, oppressive and heavy. The water was as smooth as a dark blue glass plate. The color reminded Yves of the Chartres blue plate he ate from as a child, in France. Snags stood in the water where once tall pine trees grew and the three travelers pushed on, ignoring the Greens behind them.

"What is with it these things?" Yves asked, bending down to give an eye to some small tube-like projections in the water. They stuck up a few inches and looked like little trumpet bells pointing above the surface. There were tall ones, short ones and one was big and bloated. *Their skins are dark Burnt Sienna, smooth and glossy, with patches of Venetian Red and Sennelier Blue,* Yves reflected.

"Be careful," Old Scratch warned. "Those are Swamp Snooks and they...squirt!" At that instant three of the Snooks recoiled and let Yves have it right in the face with their water jets. Gourdhead and Scratch started laughing.

Yves jumped back, sputtered and gave Old Scratch an exasperated wet dog look. The mouths on the Snooks wrinkled then tightened shut. Then these odd atavistic animals squirmed and expanded as if they were recharging for another blast.

"Swamp Snooks," Old Scratch started lecturing quite matter-of-factly, "are quite common in the warm regions."

Old Scratch barely stifled a laugh. "They are quite harmless except to insects. They shoot them down and then search around with their snout. When they find the downed bugs, they suck'em up and devour them."

Yves let out a wail. "What am I doing here! This is crazy! I can't be doing this. I have to be home, painting. This can't be happening!" Scratch and Gourdhead stood back in fright. Yves' face echoed his fright—he needed to be not here. They'd never seen Yves act like this. He bolted past them, lost his hat and dashed across the foot bridge toward the island. He tore along like a hunted man! Yves kept sprinting. He didn't know to where, nor did he care. The wind felt cool and refreshing on his face and he laughed into the wind. As he reached the island, his shoes slogged in mud and trees blurred past him. He ran as fast as his body would allow, advancing around the shores of the isle.

Then a voice stopped him in his tracks, "Stop!" He lost his footing, hit the mud and slid forward on his hands and knees, mashing the muck ahead of him. He felt the sting of sharp rocks scraping at his hands.

"Stop where you are," a voice in the forest boomed. "Do not come any closer. This is the cave of Say Kage and she does not want to see anybody."

Yves stood jack straight with a surprised stare, wiping his face on his muddy sleeve. Scratch and Gourdhead eventually caught up with him. They all were breathing hard.

"Are you all right?" Scratch asked with some concern. "You're covered with mud!" Scratch handed the hat back to Yves and he placed it back on his head.

"Je ne sais pas. I just have to get out of here!" Yves

was shivering. "This isn't right. This isn't my life. What am I doing here? *Why* am I here?" Yves stumbled over to the water's edge and rinsed off his hands, then his clothes. He gave his hanky a good rinse then wrung it out. He was feeling nil right now. He was a mud-soaked mess. His hands trembled badly.

"Most are here to find themselves," Old Scratch said soothingly. "You, however, in equal parts, are here to find your way home again. Isn't that right?"

"Yeah, I guess," Yves said picking dirt from his nose.

"And when you do, you will find peace," Gourdhead added. Yves nodded, slowly getting a grip on his fright.

"Did you hear that voice?" Yves asked, gathering his wits.

"I heard no voice," Old Scratch said. "Gourdhead, did you?"

"No, I only heard him howling in the trees."

"I know I heard a loud voice," Yves insisted.

Again a voice from the darkness rose to an uncommon pitch. "Do not come any closer." Scratch and Gourdhead crouched and looked around.

"That voice," Yves said pointing a shaking finger at an opening.

"Oh," Old Scratch said, "that voice."

"Say Kage must be in there," Yves said. "Cave of Say Kage, did you speak?" They walked carefully toward the opening.

"Yes, but you still must leave," the cave commanded.

After coming this far Old Scratch thought it wasn't fair to end now, stopped by a cavern in a hillside. Yves' fate depended on this meeting with Say Kage.

"Mr. Cave," Old Scratch said in his best threatening

tone, "we have been sent by King Solanum to see Say Kage and ask how she may help this man get back to where he came. If we can't see her today, we will hang here until we can see her. Tell her that for us, will you?" There was a heavy-handed silence.

Yves added in a large, brassy voice, "I need to see Say Kage because King Solanum said she might be able to help me. Is she around?"

"Yes she is," the cave replied tersely, annoyed by the group's stubbornness. "I will consult with her and be back with an answer shortly." Yves wondered how such things could be. How do caves speak? After all, it was simply a hole in a hillside with dark walls and a damp, musty smell.

Trees grew on the slope above the cave, with their roots penetrating down, dangling from the entrance. Water dripped from them. *Is this part of my trance world, part of my painting or is it reality?* He didn't know what was true any more.

"Come on over and sit under those trees," Old Scratch said, trotting toward a grove. Yves thought that was a good idea, a much better plan than running like a mishuggah man. His shoes were muddy and his clothes were a bit crusty, too. He started to relax and stopped shaking.

Gourdhead thought it was a good idea as well because he quickly ticked and snapped and was the first one to get under the trees and relax.

"I wonder how long it will be?" Scratch asked Yves.

"I think it will be soon because it sounded like the cave knew where to find her," Yves said.

Gourdhead agreed with Yves. Right then, the cave provided their answer. The voice rumbled out of the mouth and startled the threesome.

"You may enter, but you must be careful, for I am full of poisonous waters. If any of it should get on you, it will dissolve you within minutes. Enter now, for I have made it as safe as I can."

"Whoooo boy," Old Scratch said, dragging himself to his feet. "Here we go again."

"How many dangers can one land have?" Yves asked Old Scratch.

"Usually one more than you would expect," Scratch philosophized.

The three travelers carefully entered and walked on a path of stepping-stones. The water was in front of the entrance and part way in, the stones barely stayed dry. Yves could hear water dripping farther in and he feared some of the poison might drop on him and the others. He took off his shirt and gave it to the stickman. Gourdhead spread it out with his stick fingers, holding it over their heads like an umbrella, for protection.

After some distance in, the darkness lightened, revealing a large commodious concavity with smooth stone ledges carved in the walls. From the ceiling hung a mass of gnarly tree roots and the floor of the cavern was strewn with stones of assorted sizes. There were other small, dark passages leading to parts unknown. Sudden scrappling sounds indicated living creatures were hiding behind rocks. Something made a "foosh" as it flew past Yves' ear. This was where Say Kage lived.

Gourdhead gave Yves his shirt back and he put it on. They climbed some stairs to the first ledge to find an old woman sitting in a stone chair waiting for them. This was Say Kage. She was the only one they saw and she was human, like Yves.

Her clothing was ragged and torn as if she owned no other garments. They hung in ribbons from her and when she moved her arms, the shreds waved to and fro. Say's hair dangled in strands and it was matted from years of neglect. Her face was wrinkled and her skin appeared as hard as old leather.

"Come and sit here in front of me. I want to see you. My eyesight is not good because of the darkness." The group did what she called for. "Now what brings you here? You say King Solanum sent you? Why?"

Being polite, Yves removed his hat and explained his troubles as best he might. "King Solanum sent me to see you because you may have some understanding of Sathedra. He says there is a wishing chamber where I could wish myself back to my own land. Do you remember where the chamber is?"

Say took a trice to consider his question, gave a short hack, spit out a phlegmy mass she had raised, then said, "Yes I do, but it has been such a long time, I cannot remember all. Howsomever, there *is* my book under Appellation City. In the Athenaeum. Athenaeums have much more memory than any of us. What we forget, it remembers. The book has a surfeit of information as to Sathedra and her castle, including her illusions. I know, I wrote it."

"You wrote a book about Sathedra? But wait, if it's in the Athenaeum, that could be a problem because I don't know where any of the books are located," Yves said, concerned.

"Well, I remember where this book is because I put it there myself. Now, listen carefully and I will tell you how to find it." Say Kage cleared her throat noisily. She sounded like a frog with a severe cold. "You know there are

two entrances, one in the up and one here in the down." Yves nodded his head. "The entrance in the down is nearby and easy to find. There is a wind produced by dark science." The three visitors energetically nodded their heads at her last remark.

The old woman resumed, "Sathedra was asked to help the people of Curiosa to keep their caves dry. There is no way we can stop the wind, but you can go in from the down side if you are careful. Now, after you get to the main large cavern of the Athenaeum," Say Kage dropped to a quieter voice, reasoning the cave wouldn't hear her. All three put an ear toward Say. After several minutes of intense instructions Say leaned back. "Can you remember that?" Say Kage asked.

"Yes we can," Yves answered matter-of-factly. "It's something I am familiar with."

Say continued, "I have many ropes and you can use as much as you need. Now, to find the entrance, you must find the flat plateau. Just below the plateau you will see a cliff. At the top of the cliff you will find the windy cave. You should enter at night where no one can see you. It is forbidden for anyone to go into it. You must get out that same night or else you might get caught. Do you have any questions?"

Old Scratch, Gourdhead and Yves stood silent, absorbing the woman's instructions and then eyed at each other. They shrugged in unison, but Yves remembered one question.

"Yes I do," he started. "How did you get the name of Say Kage? You see, I know a woman...in life; she is my wife and I cannot fathom how you got her name. I mean, your names are so very much alike. Her name is Kay Sage.

Do you have any explanation for this?"

Say made no attempt to explain the mystery or the unexplainable. "There must be many people in this and your worlds with names mixed up as mine and hers. I wouldn't be bothered. You must concentrate on getting into the Athenaeum and learn how to find Sathedra's wishing chamber. One more thing," Say continued, "the Dark Road of Sathedra is covered with traps and pitfalls. If you know how to get through them, you will be safe. I was there long enough to learn what the guards of Sathedra knew. There are three walls you must pass through. The first is guarded by a lion and he can eat you in one bite. The second one is a trap. The third one blocks your way to a vitriolic swamp...you must be careful not to get wet. And then there are the Blues, the Greens and those Reds! You have to be cautious when it comes to the Reds."

"Oh, the Reds. We have killed two already. We know how to handle them," Yves said lightly.

"You have destroyed her Reds?" Say was skeptical.

"And some Greens," Old Scratch said proudly.

"Now the Greens are following us!" Gourdhead added.

"What did you do to provoke the Reds?" Say asked.

"I did nothing, except suddenly arrive here. One Red hit upon me and Scratch on the shore and started shooting at us," Yves said.

"Oh, you arrived unexpectedly," Say said, thoughtfully. "I think you are more at fault than you know. Whenever anyone from outside suddenly enters the land, there are changes to the fabric of events. Before you, we had one destiny. After you entered our world, you touched off new events, new occurrences and maybe, a new future. Does it seem like Sathedra's orbs are still after you?"

"Yes!" Yves stated.

"Then she knows of the changes, too. If Sathedra is fighting for her very existence, then you are in big trouble. And if the Reds have attacked you, then they may have been changed as well. Sathedra may not have control of them anymore. My, this is interesting." Say gazed over Yves' shoulder as if into the future. "We may have a brand-new future because of you, and we've been waiting for something like this to happen; at this time we can make a new start," Say stated.

"Then...you are not mad at me?" Yves questioned.

"Goodness no! The only one that will be mad at you will be Sathedra. She wants to hold on to her rule. She may not have that choice now. It is even more important that you find that book and fulfill our new destiny...oh yes," Say said excitedly. "Let's talk more of the Dark Road of Sathedra. There are...."

From this point on Say Kage whispered directly into Yves' ear because she was afraid Sathedra might listen with her Pools of Seeing. Scratch and Gourdhead sat there, wondering what she was telling Yves.

Say Kage stood up slowly, creaking and groaning. She disappeared into one of the side caves, then returned with a coil of old manky rope and a pair of glasses. Kage remembered at the last minute, the special glasses. "You must tie yourselves together with this rope or else you might be blown away. These glasses will let you see in the dark. I often use them here. You must be going soon." Remembering her hospitality, she continued, "Yves, would you like to have something to eat before you go?"

"Why, yes I would. What do you have?"

"I have several kinds of fruit. Which would you like?

Apples, oranges or peaches?"

"Peaches would be acceptable. Thank you."

Straight away, Say Kage set about getting the peaches. She was gone a few minutes. This gave the trio a chance to discuss their situation.

"Why did Say Kage whisper the last of the directions only to you, Yves?" Gourdhead grumped. "I thought we all should know of the problems on The Dark Road of Sathedra. I don't think she trusts Scratch and me."

"Maybe she has more faith in a human than in the natives of this land," Yves said kindly. "If she'd been hurt, say, by someone in Sath, then she might only trust one of her own kind. We humans tend to suspect anyone who is different than ourselves. I know that sounds like a dreadful trait, but that is what we are. And if Say Kage entrusted me with the intelligence, then I will trust her intuitions." She returned carrying a plate of fresh peaches covered with sugar and cream.

Yves sat down on a stone and dined on the delightful fruit. Gourdhead and Old Scratch sat on their haunches, waiting for Yves to finish. Yves was hungrier than he thought and the peaches sparked his taste buds.

Pretty soon it was time to head out. Yves gathered the rope and the glasses, then asked Scratch to lead the way.

"Thanks again for your help." Yves said. "I'll return the rope and glasses when we are finished."

"Keep them. I have plenty of rope and I have my own spectacles. Have a safe journey. We may meet again, you know."

Yves donned his hat and the three carefully walked out, stepping on the stones and dodging the drips. Once outside and across the misty foot bridge, the trio set off to

find the cliff and the Athenaeum's down-side entrance. Luckily the Greens had vanished.

Sathedra the Sorceress sat far up in her castle. She was sitting next to her small pool of water into which she searched far out into the land. She was following Yves, Scratch and Gourdhead as they made their way to the cave of Say Kage. Her plan was working. Soon she would have her missing spells back.

Sathedra had already figured her copied spells were in Curiosa, but she didn't know where. Say certainly wouldn't keep the book in her own abode; that would be too obvious. Curdland was not the place, either. On balance, that left Curiosa. It was logical. One among millions would be difficult to find, and she suspected that Yves would go to the book depository.

Sathedra wore her usual garments—her favorite richly hued purple cape enveloping a crimson spider web dress. She coveted the luxury of owning the best, and the best always felt good.

She knew what Yves would do. But once inside under Appellation City, she would not be able to see what he and the others sorted out. But if her intrigue worked, she would have her secrets back. Those stolen charms threatening her rule soon would be back in her hands. She would feel more secure when she controlled the entire sum of the preternatural in Sath.

Sathedra could feel the vicissitudes taking place in her land. She couldn't pinpoint the feeling, but she knew this man Yves had something to do with it. Her Reds had acted as good as out of control before they were killed. Most of her Greens steadfastly provided information, but many

failed to check in on time and she presumed that they, too, had changed or were eliminated. She still had her Blues surrounding her castle. There was one Red left and she kept that one handy. That gave her some comfort.

When Sathedra learned that Yves had killed two of her Reds, she vowed to get the man. But when she ascertained that he, too, was pursuing the book, then she needed to change her tactics. Sathedra would let him find the book, then he would bring it to her. She would command it.

Sathedra sent out another message. She formed a small cloud and sent it on a wisp of a whispering breeze. Only those expecting the sounds would receive the signal.

"I am ready," Sathedra voiced. "You must be ready, too." Her storms could take messages and relay back answers. For this she was grateful; it was the kind of power she liked. King Solanum's storm clouds could but batter and bash. Hers was the higher and better power.

Eleven

The early afternoon found the threesome trekking along toward the organic-looking mountains with dry forests on their right and a string of lakes on the left. It was a constant uphill climb, but at least it was a gradual angle of repose. They climbed at a steady tempo, enjoying the scenery.

Yves procured himself a six-foot-tall walking stick. It helped ballast his pace. He lugged Say's ropes slung around his shoulder. His outward show was that of a mountaineer.

The path they followed was a single-file grassy way, not meant for carts, but for hiking. They waded a few small creeks, jumped a number and slogged through others.

They could hear one stream a mile from where they hiked. It sounded as if it was swift flowing and wouldn't you know, when they arrived, it was. Yves looked upstream, then turned and peered down-stream. The waters appeared treacherous.

"Looks like we'll have to ford this one, too." Yves said.

"It looks awfully rapid," Gourdhead said worriedly. "I'd be washed away and never be seen again."

"I don't weigh enough to stand in that current," Old Scratch fretted.

"I suppose we could use this rope to help," Yves suggested. "How should we do this? How can we get one end of the rope to the other side?"

They thought a minute, then Gourdhead said, "Yves, I

think you're heavy enough. You better go first with the rope tied around your waist. We will keep one end on this side. When you get there, you can pull us both across."

Yves advanced to the water's edge, paused, then with all his strength, threw his walking stick across the river. It landed short, floating downstream. Yves considered the water again. He reached down and felt the water. It was as cold as if it stemmed from a glacier.

"Maybe I shouldn't have thrown my stick. That was dumb, I could have used it for stability," Yves muttered to himself. *But be that as it may*, he thought, *what's done is done.*

"Yes, I could do that," Yves said to Gourdhead, "but I can't stay in the water too long. It's cold, and I'm sure it will hurt." He thought a moment. "Right, let's get to it."

With the rope securely around his waist and the other end wrapped around a tree, Yves, with hasty abandon, stepped into the flow. The icy water instantly soaked through his shoes and socks, and bleached the warmth right out of his feet. He placed his feet carefully, feeling for unseen stones that could trip him. The surge of water shoved against his legs as he moved across the river. Yves knew he could make it if he just kept his feet securely on the bottom. He faced upstream and leaned into the rushing current. An ache crawled up his legs.

The cold coursing water rose above his knees. He pushed on. Soon the water level swelled to his waist. The chill made his legs throb. He was able to keep his arms dry by holding them above his head. The cold would be shocking if the water became any deeper. Yves hoped it would not. He carefully gained foot holds in and around many large boulders.

Yves heard a few rocks moving in front of him, then he

lost his footing when a rock moved from under his right foot. He collapsed face down into the cold water and to catch his fall, his hands searched beneath the surface for a stable hand hold. The cold entered his body and took his breath away. Yves struggled to get his face out of the water in order to breathe.

He floated up sputtering, wiping the frigid water from his face. He then fixed his eyes for the far shore and standing straight again, he leaned into the flood and continued across while Scratch and Gourdhead played out the rope.

As he passed the midway point the watercourse became shallower and the going much easier. Shivering, he hurried out of the flow. Yves peered back at his friends on the other side and saw they were getting ready to make the crossing. They had tethered the ropes to themselves and were waiting for Yves to call. After the icy water, the sun's warmth felt wonderful soaking into his back.

Yves wrapped the rope around a tree and waited. Shivering, Yves impatiently called, "Good a time as any!"

Scratch waded into the torrent and Gourdhead followed. The rush of water instantly up-ended the two of them and they planed across the flood. Yves immediately pulled on the rope to keep them from rolling down the river. Scratch and Gourdhead bounded along the surface, clanking and clattering at the end of the stretching rope.

Yves saw for the first time his two friends in trouble; only he could save them. Even with the ropes fastened to them, the knots were loosening and he saw the ropes coming off his friends. Yves pulled hand over hand, as fast as he could. Gourdhead slipped from his knot next to the shore then continued tumbling downstream. His thin stick figure didn't float well and he disappeared into the white

water. Old Scratch slid from his knot at the water's edge, but luckily he clambered ashore, shaking and imbalanced.

Yves zipped down the river's edge hunting for Gourdhead. "Gourdhead! Where are you?" Yves called. He couldn't see him anywhere. Scratch joined him in the search. They pursued further down the shoreline.

"There he is...there, hanging on to that log!" Yves yelled over the river's roar. Gourdhead was caught on a log by his right stick hand—the rest of him slapped the speeding water, flipping like a fish on dry land.

Yves dashed to where Gourdhead was stuck, climbed out on the log, skidded and bounced on his behind, flipped off and caught the section of tree with his arms. There he was, hanging onto the log, with his legs dangling down, his feet in the water. He swung back up top the log and shinnied on his belly until he reached the flailing Gourdhead. Yves loosened Gourdhead's stick wrist from the snag, pulling him up to safety. Then they both crawled back to Old Scratch waiting on the shore.

Back on the rocky beach they rested on sun-warmed stones, gasping for breath. It didn't take long for Yves' clothes to warm and start drying.

"That was a close one," Gourdhead said at last. "No telling where I'd be if you guys hadn't fetched me."

"We have to be here for each other," Yves said, "otherwise we could get into big trouble."

"Agreed," Old Scratch said, giving his friends a positive crystal thumb.

Shortly Yves' clothes dried, Old Scratch was warm and Gourdhead's stick body was, in essence, dry too. Yves stood and headed back to gather the rope. Scratch and Gourdhead followed faithfully behind him.

Back at the original crossing point, Yves coiled the rope and again slung it around his neck and shoulders.

"Guess we should be going," Old Scratch said. The trio set off again, heading for the down-side entrance of the Athenaeum.

Yves, Gourdhead and Old Scratch soon arrived at the base of the high, flat plain. Yves ordered his crew to follow the cliff. As they walked along the base of the mountains, Yves noticed there were layers of Chinese Vermillion, Gold Ochre and Manganese Blue, those familiar iridescent, nacre colors, striated through the rock. *It appears similar to sandstone*, he thought, *but the surface is very smooth, kind of slick. Hard candy? Au contraire. More like smooth dried paint with hard dammar varnish, from the Amboyna Pine*, Yves supposed, then shook his head.

On they strode. They were dwarfed by the immensity of the stone mountain. Massive megaliths in the past had broken from the steep face above and they stood like lone sentries protecting the area. The group zigzagged in and around these stones with insectile persistence. Presently they heard wind gusts. They craned their necks and half-way up the cliff they saw a ledge and set back, the entrance of which Say had spoken.

"They shouldn't be afraid of intruders. That entrance is impossible to get at," Old Scratch harrumphed, straining his neck, peering up. "Are we expected to climb up there?"

"Sure, it will be difficult. But we must try," Gourdhead said. Suddenly two Greens appeared. They materialized out of the forest that followed along the cliff base. The two orbs hovered there, not making any moves as if they were watching three creatures.

"What do you suppose they want?" Gourdhead asked.

"I'm not sure. They seem to be waiting," Scratch said.

"They're waiting exactly like those by the sweet pond," Yves said. "Do you suppose," Yves paused, "...do you suppose that they are waiting for us?" Yves lifted the rope from his shoulders and laid it on the ground.

"That's a frightening thought," Old Scratch said.

"Look, four more have joined the others," Gourdhead said.

"Yves, do you suppose they have been affected by your presence here in Sath?"

"The Reds changed, why not the Greens," Yves reasoned.

"I wonder what's different now?" Gourdhead asked.

"Well, as long as they keep their distance I'm not going to agonize over it," Yves said stoutly. "But if they come any closer I might have to teach them a lesson."

There was such a thunder bellowing from the mouth of the cave that it drowned out the whiny buzzes of the Greens. Yves could no longer hear the attenuated songs of the birds or the rustling of leaves, just the noisy blasts from above. All the air that whistled past Diddlespider and those books was now compressed out the entrance in a grand gust.

Night rapidly descended and the sky bore clouds that grew animal shapes that changed slowly and gradually. It was as if someone was painting shapes, then painting those over, creating new cloud forms and streaks.

"Yves, do you have sunsets like this where you come from?" Old Scratch asked. They stood together, leaning with their behinds against the rock face, waiting for night to fall. For safety, they kept one eye on the Greens. Yves didn't trust them one bit.

"Yes, much like this. The sky is always blue with white clouds during the day, then they are colored at gloaming," Yves said. "We don't have the skies of many colors like you do or even the pure white sky of Curiosa. The colored clouds here are much more intense. They sometimes don't look real to me."

"Well, they are real. Just as real as you, me and Gourdhead." Old Scratch gave Yves a playful and friendly little punch in the arm. Just then Old Scratch heard rumblings far in the distance.

"Yves, are there war clouds where you come from?" Old Scratch asked, looking worriedly at the darkening skyline.

"Scratch, where I come from there are much more than war clouds. We have…we have relentless warring. We have war machines that are very efficient at killing. Some fly the skies, others travel across the land while others roam the seas. Oh, yes Scratch, you could say that we have war clouds. In fact, we just finished a major war nine or ten years ago. We hope it will be the last one. But I'm not sure. There is far too much unrest and hatred in my world."

"Were you involved in that war?" Gourdhead asked.

"No, I was in the war before this last one."

"There have been two wars?" Gourdhead asked, amazed.

"Oh, no. We've had scores of wars and millions have died," Yves said sadly.

"How much is a million?" Old Scratch asked."

"Far too many to count," Yves sighed. How could he ever explain mankind going to war?

"Were you in one of those wars where millions died?"

Gourdhead asked.

"Yes I was, but not in the military sense. I served in the Merchant Marines. We moved goods around the world. It helped the war effort." Yves turned to Old Scratch. "I, too, had to leave my place of birth. But I left because the invading forces were coming and we knew our freedom would be lost if we stayed. Many who thought like me fled for their lives." The three, feeling the need to rest, sat down with their backs against the cliff face.

"You do come from a different world," Old Scratch said, shaking his head. "Here the war clouds are aimed at the heads of state, not at the people. Hardly anyone gets hurt. Life is too precious here in Sath. In fact, it's like that throughout Sath. Your home sounds pretty ghastly."

"Right now it is. We ended the last war with two large bombs that destroyed two large cities and slew hundreds of thousands of people." By now Yves' head hung between his knees in shame. "And there doesn't seem to be an end in sight." Yves began sobbing; Old Scratch and Gourdhead sat near to comfort him.

"Woo, I thought we had it bad," Gourdhead said. "I'm not going to complain ever again."

The three of them sat unmoving for awhile. Yves, after a few minutes, lifted his head and sniffed.

"Even though it sounds awful at home, I still miss it. It's still my home." Yves looked around. More Greens had arrived—the sky was an inky dark. "I guess wherever you are you will miss what you don't have. And I miss Kay. I miss Woodbury and my barn and my friends. Sorry guys, I just do." Yves sobbing subsided.

"That's all right, sometimes I miss Crystalum," Old Scratch said. "Let's get your eyes dry." Old Scratch helped

Yves get the handkerchief out of his pocket. Yves turned his face toward Old Scratch to let the cat wipe his face and eyes. They laughed as Scratch dabbed the moisture.

The air was cooling as the night deepened. Yves stood and walked around, stretching his arms and legs. The cliff above loomed over them in the darkness. In the black distance Yves picked out the small group of Greens. They now massed into nearly a hundred and were waiting.

Gourdhead sat stock-still, next to Scratch. He was thinking of the climb and how difficult it might be. He was not afraid of this vertiginous climb, but afraid of the outcome after they got the book, that is, if they locate the book. His place in the new future eluded him. Think as he might, he didn't fit in anywhere. Being exiled from Lilium didn't help either. There had to be a place in the future for him, he hoped.

The light was gone and a few stars began popping through the night sky.

"But we still have to scale that darn cliff," Yves said pointing, making a sensible, and in every respect a neutral determination. "Scratch, you will go first and find the best route."

"You've must be kidding. Me, climb up this steep, slick cliff? I let you command the small raft on the lilipond because it sounded like you knew what to do. But here it sounds like you want me to go first based on nothing." Old Scratch glared at Yves reproachfully.

"No, I'm not kidding," Yves replied, holding his ground. "Remember you climbed that wall in the cell? I think you are the best climber of this group and you should go first. We will be right behind you, following your path. We will trust you. You must find a safe way ."

Grumbling and fussing, Old Scratch let Yves tie the rope securely around his crystal waist. He put Gourdhead in the middle and himself at the end. Yves stuck the glasses in his shirt pocket and buttoned it.

Scratch reluctantly started ascending, searching for foot and hand holes. Gourdhead followed in his exact steps. As the rope tightened Yves clambered right behind Gourdhead. They gave the impression of a large scrambling insect. They skittered over the stone's surface, gradually making their ascent. Half way up the cliff, Scratch called down to Yves.

"If we ever make it up there, you must promise to help me shape my own kingdom someday."

To keep the peace Yves called up to Scratch, "Yes, yes, I'll see what I can do. Now please, keep climbing because we must find that book and make good before daylight."

The cliff was steep indeed. Yves and Gourdhead, at times, hung by the ropes and at one point, they swung back and forth like a pendulum of a clock. If Old Scratch hadn't kept his crystal claws sharp, the three of them could have ended in a pile at the bottom of the cliff. With all their strength, the three pressed up the precipitous cliff.

Eventually Scratch proclaimed over his shoulder that he'd topped the ledge's edge and was making his way to the entrance. The others hardly heard him because the cavern's roar was so thunderous. Scratch entered the air jet and learned it was very nearly impossible to proceed. He sidetracked his way to the left side of the entrance until he came to a rock where he could safely be out of the air gush. Scratch turned and started pulling on the rope. Gourdhead showed face first and clacked toward Scratch, then soon after, Yves appeared at the edge of the cliff,

then he too, made his way to the shelter of the rock.

When all were at the rock, the wind cried so loud no one could speak. Yves used hand signals to indicate, since he was the heaviest, he should be the first to enter. He insisted they say nothing because there probably would be guards inside. He donned the glasses and with watery eyes, stepped over and leaned into the air surge. Yves was first, Gourdhead remained in the middle. Old Scratch controlled the rear this time. The wind was so powerful that they were nearly forced back. Yves pressed harder against the wind, pulling his friends in. Gourdhead and Scratch flapped and clacked behind Yves as they moved into the darkness.

The passage turned right, then left until Yves sensed the opening to a large cavern. Inside the large cavern the wind lessened and a guard stood menacingly tall in the dark. The sentry could not see, but he could respond to sounds. Yves took off his glasses. To his surprise it was pitch black—so black he could not see the guard in front of his eyes. He put the glasses back on and he could, once again, see the guard and hundreds and hundreds of book shelves behind him. Those same shelves Ann Thology showed them days ago. The tall Curiosaman stood there, stiff as a hard cover.

Yves whispered to the others to remain roped and silent or they might get lost, maybe caught.

"Indeed we will," Old Scratch whispered back. Gourdhead nodded vigorously.

Sneaking past and leaving the dark-blind guard behind, Yves turned to the right and walked toward the furthest row of books. They walked quite a distance before arriving at the far side. They turned around and paced back the way they came, then Yves began counting the rows, "One, two,

three, four, five...," Yves whispered with a steady rhythm in the darkness.

"Let's keep careful count," Old Scratch reminded the others. "We don't want to have to start over." Gourdhead and Scratch were being tugged right along behind Yves.

On they crept and counted. It took them roughly the whole night to enumerate the rows. Yves, with a sharp rock, marked each row to indicate the hundreds; in case he miscounted, they wouldn't have to go back and recommence. When they got to the 2476th row, it was nearly dawn, and Yves, with assurance, stopped. Gourdhead bumped into Yves and Old Scratch thumped into the back of Gourdhead. Yves turned down the row and pulled the other two along to the seventh section and stopped again, making Scratch and Gourdhead go bump...bump in the blackness. Yves bent down and felt for the third shelf from the bottom then counted, from left to right, arriving at the 63rd book on that shelf. He pulled the book out and studied it. *This is the book! It must have been handwritten by Say herself,* he thought. The book was at least fourteen by twenty inches, and its cover, even through the night glasses he could see it was a rich, light Raw Umber leather binding. It was vibrant with scrolled, gleaming gold markings. Yves could not decipher the meaning of the marks but when he peeked inside the book, it was full of facts with reference to Sathedra the Sorceress.

"What is it? What's going on?" Old Scratch asked inquisitively. "Remember, we can't see a thing."

In his fascination with the book, Yves momentarily forgot that Scratch and Gourdhead were blind in the dark, at that point, he explained. "The book was right where Say Kage said it would be and it's handwritten. I'm reading

things that seem not unlike spells and information about Sathedra. What we need to do now is get out of here. Sun-up will be here soon."

He tucked the book under his arm and began leading them back to the windy tube and again past the blinded guard. Thankfully, the guard took no notice of them. Yves wondered, *how much guarding this sentry actually did.*

Once inside the shaft, the wind greater than before, began pushing them forward toward the entrance. On they walked, leaning rearward against the wind. Halfway out, when the path straightened, Yves tripped over a stone. He was lifted by the wind and hurled down the passageway. Old Scratch and Gourdhead were pulled right after him, dragged along by the rope. They were completely off the ground, riding on a cushion of air. It was a smooth ride and not at all unpleasant. The three zipped along watching the entrance getting closer and bigger. Yves gripped the book with both arms as he flew along.

Phoom...phoom...phoom...they flew out the muzzle like three bullets, then tumbled over each other in the early first light. Head over heels they sailed, far out into the countryside. Luckily they landed in a soft-leaved tree. It gingerly lowered them to the ground with a "flomp." Each sat for a minute in the muted half-light, wondering what had happened.

"Whooo...wee!" Old Scratch exclaimed, undoing his rope. Yves was supine, his vision riveted to the underside of the tree limbs. The book still clasped in his arms. "That was some ride. Let's not do that again."

"I agree," Gourdhead giggled as he adjusted his head around frontways, then untying his rope, "Yves, you okay?"

"I seem to be quite calm in spite of that fall," Yves said. He unbent, untied his rope and gazed around at the glorious daybreak then propped himself against the tree. The gathering of Greens had moved to find the three. And when they did, the orbs kept their distance.

The horde of Greens after considerable deliberations, decided something in the night. Since they had experienced a change, a profound alteration, and their contact with Sathedra had stopped, they needed guidance and a reason to be. They hung around, watching and waiting.

It was bright enough to see when Yves set the large book in his lap. He opened it, then flicked to the first page and began to read. Old Scratch and Gourdhead drew nearer to hear.

"Sathedra is a sorceress. She came to power after negotiating with the Occultist of Gehenna and the Ogre King. The Ogre King was the ruler of the land before Sathedra. The Ogre King's rotten attitude was felt across the land. He made everyone feel negative. That is why Sathedra visited the magician. When Sathedra came back, her positive aura overpowered the Ogre King and with the help of the great authority and to a surprising degree, Sathedra took power. Sathedra now lives in a candle castle on the Dark Road of Sathedra. She is slowly becoming an immoral influence. That is why I, Say Kage, ran away from her bondage and secluded myself from her power. But before I left, I got hold of her secret books and read about her power. Some of her books were written by the enchanter himself. His handwriting is unappealing and common. There were many instructions on how to rule and be a demanding ruler."

Yves skipped several pages, then read on: "She has

chambers throughout her castle. There are chambers for sleeping, eating, thinking, wishing and one for making spheres and all dark things. In the sleeping chamber there are keys to each of the other chambers. They are hung on the wall and are not visible. Only she knows the order in which she keeps them. Anyone entering the chamber will fall into a deep sleep."

Yves paused, thought a second, then kept on reading: "Once you have the keys, you will have access to critical places. The eating chamber is one direction, the thinking chamber is opposite; the sleeping chamber is in the middle and the wishing chamber is in the down end of the castle. Her power comes from a candle flame deep inside the castle. Blow it out and she will lose her power. That is everything I know regarding the castle."

Yves thumbed through the rest of the book and found it contained a fair number of Sathedra's spells. This was not important to Yves at the moment because he wanted to get into the wishing chamber and wish himself back to Woodbury.

"Yves," Gourdhead said nervously, "one of those green orbs is coming this way." They looked in the direction Gourdhead indicated. Indeed, one loner was floating slowly toward our three. Yves rummaged around for something to throw. He picked out a stone—the sphere stopped. Yves stopped. Yves dropped the stone and the green orb dipped once.

"Is it trying to communicate?" Yves asked of Scratch.

"Do...you...want...to...talk?" Old Scratch asked the Green. Again the sphere dipped.

"Well, this is curious," Yves said. "First they attack us and now they want to talk. I wonder if it really understands

us?"

"If you understand us," Old Scratch said slowly, "float over to that bush." Old Scratch pointed to a bush next to Gourdhead.

"Uh...Scratch," Gourdhead said with eyes wide, "do you think that is wise?"

The green orb slowly moved to the bush and stopped, then it made another dip.

"Well, I guess that proves it," Old Scratch said.

"Wait just a second," Yves said. "Orb, please dip twice." The orb did.

"Do you want to help us?" Yves asked of the orb. The orb motioned up and down excitedly. It then returned to the assemblage of other Greens. There was some milling and three Greens returned to that same bush beside Gourdhead.

"I guess they're ours," Old Scratch announced. "What will we do with them?"

"I suppose we could use them like a...small army. They could protect us, maybe," Old Scratch suggested.

"Let's try that," Yves said, then he started again, "Greens, hear me! I command you to protect us from danger. We will be going to Sathedra's castle soon and we want every one of you to go with us."

There was some general excitement among the spheres, then five of them surrounded Scratch, Gourdhead and Yves. The others set out two perimeters. The inside circle was fifty feet in diameter and the largest circle was so big that it was out of sight. One Green ended up in charge of the rest; Yves invited that one to hover within earshot. The greens engaged in a way of communicating with each other that Yves did not get. They used whines, whistles and

beeps. The close one would have to be their translator.

"Guess there is nothing to do now except go see Sathedra," Yves said. "She might want to help us."

"I think not," Gourdhead said. "She's not the type to help anyone without good cause. On top of that, you killed two of her Reds. Think she'll be friendly?"

"Oh, that's right," Yves said, recalling. "She won't be happy to see us, will she?"

"Probably not," Old Scratch said.

"Then, we may have to sneak into her castle," Yves said, "find the keys, blow out the power candle and get me into the wishing chamber."

"That sounds dangerous," Old Scratch said fretfully.

"Maybe we can set off a diversion," Yves suggested.

"Why not? I remember a little about the castle," Gourdhead replied enthusiastically.

"Good," Yves said. "With this book, these Greens and your expertise we may stand a chance."

Yves piped up, "Anybody hungry? I sure am." Gourdhead and Scratch agreed. They located a small grove of wishing trees and made their requests. Scratch asked for a bowl of cream, Gourdhead wanted fresh red berries and Yves wished for some buttered toast with strawberry jam. Yves also requested a large mug of hot cocoa topped with whipped cream. It all felt good as they were famished.

Thunder suddenly rumbled from scant miles off. The Greens stirred, then spun. They were acting spooky.

"That sounds ominous," Old Scratch said, a shudder rippling through his facets. He'd heard those sounds over the past few days. "Sounds like something is a brewin'."

Twelve

It was just past three in the morning, and King Solanum was far above the ground in his tower, shouting that the spells were too slow. He wanted to get Sathedra this time. Many times he'd sent war clouds, huge ones, full of hurricane winds and enormous lightning bolts, which should have blown out Sathedra's power candle. But every time he sent clouds she would send powerful storms, countering his attack. He needed more strength this time. Something different, undeniably stronger, more focused.

It was time for the final effort. He paced back and forth in the glow of his lichen-lit studio, impatiently waiting for his operative to send a message. It was difficult for him, the king, to be dependent on anyone. But these times were different in that he realized his own power might not be enough.

His power had evolved for many years, but before long, his growth leveled out. He grew no more in strength. The king now needed inside help. Strong winds wouldn't be enough this time. His hopes and philosophy for his lands and people were imperative, and at this very time his spies were working to get information to him. Many were late. Some died trying to acquire this vital intelligence, and all data was urgent. Again, he examined his writings by the blue-green light of the luminous lichen lamp.

"Master!" his aide shouted. "There is a message coming through for you. It's weak, but readable."

"Can you tell where it is originating?" King Solanum asked. "Is it from the down?" The king hastened to the aide's side.

"Yes, it's from the underbelly of Curiosa," the aide affirmed. Without being ordered, the aide lifted his roots and stepped aside. Then he aimed himself toward the balcony and stood there with eyes fixed on Caylyx City. King Solanum stepped into the aide's place and sent down thick, hard-wearing roots. The king shut his eyes. He searched for the faint thread of communion. There were multitudes of meanings darting every which way. The right one, the code—his tendrils sought the code.

"Yes," Solanum said, fluttering his eyes open, "that's the code!"

The King closed his eyes again, and his face became lively. His eyes wiggled under their lids, he mouthed words silently. He stood stock-still for a twinkling and then began twitching. This was important. He wanted to get it right. Communications usually were kept short because of the energy expended, but this discourse was significant. The future of Sath rested in the hands of a few individuals, and those souls, at last, were making contact for the final contest. The king could feel the heartbeat of Sath. More talkative words, and then he relaxed. King Solanum stood there in his communication room, alone in his deliberation, thinking of the conflict that would take place the approaching day.

"Stem," Solanum called out, "my chair. I will be sitting on the balcony this morning."

"Yes, my lord," the aide called back. "On the balcony."

Stem reached to move forward his king's chair. He, too, was thinking of the great changes coming. But what if

King Solanum and the others failed again? Stem was sure the land would be in greater turmoil if his king failed. He shouldn't even think of losing. His positive thoughts would help his king. He hoped everyone in Sath were thinking positive because his king needed all the help he could get.

The king uprooted and proceeded out the terrace doors. He leaned forward on the wooden rail and looked out over Sath. There was disquiet emanating from the land. He understood his people in Lilium and felt their discontent. At last the time was near. Night clung onto the land, but occasionally he saw fulgurant lightning coming from Sathedra's castle.

"Your chair, sire," Stem said. "Where would you like it?" Stem worshipped his king.

"Over there," Solanum ordered, pointing to a low area in the wood rail on his right. "You may attend to your other duties. I want to be alone. Please, come back at dawn."

"Yes, thank you master," Stem said as he bowed and left.

Alone again. King Solanum pulled the chair closer to the railing and sat, watching over his realm. His hands were pressed together in front of his mouth as if he was praying. His fingers bounced on his lips. He was thinking, planning. *Everything must go well. The book must be found, and the power taken to the castle of Sathedra. Together it can be done—together it will be done.*

As the early dawning showed itself, King Solanum relaxed into his bark-lined chair, enjoying the coolness. He was happiest when he was alone, and in the early hours, he could feel the most solitary.

After a time, he observed the first ruddy glow of dawn

as the sun crept to the horizon. This day-glow was the deep purple of a bruise, melting from the black of the early sky. Stars still twinkled. He saw the silhouettes of the night birds flying around in the edge-of-morning light. They were doing their break-of-day dance and catching insects at the same time. They climbed high, then smoothly spiraled down to the treetops. Those were the Catch-a-Teel birds of Sath, and they only flew in the first light. Then they nested for the rest of the day, out of sight. They seemed oblivious to the coming events, and King Solanum hoped the innocent animals would be spared any anguish.

The night, in due course, let the day begin. The sky radiated a rich red, the color preceding the rise of the sun. Now was the only time he saw this kind of red. Every other red was dull compared to this.

"Ah, there it is," King Solanum sighed happily as the sun burst through the last dawn light. "It has begun."

"Master," Stem announced delicately, "I am here at your request." It seemed a shame to disturb the silence of the dawn. The light was shining directly on the two of them. It made their faces glow yellow, and their body leaves turned toward the sun.

"Bring my staff with the crystal," the king ordered.

"Yes, master." Stem disappeared into the tower and brought the tall crystal-topped stick for his monarch. He bowed and handed it to his king.

"Thank you Stem. Now, go and attend to communications."

Stem turned around and vanished back into the tower. King Solanum stood alone in the full sunlight, gathering strength. He must get as much power as possible because on this day his force would be tested.

Solanum stood heroic at the rail. He outstretched his arms above his head, held the pole with both hands then incanted a few words. A small wisp of haze formed in front of him and from this, a cloud formed. He sat back in his chair and assessed the cloud growing larger. The multitude of mist would continue enlarging until he sent it somewhere. Higher the clouds climbed. They reached for the sky and far below, the ground darkened beneath the shadow of the war clouds. Flashes flew from cloud to cloud, then quickly a massive lightning bolt severed the air and blasted the ground at the base of his castle. After several more similar bursts he would dispatch his new fighting force toward Sathedra's castle. Her tyranny would soon be over. But for now, he must wait. It was not quite time for his blitz.

Far across the landscape, Solanum saw the suggestion of Sathedra's storms building. They were small at first, but they grew larger, too. His contact requested him to wait— wait for the castle to go dark. Sathedra's candles were flickering sepia in the early oily light. He could always see a few candle's lit, even during the day.

Sathedra traversed the corridors of her castle. She was going large and she was deep in thought. Her guards kept silent as she passed their posts. She sensed an uneasiness coming from Lilium. King Solanum was starting something. She knew. He would probably send storm clouds over to extinguish her flame. *He's overdue for another battle*, she figured.

She strolled to the terrace facing Lilium. She saw dark clouds on that far horizon. There were flashes and distant rumblings. His storm clouds demonstrated strength and,

oh yes, he would blow out some of her candles. "But, not all of them," Sathedra whispered, half to herself. Her power candle would remain untouched. Her magical force field and her last trusty Red would see to that.

Sathedra came back into the castle and made her way to the seeing pool. She wanted to see if anything else was happening in the land. She sat before the water and touched it with a red fingernail. Out of the small water waves an image of Yves, Gourdhead and the old cat became visible. They were sitting under a tree in Curiosa, reading a book.

"Those are my missing spells!" Sathedra exclaimed excitedly. "Say will be sorry that she ever copied them. Bring them to me," she breathed. "Bring the spells to me." She repeated the phrase several more times.

"What's this I see?" Sathedra continued. "So that's what happened to many of my Greens. They have taken forces with those three. They will be no match for my Blues, my Red and my guards. Let them come. I fear them not!"

"Mistress," a guard said sheepishly, "the clouds are getting larger and more dangerous looking."

"Yes," Sathedra answered, her mind barely there. "Get out." Yes indeed, she could feel the power building against her.

She must defeat them all to safeguard her kingdom. Sathedra stood proud and walked from her Chamber of Seeing, up the stairs and into the tall tower that overlooked the entire castle.

At an open window Sathedra took a long deep breath, held it, then exhaled slowly. The hot breath she bore swirled and gathered into a dense fog. She used her bone-white hands to form the mist into an eddy that spun in

front of her calculating face. She released the form and sent it reeling on its own. Sathedra spread out her thin arms and the whirl became bigger. Once again she spread her arms. The form grew into a cloud. She blew a sultry, torrid exhalation into the cloud, giving it a life of its own. It gyrated and burst higher into the sky. One had to reckon with her war clouds. Sathedra certainly respected them, and too, even now, Solanum's clouds were formidable.

Sathedra stepped back and examined the thunderhead growing, spreading out in the bright sky. Lightning flickered around the anvil-shaped cloud head. At last, Sathedra was ready for King Solanum. If he sent his clouds now, her winds would blow his storms back to Lilium. Some may perish, but her rule must be supreme. She must show all in her land that her power is unstoppable.

Conf

Thirteen

Yves stood suddenly, hitting his head on the tree limb. "Ouch," Yves yelped, holding his head. "That hurt."

"Are you all right?" Gourdhead asked. "Here, let me take a look at your head." Gourdhead got up and looked down on Yves. "There isn't much of a bump here, just some mussed-up hair. You'll be fine."

"It feels kind of sore," Yves complained, touching his stinging spot. A couple of minutes later Yves forgot about his head and said, "I think it would be good if we head for the castle. It's light now and likely safe enough to travel. "Here Gourdhead, you carry the book," Yves ordered, handing the tome to the stickman. Yves made a quick glance around the tree. "Anyone see my hat?"

"No," Old Scratch answered. "It probably flew off in a different direction when we came flying out."

"Darn, I liked that hat," Yves said, rubbing his head. "Have any of you Greens seen my hat? It's large with a pink feather in it." None of the orbs indicated such a find, then Yves searched around, but didn't find it either.

"Come on Yves, your head will be all right," Old Scratch said.

They left the down-end cliff, made their way back through the standing stones and came to a causeway that led them between some small lakes. The Greens shadowed them all that way, keeping their circle of aegis strong. Right along the lake's edge were Snooks. This time Yves knew enough not to poke his nose in. He saw some of the

Snooks squirt, then search around for the doomed insects.

By mid-morning Yves was hungry. The three stopped near a small grove of trees and wished for food. The Greens simply hovered nearby, waiting. Gourdhead got an orange, Scratch wished for a bowl of cream and Yves enjoyed a hunk of French bread, cheese and a glass of wine. Old Scratch sniffed the wine and wrinkled his nose. "That smells terrible," Scratch said. "It stings my eyes."

The liquid was off-nosed with a vinegary background. "Ah," Yves said, ignoring the acerbic taste.

He took one big gulp and wished for another full glass. A while later Yves was getting intoxicated. He'd downed three glasses and was starting his fourth when Scratch said, "I think, maybe you shouldn't finish that glass."

"Why, because I might be feeling better?"

"No. You want to get back don't you?" Scratch said.

"Shore I do. Doesn't everyone?"

"We're home. You are not!" Scratch cried out in frustration.

"Yeah, I know," Yves stared into his glass of wine, then threw it into the lake. Three Snooks jerked and slid under the water's surface. Yves lay back flat on the verge and shut his eyes.

"Looks like he wants to snooze," Gourdhead said to Scratch.

"We'll let him, but only for a while. Sometimes he doesn't know what is good for him."

Old Scratch got into his toy pouch and pulled out the cat-nip scented leather mouse, then tossed it in the air. When it came down he batted at the toy and it flew again. It landed near the water's edge and Old Scratch revved up his hind-end and pounced on the mouse. He tumbled and

kicked the toy with his back paws, then mooshed his nose into the leather toy. Scratch got up and trotted over to Gourdhead. The faux mouse dangled by the tail from Scratch's crystal sharp teeth and it bounced from side to side.

In an hour Yves awakened. "How long have I been asleep?" Yves asked of Scratch.

"Actually, too long. We have to be on our way. I see storms arising. It could get nasty."

"Don't let me wish for wine again, will you Scratch?"

"I'll try, but you do like it, don't you?"

"Where's Gourdhead?" asked Yves, looking around.

"Oh, he's down by the lake, watching the animals."

A distant hammer of thunder made the birds lift, en masse, into the sky. Gourdhead stood, probing the sky. He knew that trouble was on the march. Clouds were forming higher and faster on the far horizons.

"We have to get cracking!" Gourdhead called, dashing from the water's edge. "We could get soaked."

Yves walked around studying the group of Greens. He was sifting through the possible ways to use them.

"Scratch...I think we should send the Greens on ahead and have them wait near the Dark Road."

"Yeah, and that will get them out of our way for a while," Old Scratch said. "I'll tell them."

Old Scratch called the head Green over and explained that Yves wished for them to travel ahead and wait for him at the Dark Road of Sathedra. He also alerted it that there would be more instructions when Yves arrived. The head Green seemed to get the picture because it dipped once, then hurried off, making more screechy noises that Scratch heard before. Many of the other orbs reported to the head

Green, then they too, headed off, seemingly to gather the other Greens into groups and proceed toward Sathedra's castle.

When the last orb disappeared over a rise, Yves gave a sigh. Yves wished for a tall glass of fresh spring water and then drank it down. He wiped his mouth on his shirt and he noticed his clothes for the first time. His shirt was dirty and wrinkled. His pants retained a tear at the knee and his shoes were splattered with mud. He felt grungy and gritty, slovenly. He wished for a shower and before he could blink twice, a shower head formed on a tree and warm, soft water cascaded down to the ground. Yves got under it fully clothed, sighed happily and got goose bumps. The warmth infused his being—the dirt lost its hold on his clothes. Yves finished his shower then stood there, dripping.

"I wish for a towel," Yves said. To his surprise, a towel appeared hanging from another tree. He walked over and started briskly drying himself. He rubbed his bald head and finished his toweling exercise by wiping off his shoes with a flourish. When he presented himself to Scratch and Gourdhead, they applauded his effort. Nevertheless, his clothes were still grayish and wrinkled.

"What were you doing?" Old Scratch asked.

"I was taking a bath."

"I've heard of them, but never seen one," Scratch said.

"Neither have I," Gourdhead said, frowning at the edgy sky. "Still, we have to crack on."

"What's your hurry, Gourdhead? I can see the candle castle from here," Old Scratch said.

"It's not as close as you think," Gourdhead warned.

Indeed, the castle could be seen, but because of its size,

it seemed closer, *much like the cathedral on Mont St. Michel in northern France,* Yves thought. You could walk for hours thinking you were getting somewhere, but not—only to be awed by its size and distance.

Scratch led the way. Gourdhead grabbed the book of spells and Yves squished in his shoes as he followed behind.

The road they walked along was lined with small, square lakes and the skies on the far-over horizon were filling with dark clouds. A few clouds were gathering around Sathedra's castle, too. Yves was getting more anxious as he and his friends were approaching the Dark Road. At times like these he worried too much. His mind was dimorphic, in two worlds. On the other hand he was thinking of Kay and what she was doing, and about the uncertain outcome of upcoming events. Was he, in truth, in any danger since he was obviously in an interim? Yes, he was because he'd nearly drowned, he was shot by a Red and he scraped his hands at Say's cave. Oh yes, he was in danger.

Would he wake from the middle of this and find himself on the floor next to his painting? He could, for now, only follow his destiny in this crazy land. Forcing himself to regain consciousness was not possible. He should have already. Kay should have nudged him out of this construct.

Yves, Gourdhead and Scratch noticed as they moved toward the Dark Road of Sathedra, how much colder it was getting. Ice had formed on the sides of the road and the trees were dripping icicles. There was a hoar frost on everything. The trees displayed frozen fuzz on their trunks, limbs and leaves. Even the grasses were stilled silent with frost. Yves felt frost form on his arm hairs, he brushed it off. His damp clothes stiffened from frozen moisture.

When the group walked under a tree and brushed the leaves, the frost broke off in a tinkling display of glittering light. The frost instantly melted on them, giving them the shivers. The air grew colder and Scratch started complaining.

"If it gets any c-colder I won't be able to m-move. I will simply stiff-ff-en up," Old Scratch said, dragging his feet along. Further on, he did just that. He froze right in his tracks. One paw was off the ground when he stopped.

"Scratch, are you all right?" Yves asked anxiously.

Old Scratch gave a stiff-lip reply, "N-n-n-no, I ca-can hardly ma-ma-ma-mo-v-v-e." His crystal teeth began to chatter.

"Why don't you carry him?" Gourdhead proposed. "We can warm him beside one of the candles when we get to the castle."

"Sure, that's a good idea," Yves answered, mentally kicking himself for not thinking quickly enough. Yves collected Old Scratch and was very careful not to break him.

Ice covered everything and it made the passage very slick. Yves slid along with each step. Up ahead, the castle loomed larger. As they approached the flames, the radiant heat increased, yet the ice did not melt. Pretty soon Scratch began to squirm—Yves set him down. Old Scratch began to walk normally again.

"Well," said Gourdhead, "did you have a nice rest?"

"If you think it's restful being stiff and being carried along," Old Scratch grouched, "I assure you, it is not. I'd rather be melted down into a crystal ball and placed on a table." Old Scratch's eyes noticed storm clouds surrounding the top of the candle castle. He saw a build-up of them growing over Mount Thisseless in Lilium, too.

"Look!" Yves shouted, pointing. Then his voice dropped to a whisper, "There's the Dark Road." The Greens were waiting as ordered.

The entrance to the Dark Road was blocked by a stone portal with a black iron gate. Needle-sharp spines covered the black iron, pointing every which way, making it next to impossible to touch. Both shoulders of the Dark Road were steep drop-offs, right into the Sathedra Sea.

"Any ideas, guys?" Yves asked. "We have to get through. Come on, think." Right then the head Green floated over and began pushing the trio away from the entrance.

"Hey...watch it," Old Scratch snapped as the Green bumped him. "Quit shoving."

"Scratch, they are trying to tell us something," Gourdhead said. "Get away from the gate." Scratch and Yves awkwardly skated backward a short distance. Gourdhead followed. They watched a few orbs align, single file. When the Green in charge made a beeping sound, the first orb made a bee-line for the gate. When it hit the spines, the orb exploded and damaged the gate. Another sphere hurdled itself toward the gateway. When it reached the iron needles, it too exploded and opened the gate further. Three more orbs smashed into the entryway and blasted. After those five Greens exploded, the gate hung open by a single hinge. If an orb could smile, then the leader did. Scratch stood there, bug eyed. Yves couldn't believe what he saw, either. "I'm glad you're are on our side," Gourdhead said. "Do you explode every time you hit something?"

The head Green hovered for a second, then made another buzzing commotion. A single green, a monad orb

separated itself from the group and floated in front of the smoking portal. The head Green then maneuvered over to Yves and dipped once.

"What do you want me to do?" Yves asked of the Green. "I can see the orb out there—so what?" The very next breath that Yves took was shattered by the lone Green exploding.

"Yves, what did you do?" Gourdhead demanded.

"I didn't do anything!" Yves exclaimed.

"You mean, the orb exploded itself?" Scratch asked of the head Green.

The ruling Green dipped twice.

"It appears we have an army of suicide orbs," Yves said with concern on his face. "And once they are gone, we won't have any more."

"Then let's be careful what we ask them to do," Gourdhead commented.

The threesome broke through the smoldering remains of the gate and the hundred Greens followed right behind. When everyone made it through the gap, Yves stopped. He hunted around the road, not sure if he would find what he needed. "I must find a ball of yarn."

"I have a ball of yarn right here. Why do you need it?" Scratch asked with misgiving.

"Please, just have it ready and don't ask any questions," Yves said. "Now, we need a stick. Darn, I should have kept my walking staff." Yves squinted his eyes thoughtfully at Gourdhead. "Gourdhead, let me use one of your arms for a while and please, don't ask me what I am doing, come on, let's have it." Gourdhead set the book down, unhitched his right arm and held it in his left hand. Yves picked up the book. There were puzzled looks as Scratch,

Gourdhead and the Greens followed Yves onto the Dark Road of Sathedra.

The ice lay chunky on everything and their going was very rough. They glissaded up, then down the ice. Every new prominence was slick. They scurried up, then slid down the other side. Closer and closer they got to the castle.

Much to their dismay the castle was surrounded by two more tall stone walls. The stone was roughly cut and the walls even had ice-covered green moss growing on their tops. The large, flat stones were stacked two times taller than Yves and without mortar. On top of that was a barrier of coiled, sharp razor wire. *Something like German concentration camps*, Yves remembered, shivering. Yves and his army turned right and tramped along the stone separation.

Soon, they heard the roar of a lion. When they reached an opening in the stone, Yves stopped and the Greens stopped behind the three. There they saw a large tan-colored male lion with a bushy mane, guarding the portal. The lion heard them coming. He was very angry. Strangers were not allowed on the Dark Road; most would have turned back before reaching this point.

"Stop where you are or I will come out and make shreds of you!" thundered the lion. His roar was deep and it scared the trio. The orbs remained at a halt. "No one is allowed to pass through this opening! I will not let anyone pass me here!" The lion roared two more times. Yves looked at Scratch and called for him to give the ball of yarn to the lion.

"You want me to give my yarn to the lion?" Scratch said unbelievingly.

"Yes, I said give him the yarn," Yves repeated emphati-

cally. "Hurry, do it or we might be eaten up." Scratch threw it at the lion. The yarn bounced two times and rolled over to the lion's front paws. The lion stopped roaring and peeked down at the ball.

"What is this?" the lion said. "A ball of yarn. I have not had a ball of yarn since I was a cub. Oh, such fun!" The lion stopped a second and said to the shivering trio, "I must knit myself a set of booties because my paws get cold on this ice. But, hey...I'll play first." With that the lion began playing with the yarn and forgot about the intruders.

"Hurry, let's get past the lion while he plays," ordered Yves as he pushed Gourdhead and Scratch through the way in. The spheres filed through as quickly as they could, too. Presently the lion was at the inside wall busily knitting with his claws. The lion completely ignored the passing intruders.

Then Yves saw a wood fence and another gate farther ahead. When they got to it, he stopped everyone. "This is a dangerous gate if you don't know how to get through it," Yves said.

"Oh, you know how to get through it, do you?" Gourdhead asked, disbelieving. "Well, just tell us how. It looks harmless enough to me."

"That's how Sathedra wants it to look, but just watch," Yves said. "Now give me your loose arm and note what I do with it." Gourdhead gave him the stick appendage and Yves stuck it in the gate. Nothing happened. He banged the stick back and forth in the gate; in spite of this, nothing happened.

"That's strange," Yves said. "Say Kage told me of the gate and how I must pass a stick into it before we pass through...wait, this isn't the one! There it is ahead!" Yves

showed awkwardness. "This must be an ordinary gate just to fool us. And you see, it did just that," Yves said as he walked right through. Scratch scampered in and Gourdhead snapped his way through, too. The Greens obediently followed from first to last until every single one passed. Then they came to a second rock wall.

This rock wall enclosed a portal-arch built of stone and the gate was made of wood slats. It seemed not dissimilar to a simple door. Yves studied the doorway a minute, then pushed the door open with the stick. Slam! A huge stone block crashed down, smashing one end of Gourdhead's arm flat.

"Whew. I'm glad that wasn't my head. I would be dead now," Yves said, feeling relieved.

"That's very well for you to say. Look at my arm," Gourdhead exclaimed. "What will I do for an arm?" Yves yanked the stick out and examined it. It was flattened like a fan on one end. Yves broke off the flattened fragment and helped Gourdhead place the shortened arm back on his shoulder. But now the arm was several inches skimpier than the other.

"Je suis désolé," as Yves put it, sheepishly. "I will find you a better set of arms when we get our chores done."

"Oh, all right," Gourdhead gave in. "Where do we go now?"

"We must cross a corrosive swamp where many have perished," Yves replied, sniffing the air and blinking his eyes. "Come on, let's go...I think it's this way."

The three continued on through the opening, climbing over the stone that lay there. The green spheres followed toward the rising acrid smell of vinegar. The ice on the

Dark Road, after a short time, melted and they trod on bare ground once more. But a hedge was now in their way. From a distance it seemed harmless, but as our three moved closer to it, Yves let out a moan. He'd experienced those thorns in the past. "Pyracantha…and Hawthorn. Oh…no!"

"Is that bad?" Old Scratch asked.

"Well…if you don't mind pain, it's not," Yves said, licking his lips. "I wouldn't want to get chummy with it."

They approached the hedge, but couldn't see over to the other side. The row was too high to jump over and thick enough that it was impassable. The inch-long, needle-sharp thorns pointed every direction. If there was ever a barrier to passage, then this was it. The thorns would puncture flesh as easily as popping balloons. Among the tangled needles were clumps of red-orange berries, contrasting with the glossy dark leaves.

"Ow…ouch," yelped Yves as he tested a thorn for firmness. "Say didn't mention this. At home we called this Firethorn."

"Any ideas?" Gourdhead said. "We've got to get to that castle." A few of the orb troops quivered restlessly.

"I think I could slice my way through the hedge with my crystal-sharp claws," Old Scratch said. "I don't think the thorns will hurt my crystal body."

"That's a top smart proposal," Yves said. "Start cutting."

Old Scratch approached and began hacking at the hedge. His claws chopped through one branch after another until a passage way began to form. He entered the opening and kept slashing. Pieces of vegetation flew out as Old Scratch pushed his way through. The hedge shook

and berries fell to the ground as Buzz-Saw Scratch disappeared into the hedge. When Scratch reached the other side he turned around and shouldered back through the opening, cleaning out any thorns that were sticking inward. He emerged claiming victory and started cleaning green gunk from between his front toes. "I think we can safely pass through now," Old Scratch announced.

Yves hunched over, peeked in, then pushed through the passage. He took a couple of seconds to traverse the aperture and was hooked once by a rogue thorn. Gourdhead rattled through next and was surprised how neat the opening was cut. Old Scratch asked the Greens to enter and get to the other side. Then Scratch popped back through and stood proudly in front of his companions.

"Good job!" Yves cheered, patting Scratch on the back.

"Yes indeed, wonderful work!" Gourdhead said warmly.

Towering in her castle, Sathedra turned her eyes down to her Dark Road and saw hundreds of faithful Greens massed at the hedge on her Dark Road. "Bless them," she sighed with relief. "They came to protect me. Blues, go and help my Greens keep intruders away. I must concentrate on Solanum's attack." Her Blues that surrounded the island started moving, single file, toward the Greens at the hedge on the Dark Road. She felt secure knowing that her spheres would now defend her territory.

Scratch looked past Yves and saw two lines of blues coming toward them. "It appears Sathedra has sent her blue orbs down to fight us back," Old Scratch said. "Yves, I think you'd better tell your Greens to protect us from her Blues."

Yves called the Green leader over and explained that Scratch, Gourdhead and himself were required to get into the castle. The leader understood. It called the orbs together and instructed them on their duties. One by one, Yves' orbs shot out and floated beside a Blue, then exploded, knocking Sathedra's sphere to the ground. There was nothing the Blues could do. They were directed to help the Greens defend the Dark Road, not attack them. On the Blues marched, unaware of their impending demise. Yves, Gourdhead and Scratch surprised by the first blast, caught sight of a ditch, scrambled in, and as the Greens moved against the Blues, the three poked their heads up just high enough to peek at the battle.

Boom…boom! Each blast made the three jump. The racket echoed across the landscape as each Green shot down its Blue. The trio ducked their heads behind the revetment to avoid the flying wax.

The blasts rattled Gourdhead's sticks and made it difficult for Yves to breathe. Old Scratch buried his head under Yves' arm to keep his crystal eardrums from shattering. Yves kept his fingers in his ears, too. The air was full of dust and the smell of burned wax. This continued, blast after blast until each and every Blue was obliterated. In sum now were piles of blue shards mixed with melted green wax.

Yves counted eleven Greens remaining after the carnage. Their leader hurried back to Yves and dipped once.

"Thank you," Yves said, shaking the dirt and wax from his clothes. Scratch and Gourdhead remained unmoving, awed by the sight on the battlefield.

They persisted on toward the awful-smelling swamp that surrounded Sathedra's castle. The surviving Greens

followed right behind, ever ready for action. When they got to the water's edge, the three discovered that the swamp and the candle castle was encircled by a third stone wall. Without difficulty they clamored over this partition, landing on hard sand. The Greens followed.

Bubbling vapors rose sickeningly from the quagmire in front of them. Yves become aware of wakes from mordant animals that challenged taxonomy, swimming under the bitter surface. Dead trees with drooped limbs touched the water. Limp moss dangled and moved with the slightest breeze. A green-slimy growth covered the entire surface with white chine of unknown creatures poking up. It was thick with rubbish. Dead things mixed in the indigestible turmoil. Those animals were unlucky.

On the shore and in front of our three were six logs. This perplexed Yves and Old Scratch. They turned to Gourdhead and gauged him. He was standing there looking back at them.

"What?" Gourdhead said, taking a defensive stance. "You think I had something to do with these logs?"

Old Scratch shared a side glance with Yves and together they cried out, "Yes!" Gourdhead's first reaction was to deny everything. He stomped around, kicking at bones and dirt. A few minutes after, standing alone under a tree, he thought he'd better come clean.

"Gourdhead, you'll have to admit," Old Scratch said, "that your activities have been suspicious. I mean, let's be honest, back at the sweet pond, you came back all mussed up like you were hiding something."

"Yeah, Gourdhead," Yves said. "I think Scratch is right."

"Well, you're both right," Gourdhead said, embarrassed,

dropping to his clacky knees, hoping for redemption. "I've been working for both King Solanum and Sathedra. Sathedra wants that book and Solanum wanted my help to defeat her. The two of them are getting ready for a finale. You both have noticed the build-up of storms...well...King Solanum has been waiting for us to douse her candles. That's the signal. He said with his new power and the spells in the book, we could, with a final exertion, defeat Sathedra and release the people of Sath. That's why the logs are here. The king promised that he would help any way he could."

"You've been in cahoots with both of them?" Yves asked incredulously, staring hard at Gourdhead. With the book in one hand and pointing with the other, Yves continued, "Isn't that...dangerous?"

"What if you were found out?" Yves asked.

Yves and Old Scratch frowned hard at Gourdhead, They wanted to hear the words the stickman, this quisling, offered to say. Yves briefly thought of flinging him into the nasty water. Old Scratch wanted to let the termites have him.

"They both think I'm too simple-minded. I've been fooling them for years. When I am working for Solanum, I'm away on holiday from Sathedra. Visa versa with Sathedra. They have never been the wiser. Yves, you remember the night before we met Say Kage?" Yves nodded.

"That night I spoke to both of them. Solanum wanted me to get you and Yves to Sathedra's castle to help with her downfall. Sathedra thinks I'm bringing her the book. As it happens, I'm more on King Solanum's side."

"That does explain lots of things," Yves said, circling Gourdhead. "I believe you Gourdhead. Scratch, I think

you should, too."

"I have to agree with you," Scratch relented, stepping in front of Gourdhead. "He has given us a lot of help. Mind you, Gourdhead, no more foolin' us. Do you catch my drift?" Old Scratch stared right into Gourdhead's face, not blinking.

"Yes, I...I understand. I do apologize to you both." At this point Gourdhead stood, rattling over to the logs. "It was good of the king to supply these, was it not?" he said, quickly changing the subject. Each agreed.

Yves then ordered, "Now Scratch, you get those logs down to the water's edge and set them out in pairs." Old Scratch did as Yves told him. He took more yarn out from his toy-pocket and rolled the logs out so they were in line two-by-two.

"Each of you take some of that yarn and tie your feet to the logs. Tie them tight because you don't want to slip off. They will act like pontoons. Try to keep your eyes shut; we don't want to get the harsh vapors in our eyes." A few minutes later Yves asked, "All tied on?" Then Yves said, checking. "All tied together?...Let's go." Yves foot-dragged his logs down to the swamp's edge, pinching his nose shut with one hand and holding the book in the other so he would not have to smell the acerbic air.

Yves was first to float out into the foul water. The destructive liquid bubbled. They would have to hurry or they might fall in the morass as the wood was eaten away. He walked along its surface like a water-skier, pulling the other two across the caustic water like a tug hauling barges.

They were a third of the way across when Yves heard a yelp, then a splash. He turned to see Scratch struggling to climb out of the dross and get back up on his logs.

"Are you all right? Do you need some help?" Yves shouted to his friend. Yves was trying to turn his logs around to help when Scratch made a spluttering sound.

"Look, just come here and give me a hand up on these crazy logs. Remember, I'm made of crystal, the acid can't hurt me."

"I'm glad of that," Yves said with relief, moving back toward Scratch. "I have to remember you are impervious to many things that would hurt Gourdhead and me."

"Yeah, please ask before you go and make us do something silly like this," Old Scratch said sourly, bobbing in the toxic stew. Thinking better of it, Scratch said, "I think I'll swim the rest of the way."

Gourdhead and Yves continued on through the swampy gloom while Scratch paddled his way ahead. Sathedra's castle loomed to the front of them with candles burning brightly. Somehow they had to blow out those candles. Yves saw his Greens floating across above the quagmire. Old Scratch and the Greens were waiting for them on the far side.

Shortly, Yves and Gourdhead arrived at the opposite shore. They untied, then jumped off of their logs and onto the dry land with ears perked, listening to the distant rumblings that were answered by thunder over Sathedra's castle. Right over their heads!

"Sounds like Solanum is ready for his attack," Gourdhead said as the Greens surrounded Yves, Gourdhead and Scratch.

"It appears Sathedra is too," Old Scratch said, staring, pointing at the thick, black clouds.

"Let's find something in the book that will help extinguish those flames," Gourdhead said.

Yves sat down in the shadow of a tall unlit candle. At least it was dark and he would not be seen—just light enough to read. Scratch and Gourdhead joined him. He opened the book and flipped to the heading, "Spells."

"Let's see, spells for skies, no...spells for changing, no...spells for...here's one!" Yves cried out. "Spells to banish fire!" Yves read the chant aloud. "Devils, devils never tire. Bring your power from the mire. Rid this place of the fearful fire."

Wind began to stir. The stinky swamp started rippling and boiling. A stinking wind swept from the fen, huffing and puffing toward the castle. One by one, the candles were snuffed. Suddenly it was noticeably darker, the winds stilled. They heard the guards making every kind of racket trying to relight the candles, but when they did, the wind blew and again the flames were blustered out.

Yves knew he must protect the book so he told Gourdhead and Scratch to dig a hole. They did and Yves placed the book in and covered it with dirt. He would be back for it if the whole thing went well.

Fourteen

From far below, Sathedra heard the winds gust at her castle. She immediately made haste from her chamber. Out on a rampart she witnessed the winds blowing out each candle, one by one.

"Guards, relight those candles!" Sathedra commanded. Her voice was on remarkably loud.

The guards were already rushing around this way and that, frantically attempting to ignite the wicks. But they were not having any luck. Each time they tried, more wind whooshed from the swampy trench snuffing out the flames. It was as if another force was at work. She couldn't feel any new power. But there was one. Sathedra couldn't understand what was happening. *Solanum's winds are nowhere near my castle. How could his power affect my castle at such a distance?* She screamed in her mind, *Where are those winds coming from!*

Then she looked down at her Blues; they were destroyed. She saw their smoldering remains and felt a sickening wrench in her belly and her insides felt like a sack of goop. Sathedra held her squishy gut and sank down behind the balustrade. She curled into a tight ball, holding her knees and into the creeping darkness, seeing just one foe, she shrieked aloud, "My poor Blues, my poor Greens, what happened?" *It has to be King Solanum,* she shouted in her mind. But she couldn't feel him advancing.

Had she not paid enough concern to the happenings around her? The battle between the Blues and Greens was

won by the Greens. Sathedra commanded the Blues to go and help the Greens but she did not know that the Greens would attack. Her Blues had been defenseless. Events were changing and she couldn't do anything to transform it back to the way it was. She could feel her power falling away; an inured heart of rage was on the rise. *I must do something, and soon,* her mind screeched. Her guards were carrying on. They were innocent of leadership and her candle castle remained unlit.

Up in Lilium, Sathedra's opposite waited patiently, carefully going over his work. He verified and confirmed the order of his spells. The sequence must be correct, or he might not destroy Sathedra or her power candle. He'd been awake since he first met this Yves. The only rest the king grabbed were short naps, where his mind simply gave in, clouded over or just became useless.

When his eye lids drooped and his head rested in the spine of a book or in a pile of papers, then and there Stem would shake him as ordered.

It was midmorning. Solanum had expected something to happen. He rose from his workbench and stepped out on the terrace. Stem remained on the lookout for the signal, and the esteemed Stem would have called the king instantly if he set eyes on anything. Outside, the storm clouds impatiently waited for commands that would either send them to their doom or victory.

"Anything yet?" the king asked, restraining back a yawn.

"Nothing, sir," Stem quickly answered. "And I, too, was expecting it by now."

"As was I," King Solanum returned. The king stretched long and hard. "Keep a careful eye out; in any event I'm

going to connect with the land and monitor the messages."

"You will know the instant it happens," Stem promised his king.

The king returned inside and placed himself into the ground, sending his roots farther down. He felt the tinkling of unrest. There was concern as regards the surge of war clouds. The work in the hidden city was going as planned. New houses for the growing saplings neared completion and the plans for draining the Deadly Lilipond would be put on hold until after this final attempt to secure the Land of Sath.

His people needed more sunlight; after all, it was how they lived and grew. Sunshine was their source of nourishment. But for a bit longer, the fog must remain.

Insects kept battling it out in Appellation City, Solanum sensed, and bugs were still eating away at Caylyx City. *Can't—sleep.* The king's mind slipped again. He remained rooted, waiting

Awaken!—his mind forced his eyes open to hear the tranquility of his studio. Stem hadn't seen his pause. But that break was just enough to give him the strength to continue. He listened to the land.

He hoped that by now, the three travelers were finding their way to the swamp and correctly using the logs. Solanum searched for tell-tale evidence of their movements. In his rooted trance he heard messages of persons doing strange things. But there'd been no sign of anything unusual happening along the Dark Road. Were the three ensnared in one of the traps?

A tendril made known a meaning. A lion playing with a ball of yarn. *Who knows what that means. Wait, it could have been a diversion. Yes, there are explosions coming from the Dark*

Road. The king hoped this was the sign, that the three arrived. There were other telling clues. *Sathedra's Blues are dead…and…*

"Sire! The signal!" Stem shouted. "It is happening!"

King Solanum uprooted and dashed to the terrace. Yes, the light from Sathedra's castle now dimmed; the candles were going out, one by one. *Then the three did get through with the spells.* He hoped all was going well.

The king momentarily rested at the railing, considering his actions, his future thinking. *Will my next action beyond doubt be beneficial to the land of Sath? I often questioned my right to fight back. But there is unhappiness in the land and it is caused by Sathedra. The people are being used by Sathedra for her sole benefit. She cannot leave her castle and feel the hurting. She rules, but she is not a good ruler.* Many times King Solanum would go through the same argument and come to the same conclusion. *Sathedra must be destroyed and her domination must come to an end. Yes. It is time. In that I am sure.*

Solanum stretched tall with arms extended and his eyes shut. Stem stepped back giving his monarch room. Stem thought now was not a good time to be in the middle of things. His clouds suddenly darkened and a blinding lightning bolt hit Solanum in his chest. He shuddered, held his ground and absorbed the energy. He fed off the powerful electric charge. Solanum's hands began glowing with St. Elmo's fire and he could taste the ozone in the air. Solanum hurled a bolt back into the clouds. Another bolt crashed to the ground far below, followed by another and another. The thunder was deafening.

As the lightning forked up, it formed the semblance of a supernatural being. Dark clouds filled in making the manifestation solid. A golem body emerged. Stout legs reached

for the ground and arms with fists took shape. Bolts of lightning held this new humanoid creature together then fire danced off, away from its knuckles. Its eyes, ball lightning. Each time the bolts touched the ground—micro-golems made of mud, dirt and tree parts, fashioned, then began asking for instructions.

King Solanum waved his arms above his head, then pointed toward the Castle of Sathedra. His cloud-golem advanced steadily away from Lilium, dragging the homunculi with it, making their way to the despoliation grounds.

Yves and his army sat at the steep base of Sathedra's castle. They heard the rumble coming from Lilium. They witnessed Solanum's transmundane making headway. The cloud-man golem moved with a new willfulness that spoke of unseen power and control.

There was a bet on. Which one of Sathedra's guards would first see movement from Lilium? Every eye was gazing at the distant horizon.

"There, I see it moving!" one guard shouted, losing his hat as he pushed other guards aside to report the news to Sathedra. But the sorceress could already hear the guard's shouting above the rolling thunder.

And now Solanum's storm was on the march. She hated holding her clouds back; it was leeching her energy. From her foetal position Sathedra stood again, coming out of her concealment, feeling taller than before. She carried her soaring presence from the rampart back to her chamber, letting the guard make the announcement.

The guard sprinted down the hallway and came too close to Sathedra, well-nigh smacking into her as she stood

waiting in the doorway.

"Yes, yes I heard, now get out of the way!" Sathedra's voice exploded. The hatless guard, clearly shaken, backed off letting her pass. She rushed to her high tower, flying up the stairs two at a time, then dashed onto the balcony. Yes, his storms were on the march. They were miles away, but her storms needed to meet his, far from her castle. Her darkened candles had to wait.

She crossed her arms and put down her eyelids. Sathedra's thoughts pressed her assault on his attack. Her clouds began slowly at first, then pressed on faster. They walked on lightning legs, out to meet his clouds. The two dark storms stalked across the landscape until they met over the upper Sathedra Sea.

King Solanum remained at his railing, pushing his forces onward. Sathedra was in her tower, willing her defenses to shove Solanum's clouds back.

"But wait. His clouds were more than clouds. What has he done?" she hissed. "What are those things?"

Solanum's golems plodded over the landscape, like walking tornados, sucking up all manner of things. More minor golems rose up to push into her territory. His beast stepped into the sea sucking up water, gaining more firmness of body as it filled out its shape.

When his golems and her storms met there was a crackling of strikes at her clouds' front edges. Solanum's beasts sidestepped allowing her clouds to pass by. But then Sathedra's clouds surrounded his giant. The sky gave off a fierce glow as lightning danced to the water below creating water daemons. Those miniature beings pushed on through the water toward her fortress. His daemon

thrashed its arms around dissipating her war clouds until they were mere wisps of what they were. With gained strength, the mega-golem marched on to Sathedra's castle.

Sathedra's Seas were whipped into a froth, with rolling waves crashing onto far shores. Populace living near the coasts fled for their lives.

Sathedra was dismayed that there was more power in his evilness than she'd expected.

Solanum grinned. He knew what the outcome would be. All he needed to do was get his colossal over her castle and Sathedra would be history.

With Say's book safely buried, Yves took a quick look at the moving clouds and said, "Let's go, that's our diversion. We've got to get in now while Solanum keeps her busy."

A sheer wax cliff stood in their way. They had just started climbing when three Greens flew over to our climbers and nestled into their midriffs. Their wax lamina felt warm to the touch.

"I think they want us to ride on them!" Yves said with surprise. Yves spread across the orb, riding it on his stomach. Scratch and Gourdhead aped his action and the three were lifted quickly and steady to the main gate of the castle. When they reached the big wax doors, they jumped off the carrier Greens and thanked them. The other Greens came into sight moments later. All were poised to enter the castle and get the job done, but the doors were shut tight. Yves rushed against the twin doors and bounced back on his rear.

"Yee-ouch!" Yves cried as he rubbed his shoulder.

Old Scratch saw the futility in ramming the doors. "I think we should find a large pole and try to lever it open,"

Scratch suggested.

"Well, it might work," Gourdhead said. "It's better than hurting ourselves."

They poked around in the bushes surrounding the castle until Old Scratch uncovered a straight tree limb. They brought it to the main entrance and set it on the ground.

"Now we need to sharpen the end, you know, make it fit," Yves said. And with that, Old Scratch began whittling away at the end with his crystal claws until it held a sharp point. When he was done, he smiled and said, "Let's go."

Scratch, Gourdhead and Yves lifted and clutched the heavy pole and shoved the point into the crack between the doors. As they pried, it found purchase and the two doors edged apart until the gap was wide enough for them to pass.

While the guards were busy trying to relight the candles, our intruders slipped in the front door with no trouble. The blasting gusts ultimately blew each and every flame out, making it impossible for the guards to relight the candles. The guards were stumped; they didn't know what to do. They heard confusing orders. Many guards shouted questions that received no answers. They had no leader. Sathedra was kept busy holding Solanum's new phantasm away from her castle.

From inside the castle the three saw the lightning flashes and heard the thunder.

"There must be one heckuva storm outside," Yves shouted to his comrades. The castle shuddered from the rumblings.

Yves instructed each of them where they would find their goal, "Gourdhead, you have to probe deep in the

center of the castle," Yves began. "There is a power candle and it is protected by the unnatural. Take these Greens and do whatever you must to put out that flame, then come back to this spot and wait for us." Yves pointed to the floor.

"I'll do my best," Gourdhead promised.

"That's all we can ask." Yves patted him on his thin stick back. Gourdhead left then turned down a corridor with the spheres following directly behind.

"Scratch," Yves said, "you need to locate the wishing chamber, then return here...and wait."

"Sure thing, but what are you going to do?"

"I'm going to find the sleeping chamber and get those keys. It's in the center, protected by the castle."

Old Scratch took off down one hall and Yves down another. Darkening clouds obscured the invasion.

Sathedra, in her lofty tower, stood in the gusting winds watching his advancing cloud contrivance. She was alone. Her guards were below, reacting in a panic. She'd gained her strength back by remembering for what she stood. *I am the leader of Sath. I've worked long and hard for this position and I'm not going to let anyone take it from me*, she resolved. Her confidence helped to push more salvos forward.

"Back! I tell you, go back!" Sathedra was using her far-reaching power to keep Solanum's leviathan at bay. But his enormous cloud brute made its way toward her, measure for measure. The winds whipped Sathedra's hair, flailing it.

His gargantuan grew more dangerous by the minute. She saw her storms ripped apart by his golems. Below, smaller stick and mud figures wrestled with her guards, tearing them apart—scattering living limbs—arms and legs

left behind as the diminutive ferocious figures fought—chomping their way forward.

Her free cape undulated in the waves of wind gusts. She had no time to regroup and learn new spells. She was failing. "This can't be happening!" she wailed into the wind.

"Onward, my golemness. Dig out the power of Sathedra," the king of Lilium commanded. Solanum knew his power was overtaking Sathedra's. "Push...onwards!" From his stick fingers, King Solanum sent bolts of energy out across the sea and into his monster. His goliath gained more power and height. The sea was very dark far below, but details of the land were lit by the flash lightning. Flash...flash...crash...boom was seen and heard across the Land of Sath.

Yves was the first to locate his goal. The chamber was a large translucent bubble of wax. Through the polished membrane he identified Sathedra's wax bed with candles surrounding it and the row of empty hangers for the keys. There was no obvious entrance so Yves began probing it. The warmth of his skin softened the wax wherever he touched. He held his palm against the wax. It slowly allowed his fingers to pass through. When he pressed his body, he felt the wax give, then the wall softened and allowed him inside.

The membrane melted shut behind him, giving no sign of an entrance. The deep din of battle was silenced inside the large wax orb. He heard no sound except his breathing and his own footsteps.

Remembering that he wouldn't have much time before he was forced into sleep, he advanced over to the rack and

felt for the keys. He knew they were there, but he could not see them. Blindly he picked them off the hangers one by one, then put them in his pants pocket. Just as he finished gathering the keys, he grew drowsy. He staggered toward the membrane and when he got to it, he lunged and fell through. The storm noises returned just as Yves crumpled to the hard, wax corridor floor. His mind reeled and he couldn't stand up.

Scratch made his way to the wishing chamber and was heading back to the meeting place. He trotted down one of the wax hallways when a movement caught his eye. It was Yves sitting on the floor in a daze. Scratch quickened over to him and helped him to his feet.

"You all right?" Old Scratch shouted above the thunderous rumbles outside the castle. "You look dreadful."

"Just groggy...I'm...okay," Yves groaned in a sleepy voice. "What's that awful reverberation?"

"Sounds like the mêlée outside is getting worse," Old Scratch said. "I think the king and Sathedra are really going at it." Scratch helped Yves get back to the meeting place.

Deep in another part of the castle, Gourdhead stumbled upon the candle that gave Sathedra all her power. It was easy to find because it was the single candle burning, no matter what, and it emitted a blaze as radiant as a bonfire.

Gourdhead stopped just before rounding the last corner to the power chamber. He peeked around and then backed away. "A Red...why a Red!" Gourdhead moaned.

Because of an invisible force field and that Red, Gourdhead could not, in any way, get near the huge candle. The field was there to keep the wind from getting to it and the Red was there to keep anyone like Gourdhead away, too. *What to do*, Gourdhead thought. The Greens behind him

started making a high harmonious sounds similar to a choir. It sounded as if they wanted to help.

"All right then, you can," Gourdhead said. "Get in there and destroy that Red!"

Gourdhead was astonished by what he saw. One at a time the green orbs rounded the corner and after doing so, each one burst right beside the Red. The Red fired its bolts at the Greens, but after the first impact, the Red lost its stability and aim. The Greens picked off the Red with vigor, with élan. The Red now was bouncing and spinning off the interior walls. As it passed a Green, the Green expended itself and the Red was gouged even more. Gourdhead counted ten detonations. Now there was simply the "whoosh" of the damaged, spinning Red.

One more Green. That's all Gourdhead controlled. His eyes fixed on it sadly and said, "Guess you're it." The head Green paused for a moment, dipped once, then rounded the corner. Gourdhead waited. It seemed like it took forever, but with no turning back, a massive fulmination rocked the chamber and a great wind pushed Gourdhead, tumbling him up two flights of stairs. He lay there in the flecks and brume of burned wax. The vapors stung his eyes and he hacked smoke and waxy ash.

Gourdhead got back to his feet and stepped slowly down to the chamber. There was stillness. He carefully peered around the corner and stared in awe of the Greens relentless effort. There were bits of Greens covering the walls and many pieces piled around on the floor. It looked the remains of an egg chamber, when all the young had flown away. The Red sat lifeless in a corner. It was smoking and sizzling beside the intensely blazing power candle. The protective shield held firm. Yet, he needed to get that

candle out. Then he remembered the chant Yves used to put out those other blazes. He spoke the words: "Devils, Devils never tire, Bring your power from the mire, Rid this place of the fearful fire." His voice rose in volume with each word.

Again the wind gusted strong and hard. But it could not get through the unseen shield where the flame bloomed. Gourdhead could hardly stand because the wind blew beyond brutal. He chanted the verse again and the wind blew harder. Then a ghostly form appeared in the wind and started beating at the force shield. Slowly but surely the field began to bend under the pressures of the wind. It was like pushing on a balloon.

To make sure the candle was completely blown out, Gourdhead chanted once more; another apparition appeared and pushed on the invisible shield. The force field was buckling. Any minute, it would pop. Now he felt confident the job would be done. Gourdhead put his head against one wall and silently thanked the Greens for their sacrifice.

Gourdhead left the wind and the soundless Greens behind and made his way back to the wax stairs and the main door. He saw Scratch and Yves standing, waiting for him.

"Did you find the candle and put it out?" Yves asked anxiously. "We heard explosions. Was that you?"

"I think the flame should be out very soon. I put the forces of the spell on it." Gourdhead recounted to his friend the price the Greens paid and they hung their heads. The fierce winds howled outside the castle, making it hard to hear.

"We will always remember them!" Yves shouted.

"Sure will. They are what legends are made of," Gourd-

head hollered.

"I found...the wishing chamber!" Scratch yelled.

Yves shouted into the roaring winds, "Good. But we'd better wait until the power of Sathedra is broken before we go there!" He was hoping and praying that her power would end soon.

The wind could be heard everywhere and the guards were running around in a state of panic. Many of them were fleeing the castle, while others huddled together in self-defense.

The trio stood at a window and felt the ravage. They were astounded. Several small clacking golems snaked their way toward them as the huge beast twisted its way forward through her weakening storms. Never had Yves seen such a battle. The growling gargantuan stepped right up to Sathedra's castle, tearing trees and shrubs from the surrounding grounds. Yves recognized what would take place next.

"Get to the center of the castle!" Yves screamed. The three dropped to the wax floor and crawled beneath the slamming, wailing wind gusts. As they made their way through the corridors, the castle shuddered and shook. Yves became aware of a small closet and told Old Scratch and Gourdhead to stuffed themselves in and Yves followed right behind, then he shut the door. The sounds were deafening even in their enclosure.

"Oh, no...no...no," Sathedra cried as the creature loomed over her head. Her hair stood straight skyward, sucked by the beast's breath. Then the brute reached down and lifted her from the tower, drawing her heavenward and flung her, like a ghost, far out into the Sea of Sath.

"Hang on!" Yves yelled. "It sounds like it's coming down on us again!" The trio hugged together as hard as they could. The giant drilled its fist into the candle castle and wrenched the power candle out and threw it into the distressed sky, following Sathedra into the water, creating a tremendous wallop and hiss that formed a gigantic tidal wave that swept onto the near and far shores, causing widespread ruination.

The monster and its minions stopped. It was waiting for more directives from Solanum. Only a comment: "You have done well." With that, the ghostly golems began to dematerialize and rain down on the land.

"You did it!" Stem exclaimed. "You did it!"

"No," we did it," the king calmly corrected Stem. "It took the efforts of Yves, Scratch and especially Gourdhead. He kept us clued in. Hope they're all right."

Without being asked, Stem pushed the chair behind his ruler and King Solanum sat down in it gratefully. Solanum was steaming as he sat and he shook his head as if in a daze. He rested his hands on the railing.

"What is to happen now?" the king asked of his aide. "Stem?" Stem had slipped away, going to the communication room, where he heard messages from across Sath. Words of thanks, of hope, of devastation.

The king sat with concern watching his creature dissipate. The once monstrous was now folding in on itself. He knew the job was done, tidy; successfully, gloriously. Although the landscape in front of him was ravaged by winds, rain and lightning fires, he sighed happily, gratified with his great achievement. Smoke traced into the clouded sky. He hoped no one was hurt, but feared that was not possible.

Fifteen

Tabula rasa, a clean slate. When the winds calmed down, Scratch, Yves and Gourdhead emerged from their safe closet. The castle was barely hanging together and there was a gaping hole leading down to where the power candle had been. Yves climbed some stairs then walked around a rampart and peered down. It gave the aspect of a huge wax jaw where a tooth had been rived. "Ouch, bet that hurt," Yves mumbled to himself, rubbing the side of his face.

Scratch and Gourdhead joined him. They, too, were awed. Then the three made their way down another shattered stairway and across a buckled roof. When they hopped down to the main level, four guards, out of desperation or more to the truth, obligation, who hadn't run away, dashed over to the trio, wondering if they should be taken into custody. "Halt...I think," one guard called.

"Let's not try anything like that," Scratch said back to the guards.

"But...it must have been you that destroyed the castle," one guard said, his uniform still wet. "Sathedra isn't going to like this." He made a gesture including the whole castle and its grounds.

"I don't think Sathedra is around any more," Yves said. "Now why don't you put those spears down."

The guards with hair hanging from under their hats, considered the request, shrugged their shoulders and turned to leave.

"Wait! Old Scratch called. "Will you do something for

me?"

The guards spoke back. "Why should we do aught for you? You destroyed her castle."

"Because someone has to take charge," Old Scratch said, "and it looks like none of you are doing it."

The guards considered the offer. "All right, take charge."

This surprised even Scratch. But he accepted the challenge and ordered the four to gather the other guards together and begin rounding up survivors, then find the victims and bury the remains in a mass grave. The guards grimaced at the thought, but headed off anyway to assemble the scattered sentries. The surroundings started to take on an air of death.

"You know that you just put them in control of the others," Yves stated.

"Sure, I know it," Old Scratch said. "At least they exhibited some loyalty to Sathedra, even if it was misplaced. Now we'll see if they can be loyal to me. Who better to have in charge of the troops?"

"Anything I can do for you?" Gourdhead asked.

"Just hang around for now," Old Scratch said. "I'm sure there will be lots for you to do."

"How about me?" Yves asked.

"Yes, Yves, you too." Old Scratch said. "But right now we need to find her before she does any more harm. Scratch's eyes investigated the beach. Let's ask those guards over there if they know where Sathedra might be." Old Scratch, Yves and Gourdhead made for the two sentries. "Have you seen Sathedra?"

In unison the guards pointed toward the water. One said, "That way, way out in the water." The other said,

"Somewhere in the middle."

"I want to go down and search the beach," Old Scratch stated, regarding Yves and Gourdhead.

Our three and the two guards left to search for the sorceress. They circled around much of the destruction and stopped at the shoreline. They waited and scrutinized, but spotted nothing in the choppy waters.

For an hour far out in the sea, Sathedra carried on swimming toward the shore. After that time, her flesh started to crumble. Her integument melted away from the muscle until it was no longer there. Then her muscles flaked apart, putting on view, in an instant, the bleached bones of the once-omnipotent sorceress. By the time she'd reached the shore, she was but a petite white skeleton, just a whittle of her former self. Her lot was cast; she was reduced to her original state.

Sathedra dragged herself onto the dry land some distance from the castle. She gawked at her skeletal hand and despaired. She touched her chest—bony fingers clanked between her exposed white ribs. Townsfolk surrounded the ex-sorceress and firmly escorted her along the strand toward the crowds.

Scratch, Yves and Gourdhead were ready to quit the search when the guards saw the townspeople. "Look, they have something." As the two groups converged it was apparent that this something was a walking white skeleton.

"We caught this...this...not quite a thing," a man in a green coat said, choking back a gag, "crawling its way onto the beach after the battle. We think it's Sathedra. Where do you want her?"

"Are you Sathedra?" Old Scratch asked, shocked at the

skeleton's manifestation. He received no reply.

"Answer us!" Yves demanded.

"Yes, I'm Sathedra," the skeleton answered. Her skull hung low in defeat.

"We'll take her." Old Scratch said, then thanked the escort.

The two guards walked ahead, prodding Sathedra along. Scratch, Yves and Gourdhead followed behind.

"What will we do with her?" Yves asked.

"I think we can keep her in the castle until we figure out her fate," Scratch replied.

Sathedra's guards, back at the castle, now reverted to the children they once were. And her candle castle slipped back to the previous form it was some time earlier, into Crag's Mineral Palace. The palace was a glitter of large gemstones that stood on end, making the walls rise majestically. The palace was completely faceted and reflected an image of the landscape from all directions.

The escort and Sathedra pressed forward to the middle of the Dark Road that had changed back into the Mineral Gardens. Every pitfall and trap on the road disappeared. The guards following Sathedra changed into two Curiosa children, they cheered and began to dance.

"Hold on there you two," Scratch ordered. "You can play after we get Sathedra safely tucked away." The children calmed down and continued guarding the skeleton. Scratch saw that the ones put in charge had changed, too. Scratch then asked the townsfolk to clean up and bury the mutilated remains before they putrefied.

Sunlight refracted through the minerals and beamed vibrant shafts into the relaxed sky like search lights. Most of the colored gemstones were faceted, but many were uncut,

smooth and piled haphazardly. Yves wandered over and touched a smooth facet on a waist-high, honey-colored citrine. It felt cool to the finger.

"It appears the garden isn't finished yet," Yves said looking at the stones.

"It probably never will be and that's the joy of it. But would you look at that, looks just like home." Old Scratch sighed. "Such power she held over the land!" Old Scratch stood there beaming, then they took Sathedra into the palace, cleared out a room and silently, without ceremony, locked her securely away.

Those in other lands knew what had happened because all that was done for them just stopped. The colored skies, the wind through the Athenaeum and the cool winds in Curdland ceased. Old Scratch, Yves and Gourdhead were amazed at what they had accomplished. The children were carrying on playfully—the air was warm as in the spring. It was such a pleasant place now. Yves was not thinking of departure, that is, until he remembered the keys. He found them in his pocket. They'd turned into crystal keys with name tags.

"This key must fit the door to the wishing chamber," Yves said, hopefully holding the key in front of him. "If there still is a wishing chamber."

They set off back to the wishing chamber area, found it marked by these words over the door: "Through these doors only the kind and light hearted may pass. The wicked will perish. Once inside, the world is yours."

Yves hesitated. Then looked at Gourdhead and Old Scratch. "Do you think it is wise for me to leave right now?" Yves asked. "You know, I might be of some help. The land has been ravaged and the people need all the help

they can get."

"It's your choice," Old Scratch said, "but we sure could use your expertise."

"That's it then, I'll soldier on a while until life comes back to normal." Apparently he wanted to go via the doors right then, but he felt a job must be done before he left.

Over the course of several days, Yves set out discovering Sathedra's former home and the glories of Mineral Land. He hiked among the colored stones, exclaiming over the actual size of this new area. It extended down through the Mineral Gardens, formally the Dark Road, and out for a mile in front of the first gate the Greens had destroyed. Yves reported back, then decided Scratch should officially take charge.

Then Yves remembered Say's book. He hunted around where he thought it must be buried and started digging in the dirt. In awhile he uncovered it, brushed it off and gave Scratch the book. In searching the Mineral Palace, Yves also came across other books stole away. They were tucked behind a panel. When Yves touched an imperial topaz knob, a panel slid open with the screech of glass rubbing on glass. Four large leather-bound books tumbled out and landed at his feet. He peeked deeper inside the cavity and saw piles of papers, more books and numerous crystal boxes. The boxes were labeled: "Souls of My Guards," but one was marked: "The Stickman's Soul." They held the souls of her workers. Yves opened the containers, except Gourdhead's, and thin strings of spirits floated up and out a window, on their way to find their owners. Then he put Gourdhead's soul-box in his pocket.

Yves took the books to Scratch and asked him where Gourdhead might be. "He's down in the gardens," Scratch

said. "Why?"

"I have something here." Yves pulled the crystal box out of his pocket and showed it to Scratch. "I really think he wants this," Yves said. "It's his soul."

Old Scratch discerned the importance of the box and said, "Come on, let's find him."

Gourdhead was down in the gardens, poking here and there. He had had the urge to do something, so he began pushing boulder-size gems around and placing them in order of their size, color and clarity. He didn't know why, he just did.

"Gourdhead!" Old Scratch shouted.

Yves was searching in other parts of the garden for Gourdhead when he heard Scratch calling. Then he came hurrying back to Old Scratch.

"Hey, Gourdhead!" Scratch called again.

"Yes?" Gourdhead answered thoughtfully, popping up from behind a row of stones.

"There you are," Old Scratch said. "Gourdhead...Yves has something here that you have been looking for."

"I don't think I've been looking for anything. Except... maybe my purpose."

Yves pulled the box out of his pocket and presented it to Gourdhead.

"Just a box?" Gourdhead eyed Yves. "What's in it?"

"Your soul!" Old Scratch said excitedly. "Open it...open it."

"Now, wait!" Gourdhead said, holding the box at arms length. "This can't be. I already have a soul. You can't have two souls. Or maybe...I haven't had a soul...," Gourdhead paused, "...since I started working for Sathedra." He examined the crystal box in detail. His description was

marked on the cover. He looked at Yves, "And you say my soul is in here?"

"I think so. When I opened other boxes marked "Guards," many spirits materialized and flew away," Yves said. "Go ahead, open it."

Scratch and Yves stood back as Gourdhead slowly opened the box and peeked inside. He saw a misty form floating in there and when he opened the box completely, the nebulous form flew out and made three turns around Gourdhead, making his eyes spin around. On the fourth circle, the nebula struck him in his stick chest. Gourdhead took a sudden deep breath.

Gourdhead stood there, wondering what had happened. The soul entered him and he felt as if he'd been reunited with a lost friend. A warmth reached deep, pulling out old feelings, old memories. His past became clear, his future more certain.

Scratch and Yves witnessed his soul enter and from the look on Gourdhead's face, they saw a calmness wash over him. It was like the sudden realization of one's purpose. Gourdhead breathed deeply, his eyes went wide, then his stick body changed from twig-like to robust oak strength. He appeared to expand a tiny bit in all directions, making him look and feel bigger. His expression and demeanor soften and his manner became more elegant. Yves and Old Scratch decided right then that Gourdhead should be in charge of the gem gardens.

"Oh...this is wonderful," Gourdhead said as he gazed down on Scratch and Yves. "I have lived without my soul and purpose for far too long."

A day after Gourdhead absorbed his soul, Yves suggested something to Scratch. He was surprised that Scratch

hadn't thought of it sooner.

"Scratch," Yves said, "I think it would be good if you traveled around your land to see the damage for yourself."

"That's a good idea. I could get firsthand information and lend a hand to those who need it. I need to see Gourdhead before I go, though. Could you get him for me? He's probably in the Mineral Gardens getting a staff organized."

"Sure thing, Scratch," Yves said brightly. "I'll be back in a bit."

Yves left the palace and headed straight for the gardens. Gourdhead sat in the middle of a group of workers. From the back it looked as if Gourdhead was giving instructions and the listeners were on the alert, taking notes. Yves, in silence, came up behind them and a member of the group indicated to Gourdhead that someone wanted to see him. Gourdhead turned to see Yves. "Sorry Gourdhead, but Old Scratch wants to see you now," Yves said.

"All right," Gourdhead replied. Pointing to a workman, he ordered, "Catrina, take over and finish the indoctrination, would you please? I'll be back in a while."

"Yes sir," the chipper Catrina said merrily. She stood, then happily took her place in front of the group. Gourdhead and Yves made their way back to the palace.

"What does Old Scratch want?" Gourdhead asked.

"He wants to inspect the area's damage," Yves said. "I think he wants me to go with him."

"Oh," was Gourdhead's only reply.

The palace gates were no longer guarded and were left open much the time. Yves and Gourdhead marched right into Old Scratch's office.

"Chief...what's up?" Gourdhead asked.

"Gourdhead, I want you to take over in my place while we visit some of the damaged areas around Sath," Scratch told him.

"Sure. I can handle that. How long will you be gone?"

"A day," Scratch said. "We'll leave in the morning."

Gourdhead returned to his group after taking his leave of Old Scratch. Yves inquired of the trip. "Who will we see first?" Yves asked.

"I think we'd better see those with the most disruptions. That would be Queen Creamy in Curdland," Old Scratch returned.

The next day Scratch and Yves set out in a horse-drawn cart. Its two big wooden wheels creaked as the cart rolled along. The horse was light brown in color and clopped along at a slow pace. The area between the edge of the Deadly Lilipond to the former candle castle and way over into the outskirts of Milkolopolis was torn asunder by the lumbering behemoth and lightning. Whey Way was breached and the water levels of the Lower and Sathedra Seas equalized. The water flowed for several days as if a dam had burst. Torn-up trees and parts of houses coursed through the spillway.

Scratch and Yves ventured over into lesser Curdland, coming across scarred farm lands. Most cattle was scattered, but others were utterly gone. The remaining cows presented themselves thin and hungry. Farm houses and several small hamlets were ripped apart, revealing empty foundations. A few Curd people were walking around aimlessly.

"Help us," cried a small Curd woman. "We need help!"

Scratch climbed down from the cart and walked over to the woman. He tried to console her. She and her group

were tattered and dirty. They sat next to what once was their home; now it was a hole in the ground. The basement was filled with chunks of broken building and house furnishings.

"Was this your home?" Old Scratch asked kindly.

"Yes, this is our home," the lady said.

"Of course, this is your home, sorry. We will have help to you shortly. Yves and I are visiting Queen Creamy this day to offer our help. Please be patient. Your suffering will be relieved soon."

"Can't be soon enough!" shouted one of her family standing behind her.

"I'll see that this area is helped first," Old Scratch called to the family as he walked back to the cart. "We will bring wishing trees to the area. That should help."

"We need more than wishes!" the woman yelled with high volume at Old Scratch. "We need our cattle back. We need our house. We have to rebuild our community!"

"Scratch," Yves said, as they climbed back on the cart, "you know they are right. They need help now. Not tomorrow or next week."

"I know they are right. But what can I do?"

"For starters, you can get some new wishing trees in here right away, today."

"All right, I'll do that," Scratch decided. "Woman, come here please." The woman carefully and slowly walked over to the cart.

"I want you to send your best runner back to the Mineral Palace." Old Scratch scribbled something on a scrap of paper and gave it to the woman. "Have the runner give this message to Gourdhead. Gourdhead will know what to do. You will have more than wishing trees; by tonight you

will have an army to rebuild your homes!" The woman smiled gratefully and gave the note to her strongest son. Immediately, he trotted off in the direction of, what had been, Sathedra's castle.

"I advised Gourdhead to choose a hundred workers. They are to bring tools, building materials and new wishing trees."

"Thank you," the woman beamed. "You will be an impressive ruler."

The small group gave Yves and Scratch a tiny cheer. Old Scratch waved back and clucked the horse to gitty-up. The horse whickered then clopped along briskly, toward upper curdland. The storm's damage continued into Curdland, but Milkolopolis was spared. The city continued to hum. That was a good thing to see. Old Scratch was grateful for something normal. Queen Creamy only wanted to have the farms in her westernmost province returned to their usual state.

Scratch and Yves were in conference with Queen Creamy in her private meeting room. They were equals now and that made the queen nervous. There was always an uneasy feeling when power changes hands.

Queen Creamy scolded Old Scratch over the damage. "But, I'm glad you are working on the problem." She heard reports from the western area that the destruction was something like total. She hadn't visited the site, but she believed what her envoys reported.

"No fear, Queen Creamy," Old Scratch assured her. "My power will be different than Sathedra's. I won't be using forced labor. I will not spy on you with magic. Now, as I promised, we will have a hundred workers in your western areas by tonight. Your people should be back to

normal in no time."

"We are grateful for your help," the queen replied with graciousness. "Were other areas damaged?"

"Up to now, just your land was marred, but we need to visit the territory further to the over-there. That's why we must be going."

"Very well then, have a safe journey," the queen said, waving them good-bye.

Old Scratch and Yves traveled via Whey Way, finding minor damage to the landscape. Most of the battle occurred over water, and as it were, the actual land damage in this expanse was minimal. Old Scratch was happy for that. When they arrived in Curiosa, the scene offered itself the same as before; piles of bug parts heaped against the paper walls. But this time the guards let them in the gate immediately. Ann Thology came forward to meet them when she heard of their arrival.

"Such a ruckus you caused. I heard that many in Curdland are without homes. Was Milkolopolis spared?"

"Milkolopolis was spared, but much of her out-of-town is in ruin," Old Scratch said. "We are sending help right now, as you can see, my rule will be helpful and compassionate."

"That's grand of you," Ann Thology said, pleased. "We need someone to trust. How soon before we can get our wind back?"

"When I get back to the Mineral Palace I will invoke the spells. I should have the spells that will keep you dry and safe from fires as well."

"Maybe you can find a spell for these bugs," Ann Thology said hopefully.

"I will look into it. We really must be going," Old

Scratch said to Ann. "Seems like everyone needs our help."

"Well, yes then. Good-bye," Ann Thology said, a bit reluctant to see them go.

The people were so deeply appreciative of Scratch and Yves that flowers were tossed on their cart as they departed Curiosa. The brightly colored blooms were heaped so high now that Scratch couldn't see the road ahead. The fragrance of the blooms was so fresh and wonderful. The horse knew the way home; Scratch just let him have the reins.

They finished making their rounds throughout the land and returned through the Mineral Gardens in the late evening, riding in style to the Mineral Palace. Blossoms dropped off the cart as it rolled along and children happened alongside, gleaning the petals.

Scratch spotted Gourdhead busy organizing the relief efforts. "Gourdhead, did you send out the hundred to rebuild Queen Creamy's province?" Old Scratch asked.

"I questioned the runner at first, but then realized the truth when he described you and Yves. Yes, I sent the workers as soon as I got your note. Was much else damaged?" Gourdhead inquired.

"Thank goodness no," Old Scratch answered. "Have we heard from Lilium yet?"

"Yes, indeed. It appears that nothing was harmed in Solanum's land. He sends his thanks and appreciation."

"Thank you, Gourdhead, for helping. Why don't you go back to your duties in the Mineral Gardens," Old Scratch suggested. Gourdhead left and Yves stood there alone in his mind while Scratch resumed reading the book of spells.

"Do you need any help?" Yves asked hopefully.

Scratch turned to Yves, "Yes, please. I need you to pronounce some of these words. Come on, sit here and help me get through these spells. Now, how do you say this word?" Old Scratch squinted and put his nose down on the page.

"I thought I was not needed anymore," Yves said mournfully.

"Not so...not so," Old Scratch said, raising his eyes from the book. "I have plans for you."

A week after the titanic battle, messengers arrived in Mineral Land from every corner of Gehenna to find out what had happened. There was speculation from every corner of the many lands.

Representatives from most of the countries arrived to see the damage. Promises were made for aid and true to their word, a few days later the aid arrived. Old Scratch told Yves to get out there and help with the relief efforts.

Yves established a central staging area where the aid was brought and stored. The Flatfeet sent blankets and the Boozles gathered nails and small tools for construction. Thimble-rigs offered themselves to help transport the needed supplies. The effort seemed to naturally organize itself. Whatever was needed, it arrived. Apparently the populous knew what to do. Houses were built and fences restrung. Cattle were herded back to their owners and penned. There were days when Yves just kept an eye on everyone. The people knew what to do and do what was right.

Near the end of the effort, when everything was accounted for, a Lilium citizen brought a cow to the relief station. It'd been sucked into the sky and landed on the up slope of Mt. Thisseless. The cow must have wandered for

a week until it was rounded up by a local. On his own accord, the finder led the cow back by himself.

"How many days have you traveled with this cow?" Yves asked, amazed.

"Only a couple of days," the Liliman said. "I knew she inhered in Curdland. The question now is, where in Curdland does she belong?"

"We'll just check the ear tag here...um...yes, this one belongs to farm number 67C. Thank you. We will take care of her now," Yves said thankfully. "The owners will be grateful."

Yves leaned against the door jam with his arms and legs crossed in a relaxed pose. His shirt sleeves were rolled above the elbow and he kept an eye on the cow being led away. The Liliman headed back from where he came. Yves smiled, indulging in the warm glow in his heart that was big to bursting. He'd always wanted to help this way—up close and one-on-one. *Life, before this never offered such a situation,* Yves reflected.

Sixteen

Magus, the autocrat of Gehenna, was overmuch impressed with the derring-do of Yves, Scratch and Gourdhead that he, Luci and her entourage, from Chicane-City, made a state visit. Preceding the arrival of Luci and her associates, two whirly-topped planes descended low over Lilium in a fantastic aerial display. Each plane traversed sharp turns, climbed and made loop-the-loops. The planes glided side by side as they entered the skies over the Deadly Lilipond, then they parted. One circled around over Curdland while the other flew over Curiosa. The folks on the ground cheered when they recognized the incoming fliers. Then both whirlytops headed for the Mineral Palace.

Their spinning blades slowed just before they made a soft landing in a clearing outside the Mineral Gardens. The two silver and glass torpedo-shaped planes came to rest on the ground while their rotors slowly spun down with a funny whiny sound.

Yves, Scratch and Gourdhead raced out to greet the fliers. Through the square panes of glass Yves caught sight of the passengers getting ready to disembark.

"Well, what did you think of that?" Old Scratch excitedly asked of Yves.

"I've seen airplanes, but none like this," Yves said breathlessly.

Magus the Great Enchanter, Luci and Ms. Dunklethorne, Luci's chummy aid, climbed down a ladder from one plane while Weaselwords and Fourflusher climbed out

of the other. They stood in a line expecting to be greeted. Scratch, Yves and Gourdhead stepped over to them.

"Greetings and welcome to the Mineral Palace," Old Scratch said. "May I introduce Yves and Gourdhead?" Gourdhead and Yves presented themselves, bowing before the guests.

"Please, let's not be so blasted formal," Luci sniggered with irritation. "Take us to the palace or whatever it is now. We have a lot to thrash out." Luci was wearing a rumpled, armpit stained green silk dress with whitish discolored lapels. On her head sat a barely balanced brassy crown and a large drooping flower was draped over each ear. Not the unassuming nature of a ruler.

"Onward, to the palace," Magus commanded. He was wearing his shiny-in-all-the-wrong-places black tuxedo with knee-length, ratty-looking formal tails. His moist white shirt was topped with a weary black bow tie which bore a resemblance to a dead butterfly. His mouth held an old chewed unlit cigar, his breath heavy and dark. His was hair pushed back reeking of tallow.

The group left the Whirlytops behind and made their way through the gardens and into the palace. Old Scratch spoke to a worker. "Take our guests to their rooms; they may want to relax and be refreshed." Scratch winked and fanned the air in front of his nose.

"I would be happy to," the worker said. "Please follow me." The visitants followed the worker down a hall then up some stairs.

"Can you believe this?" Old Scratch exclaimed. "Luci and Magus...here, to see us?"

"Scratch, don't you think we deserve their company?" Gourdhead commented. "Ultimately, did we not free Sath

of Sathedra?"

"I guess we did do a good thing," Old Scratch reflected.

"You bet we did," Yves said. "We freed the land and then rebuilt it. We honestly deserve a pat on the back."

Say Kage arrived later that same day and was warmly greeted by Yves. She was carrying a bag and she reached in and pulled out something pink.

"My hat! Where did you find my hat?" Yves exclaimed.

"Some friends of mine were in the forest near the downside entrance and they brought it to me. I remembered it was yours." She handed it to him and he put it on and swished the feather around. It did look good on him.

"Thank you, Say."

"Where are we going to put me?" she asked.

"Oh, we have a room for you," Yves said. "Please follow me." Yves grasped the bag and escorted Say to her room where she took a long, hot bath and was given clean clothes. When she presented herself again to Yves he was struck by her beauty. Even in her advanced years there was a refinement that transcended her age. She walked with the grace of a dancer and spoke with elegance. Yves was taken by her mannerisms. Why not. She reminded him of his wife Kay.

Scratch and Gourdhead thereupon planned a grand parade to be staged in everyone's honor. It would be a celebration for every part of the land and it took place on the road tracking through the Mineral Gardens. Scratch asked Gourdhead to make up a list of other dignitaries that needed to be contacted and send each an invitation. The parade would be in two days and the invitees needed to make haste. Gourdhead got the fastest runners, the swiftest birds and smartest Lilipeople on the root network to

send the messages. Word came back saying, most would be arriving on the morning of the spectacle.

On morning of the procession the avenue was lined with all sorts—Curiosa people, Lilipeople, Mineral people and Curd people. The first to head the parade was Weaselwords, pompously waving the sooty-looking flag of Gehenna. His high-stepping set the poignant mood and his bushy tail flipped from side to side. Magus followed next. Our heroes: Scratch, Yves and Gourdhead, marched side-by-side in the middle.

King Solanum, Ann Thology, Dick Shinary, Say Kage and Queen Creamy followed the intrepid three. Luci brought up the rear of the bigwigs. Many in the parade were from lands far away. There were Thimble-rigs, Ballsups and Flatfeet, Boozles, Foboffs and Pinchbecks advancing along in dissonance. They hardly wanted to be there let alone be in a parade. One more for Luci, they were warned.

Mandatory applause dribbled out as each group passed by even though the marchers looked grumpy. Still, despite this, there were wagons filled with young children who threw candy at the crowds. Bells clanged and dancers danced. Musical bands from Curiosa celebrated the new understanding as their drums beat out the cadence. Gymnasts performed hand springs and tumbled over each other. Many brightly colored groups held balloons and sometimes let them rush into the sky.

On they marched, right to the front steps of the Mineral Palace. The importants, cheerless mostly, ascended the steps first, turned around and faced the multitude. The commoners filed in front of them and stood grave faced waving cheap five-and-dime flags. They were waiting for

something to begin.

Yves guessed that there were thousands of spectators. As he scanned the crowd, he picked out Diddlespider as he stood a head taller above the others. The spider's snout curled in and out with tediousness. He really wanted to be someplace else. Yves waved to catch his tiny black eyes and Diddlespider tilted his head and his mouth parts barely smiled back.

Then Yves raised his hands to silence the masses. The crowd hushed to near silence. Yves turned to Luci and bowing as low as he could, seeing her crooked shoes, said with discretion, "Luci, we welcome you to the new Land of Crystallis."

"Thanks, Yves," she said tersely. Then she looked over to our other heroes and said, "Cat and Stickman?"

"Yes," Scratch and Gourdhead said as one. Scratch was polished to a gleam; every facet glittered and Gourdhead sprouted a new arm and acquired a new gourd.

"And may I also say that we are grateful for your visit," Old Scratch said with as much dignity as he could rally considering the look of Luci. "Your presence here gives us more confidence and resolve in order to solve our problems." He stretched large until his crystal whiskers tinkled.

"Sure, thanks," Luci returned with a cough. She pulled a short cigar from her pocket, lit it, then sucked a long breath until her lungs were full of smoke. She exhaled gray stinky swirls. "Well, I am also here to confirm your ruler ship of this place." Scratch knew that already. He didn't need to hear it from Luci. Believing it himself was enough.

Yves took Luci's clumsy hand and helped her up one higher step. There she could better look out over the land and people.

Yves smelled the smoke, wishing he could have a drag. Luci handed the cigar to Yves while she read from a ratty piece of paper. "Good citizens of Crystallis," Luci began after waiting for silence again to fall. "I, Luci, of Chicane-City, do hereby pledge the power of Gehenna to back you in whatever your endeavors might be. I confirm the right of Old Scratch the crystal cat. He shall be your rightful monarch. Obey him because he has the wisdom of age." Old Scratch blushed a light tourmaline pink.

"Good people of Crystallis," she continued with stogie breath, "you also have earned the right to travel anywhere in Gehenna. You will be welcome wherever you go." She turned and gazed soberly at Old Scratch. "Now, if Old Scratch would come here, please."

Old Scratch, trotted up to Luci then stood there. She placed a gold colored band on his head. The crown was studded with many faceted gems. The inscription of Gehenna was right on the front.

"With this crown I welcome you to the Court of Rulers in Gehenna." Speaking aside with a low drizzly voice she continued, "Keep your nose clean and you may visit and confer with other rulers in Gehenna to help solve problems." Luci returned to the crowd, holding Scratch's crystal paw in the air, she coughed then voiced, "May I present Scratch, the Monarch of Crystallis."

A deafening cheer soared through the throng. It lasted for a good while. By and by it became quiet again. Old Scratch stepped sideways to a higher platform and pointed to Gourdhead.

"My first proclamation in the land will be," Old Scratch ordered, "that Gourdhead is to be my prime minister!" There was small cheer and Gourdhead glanced at Scratch

with an amazed demonstration.

"Me...really?" Gourdhead couldn't believe it. Now he owned a purpose, a promise made flesh.

"Yes, Gourdhead, and I want you to indulge the Mineral Gardens for me, too." Pride could be seen radiating from Gourdhead's face. He would be the best darn prime minister Scratch ever had.

Yves was feeling lost in the excitement. Luci noticed this and she stepped back to stand beside Yves. She knew that this was not his place.

Luci whispered hotly to Yves in a way that did not distract from the proceedings, "Don't be troubled, everything will be first-rate here. You may one day return, you know." Her weary eyes surveyed the crowd. Yves certainly would, if he knew how. He wasn't even sure how he got here in the first place.

What is Gehenna?" Yves said sideways to Luci.

Giving him the once over, then poking him in the chest with her knuckles, "Gehenna is not a happy place. Never was supposed to be. Magus sees to that."

The assemblage cheaply cheered Old Scratch as he spoke more, "There will be peace in the land, I promise that. I will have a word with the Great Magus and Luci before they leave. The only thing I want from you is...industry and hard work! We face a short time of finishing our rebuilding and then you will feel a sense of wellbeing. If any of you need my advice, please feel free to visit and consult me. I will endeavor to be true to the calling. Please rejoice, then return to your homes and complete your work."

Say retired to her room while Yves, Scratch and Gourdhead found wishing trees and got an evening meal pre-

pared. A tray of food was sent to Say's room, as she had requested. The dignitaries enjoyed, as best they could, trays of fruit, plates of baked fowl and drink in great quantities.

Yves insisted that everyone would enjoy rounds of wine. Yves wished for pink wine, brown wine and amber wines, too. Some wines were sweet, others were dry, somewhat sour. Luci rather liked the sweet blushes while Magus fancied the dryer reds, more robust. It tasted good with his cigar. Scratch got pleasure from the lightest pink wine. He turned his nose up at all the others. Gourdhead sampled all the wines and ended up smashed much sooner than the others.

By the end of the evening, most were inebriated beyond help. All made it to their rooms collapsing in stupors. Only Say kept a level head and had fewer glasses of wine.

The next day a groggy Yves, a tired Scratch and sleepy Gourdhead liaised with an unsteady Magus, a bleary Luci and her shaky company. They met in a quartz conference room.

"Bring Sathedra in," Luci commanded quietly. A few moments later the skeletal Sathedra was presented in chains. She stood at the opposite end of a twenty-foot mineral table. Luci and Magus sat at the other end. Everyone else sat at the sides.

Magus put a dirty hand in the air, hushed the crowd and in a smoky voice was the first to speak. "Sathedra, you are charged with misusing your power. Do you have anything to say?"

"I might have...misused a little," Sathedra said tearfully. "But there was peace in the land, wasn't there? Didn't I help everyone I could? What more could I've done?"

"You confess to all the charges I have here?" Magus

asked, waving a half-rolled parchment.

"Yes, I suppose so."

Luci asked, "Sathedra, what possessed you to do this?"

"I don't know." Sathedra's chains clanked noisily on her bony wrists. "In my home town, I was a lonely child. I enjoyed few friends. I got into trouble and was sent to Boneland. When I saw the opportunity to get out of Boneland, I took it. Then I learned the magic from you Magus, but you know this already. Guess the power was too much for me. I wanted to help everyone. The more I helped them the more they resented me. Why was that?" Sathedra stared hard at Luci. The reduced bony creature remembered the fun she once engaged in.

"Sathedra," Luci said, "people will resent you if you force your help on them. They have to ask for it. Spittle-spattle, you should have known that."

"I know, I know. There, you see," Sathedra said woefully, "you always have the right answer."

"Is there anyone here who wishes to speak for Sathedra?" Magus asked.

A white duck, with a short downy tail, pushed his way through the tangle of legs and waddled up beside Sathedra.

"My name is Gabby the Duck. I come from Lilium. May I speak?" Yves and Scratch shared a smile, glad to see their web-footed companion again.

"Let's have it," said Magus.

"I know the troubles that Sathedra caused," Gabby began. "But I also saw the good she did. Sathedra gave the land peace. She also gave all their colored skies and beautiful sunsets. And the wind kept the books dry in the great book depository under Appellation City. She kept the milk flowing in the runnels of Curdland. She even kept fire out

of Curiosa. Sure, she did some appalling things but I think the good she did balanced the bad she did. Thank you." Gabby wagged his short tail feathers and waddled back to his place behind the line of feet.

No one believed Bonepeople could shed tears, but Sathedra stood there with tears dripping from her empty eye sockets. "At least one understood what I was doing," Sathedra cried wistfully.

"We knew what you were doing," Magus said, "but we had to leave you alone. Left alone, you would find yourself...good or bad." Magus continued abruptly, "You will be sent back to the Bonepeople."

Sathedra gasped, "No, please no!" Those were her only words she could say as she was led from the room.

Sathedra was sent back to finish her sentence—back to the criminals, the outcasts. Years later she would be returned to her home, where she could be seen taking care of the homeless dogs and cats in her small town. Sathedra would be happy at last. She learned her lesson—not everyone is meant to rule and that you cannot have power over without accord.

Congratulations were shared among the dignitaries and a regular meeting was convened.

"Luci, how can we make the bugs quit eating at the books in Curiosa?" Scratch asked.

"Scratch," Luci started, "if the insects are nibbling at Ann Thology's residents, then the bugs are hungry. You could find something else for them to eat." The simplicity of her answer again hushed the crowd.

"This may solve the problem in Lilium, too," Scratch commented.

Luci continued. "You will find that if you meet the basic

needs of your people, then discontent will disappear. The best solutions are often the simplest." The Great Enchanter nodded his head. "Don't complicate their lives with too many rules. Provide a basic structure in which the people of your land can live. Don't stifle them or their talents. You will then see everyone do their best." Cheering could be heard coming from outside the meeting room. This sent waves of good feelings across the land.

While the meeting bore on, Yves glanced out the window, eyeing the Whirlytops. He wanted to take a ride just for fun, but he didn't think Old Scratch would approve of a fun ride, subsequently he suggested a business trip over his realm to check up on the rebuilding.

"Scratch?" whispered Yves. "Why don't you ask Luci if you and I could take a ride in one of those planes. It might be good to see the restorations in progress."

"That's a splendid idea! Yves, you do think sometimes, don't you," Scratch whispered. "I'm going to ask her right now."

Magus stood and asked if there was any more business. Scratch raised his paw.

"May I ask Luci another question?" Old Scratch said.

Luci nodded a curt yes to Magus. "Yes," Magus said.

"Luci, can Yves and I take a ride in one of those Whirlytops. I need to survey of the restoration of our lands?"

She glanced over at Magus shrugging her shoulders. He nodded affirmative. "I think that can be arranged," she came back. "Would tomorrow be okay? That way we can make your tour part of our flight back to Chicane-City."

"Tomorrow would be terrific," Scratch said. Yves was all smiles. "If there is nothing else to discuss," Magus con-

tinued, "then let's adjourn from this place." The rulers went their separate ways.

Scratch dropped back into his study and buried his crystalline nose in his books. Yves took Say out to reflect on the planes while Luci and Magus made a walking tour of the Mineral Palace and its gardens.

"What do think of Scratch?" Magus asked of Luci. Smoking their cigars, they strolled in and around the large crystal displays.

"Scratch seems to have what rulers need," Luci said. "He is skilled at thinking of others. I think he has a natural knack that will help him do good here." Magus nodded his approval. Luci continued. "He also has lots of dedication to this land. He won't be thinking to expand. Not like some people I know of. The countries around Crystallis should feel safe."

"Yes, I agree. Now what about this Yves? Is he just lost like he says, or will he want to continue here?"

"This Yves wants to get back and he will. I recall that you possessed those same feelings," Luci said to Magus. "But, you came back. You must've had business to do. I'm sure Yves has issues he must finish. When he's ready, he will return to Gehenna...that's how I feel."

"I'm sure you are right. He will probably stick it on here, helping Scratch rule. I think he will do well here."

Luci and Magus returned their jaded eyes to the Whirlytops and saw Yves and Say walking with one accord, holding hands. Yves was pointing at the names on the planes. Say was acting impressed. Yves held Say's attention.

"Yes, I think he will come back," Luci said precisely. "I'm sure they are a comfort to each other." Magus nodded his perception.

Seventeen

The following day, Luci, Magus and the others climbed aboard the planes. Yves and Scratch climbed into the plane named "QR1." They waved good-bye to Gourdhead through the square panes of glass. The inside of the plane was just as shiny as the outside but the air inside was stuffy and smelled like an oil can. One command chair was forward and four other passenger seats were behind that. Luci and Ms. Dunklethorne took the passenger seats. Scratch and Yves stood, holding the brass railing connected to the inside of the plane. Magus sat in the command chair and started operating the controls. He checked out the windows to scan the area for takeoff clearance.

"QR1 to QR2," Magus boomed into a large microphone. He turned to look out the window.

"QR2 here...Weaselwords speaking."

"Remember, you are to return directly to Chicane-City. We will fly over Crystallis, drop off our guests then follow you shortly. Do you savvy?"

"Yes Enchanter. Understood."

"Good...begin rotation," Magus commanded.

The Whirlytops began humming. The pitch rose until the resonance actually became silence. Magus pushed some buttons and pulled a few levers. The rotors spun faster, then tilted and grabbed some air. Then the two planes lifted off the ground. As the blades seized more air, the planes climbed faster.

Scratch and Yves struggled against the acceleration to

peer out the windows at the ground far below. It receded at an alarming rate. Then their climb slowed and Scratch noted the havoc the battle had caused. QR2 rolled off and headed for Chicane-City as ordered. QR1, the whirleytop Yves was in, banked right; Scratch saw the builders hard at work on the new homes. Work was progressing quickly. Groups far below waved at the planes chugging over their heads. Scratch imagined he could hear their cheers.

As the plane banked and soared, Yves had the uneasy feeling that he'd seen this landscape before. He saw with certain clarity that he had; it was his painting. He'd been right the whole time. It was like seeing in his mind's eye *his* painting, but now he was flying close to it—like his nose to the canvas. He could all but smell the linseed oil and turpentine medium. Even so, he said nothing. He pondered the lands. He saw the flake whites, the burnt sienna shadows, the umbers, every blue, yellow and green. This was his creation. No one would believe this, here or in Woodbury.

The Whirlytops flew to the left and started toward Curiosa. They crossed the seas and made a low pass over the walls of Appellation City, then climbed again as Magus shifted some levers. All seemed well despite the devastation.

"Uh oh!" Magus exclaimed. A red light was blinking insistently on the control board. "We are, for the most part, out of fuel."

"What does that mean?" Old Scratch asked. Magus pushed buttons and flipped levers full on.

"It means that we have just enough to get you two over to your palace, drop you off, then glide back to Chicane-City."

"That sounds good enough," Old Scratch said with relief.

"All right with me, too," Yves said.

"You don't realize. I mean drop you off. Open that storage box behind you and put on those puffchutes."

"What?" Scratch exclaimed. "You are dropping us out of this thing?"

"That's what I have to do. You see, with your extra weight on board, we used too much energy. I don't have enough fuel to land and climb again. You will have to jump. Now, find those puffchutes!" Magus wiped the beads of perspiration from his head and sucked harder on his cigar as if it would help his plane fly.

"Scratch, I think everything will be okay," Yves said. "Come on, let's get into those puffchutes."

The plane started back toward the Mineral Palace. It banked right, then left. Scratch helped Yves on with his 'chute, then Yves helped Scratch on with his. Magus called out over his shoulder, "Are you ready yet? Any minute now."

The puffchutes were checked and Yves said, "Ready!" They were coming up to the palace at top speed.

"When I make a turn around the palace it will be time to jump," Magus called back at the pair.

"Okay!" Scratch hollered. He stared at Yves then blinked both eyes.

"Don't worry," Yves mouthed. Yves pointed to the ripcord and indicated to pull it after jumping out.

The plane made the final turn. It banked. The door opened when Magus pulled a rope. Air rushed past the exit and Magus ordered them to jump. Yves lifted Old Scratch by the 'chute and tossed him out the door. Yves waved

good-bye, then jumped head first out the exit.

Rip-cords were pulled and the 'chutes grasped air and opened, much to Scratch and Yves' joy.

Gourdhead watched as the plane made a swift turn and bank around the palace. An opening appeared in the side of the Whirlytop and right after that two dots shot out.

"What the," Gourdhead said, watching the two dots begin to fall, then poof a 'chute opened, then another right above the first. They gave the face of tiny mushrooms drifting down. The Whirlytop again soared into the sky, then began gliding back to the far-over.

The two dots became figures and Gourdhead could just recognize Scratch and Yves. Gourdhead started running toward their expected touch-down site. Minutes later, Gourdhead stood right under the descending pair. Yves was heading for a grove of old trees and Scratch landed behind a crystal tor. Yves crackled through the branches and was hanging a few feet off the ground. Gourdhead heard a yelp, then a splash. Gourdhead got over to lift Yves, then unhook his straps. Yves dropped into Gourdhead's strong oak arms.

"Are you all right?" Gourdhead asked.

"I seem okay...where's Scratch?

"He landed behind that rise. I heard a splash."

They sprinted to the brink of the hill and saw Old Scratch sitting in a fountain covered with his puffchute. They could hear Scratch muttering all sorts of words that couldn't be spoken even in Luci's court. They loped down the slope and came within reach of the fountain.

"Scratch, you all right...not hurt are you?" Yves yelled.

"I'm down now...just get me out of here!" They pulled the 'chute off the fountain and there they beheld Old

Scratch in the arms of a crystal simulacrum of Magus. Gourdhead jumped up and helped Scratch down.

"That's the last time you will find me in one of his inventions!" Old Scratch yelped, shaking off the water.

"You and me both," Yves said, "let's get back to the palace. There's lots to do."

Everything was going along well and in time the other dignitaries left. The Curiosa people received their wind and they maintained no secret now. The Athenaeum was opened anew and a new filing system was established. It would take them many years to get it completed, but everyone would be far better for it.

The Deadly Lilipond was transformed into a sea of new waving seedlings. These were to grow into young Lilipeople. The hidden city was no longer a secret and traders started to go back and forth between the lands. There was such joy in the land now. No one was afraid of being attacked or destroyed by the Reds. There was peace once more.

A few weeks later Say was placed in charge of painting the flowers throughout the country. Each spring, summer, fall and winter she would go around making the land as colorful as she could. This pleased Yves and it made Say very happy.

More weeks passed by with the whole enterprise going well in the Crystallis. One day Yves said to Scratch, "I think it's time to go. Come with me to the wishing chamber and see me off."

"Wait, I'll get Gourdhead and Say Kage," Old Scratch said.

"All right, I will wait," Yves replied. "But not much longer." Gourdhead and Say Kage arrived and wondered

what was happening.

"It's time for me to go," Yves announced sadly. "Everything that can be done by me, has been done. I hope what I have done was right and it will last for a long time. Remember, I am just an artist and I will always believe that I created this whimsy. It might seem odd, but that is what I believe. I also know...I may not be able to come back once I leave. But, whenever I look at this painting, I will think of you and remember the good times we valued." A tear came to his eye and a lump formed in his throat.

"I know that you, Gourdhead," Yves continued with a tremble in his voice, "will pamper the gardens and see that nothing happens to them. Say Kage, I have faith that you will tend the colors of the countryside. And you Scratch, you have helped me through this whole shebang. It was you who rescued me and took me to those who could help me. You have taught me just what kind of dreams I have.

"Within each one of us," Yves continued, choking back tears, "there is a mind-world, unseen from outside notice. You and these people, this land and all that is here, is part of my way of thinking. It can never be taken away from me."

"What you did for us is immeasurable," Old Scratch said. "You triggered changes to happen."

"You know, Scratch," Yves said, "when we are born, we turn a thread in the weave. When we engage in a positive and fulfilling experience, we help create a pattern in the lace of life. When we die, we become part of that pattern which we call history."

"You mean we share a history now?" Gourdhead asked.

"I can picture it now," Old Scratch said, "we are part of your history and you, ours."

"That's right, Scratch," Yves said. "I enthused you and you have influenced me."

Say stepped over to Yves and took his hand and squeezed it. "Yves," she said, "go back and be a friend to those nearest to you. I will take joy in your journey home."

Scratch turned and hit his tail on the door. "Chink," the end of his tail broke off. "Darn, not again." They all laughed. Scratch picked up the shard of crystal and gave it to Yves.

"Thank you, Scratch." Yves tossed it in the air and caught it, then put it is his shirt pocket and buttoned it.

Yves could hardly finish what he was saying, but he did manage to say, "Good-bye Old Scratch, careful of that tail...good-bye Gourdhead, farewell, Say Kage." And with those words, Yves slipped into the wishing chamber. He stood there gazing out through a crystal window at his newfound friends, then made his wish. "Please send me back to my home in Woodbury, Connecticut." There was a gust of wind, a flash of light and Yves disappeared in a cloud of stinky yellow smoke.

Eighteen

"Yves!..Yves!" Kay yelped as she shook him out of a deep sleep. "Wake up...come on, snap out of it!" Kay flipped on the light to find him folded with his knees to his chin, asleep on the old couch. He was jolted out of a sleep of exhaustion.

"Say...Scratch?" Yves mumbled in a stupor. His mind was clouded in yellow smoke.

"Why should I say scratch? Who is Scratch?" Kay asked, perplexed. Yves mind cleared quickly.

"Say...I mean Kay! Oh...Kay. I've missed you!" He rose, gathered his wife in his arms and gave her a good, lingering hug.

"All that just because I drove into town? I was only gone for a couple hours. Are you all right? Here, sit." She pushed him down on the couch again and she noticed his studio was a mess.

"What happened here?" Kay said, checking around the studio. There in his studio she saw the overturned stool, the spilled paint and the painting lying on the floor.

"I'm not sure," Yves said truthfully.

"Well, you'd better get it cleaned up quick because Peggy from the Art Guild will be here soon. And by the way, you called me Say. Who is Say?"

"I must have been dreaming," Yves said.

"Yes, you must have been," she said, somewhat annoyed. She tossed the paper bag of newly-purchased oil paints on the couch and walked into her own studio.

Yves set the stool back upright and carefully, so as not to smear the wet oil paint, positioned the canvas back on the easel. He sopped up the spilled paint and medium with a rag, then stood back, viewing the painting. Was that experience, in actual fact, in his mind or was it just a mental brew? If it was a fantasy, then why the spilled paint? He thought of the things that had happened. He saw an insect climb up his pant leg. Not thinking, he flipped it off onto the floor and let it scurry away. He sat down, contemplating what he had created. Was each painting a part of his clever world? *Could I have created all that is there?* He felt in his shirt pocket and smiled.

Yes, he'd painted a dream, but it was not supposed to end up in his real. Had he come to the point in his artistic life where he resided in the real world, painting what was in his mind? If this was true, then Yves had just scratched the surface of what he genuinely wanted to paint. He wanted to paint dreams, dreamscapes and those blinkered recesses of his mind. Had he, in the end, accomplished his goal?

Apparently Mr. Tanguy did not feel as if he'd fully "made it" because he endured a while longer to varnish paintings he'd started years before. In his paintings, the dreams are untold. What was he thinking when he painted them? Did he experience the deep feeling he felt with "Imaginary Numbers?" I think he did, because for what other reason did he paint, but to reveal the innermost reaches of his mental state?

Many times Yves would stop at one of his paintings and press his fingers onto the paint, hoping they would pass through the canvas. He would never perceive the colors red, blue or green the same ever again.

In January 1955, Yves felt he would die, he could feel it in his headaches, his swollen-head feeling and those occasional vision changes. Near the end of his life did he want to go back to Crystallis and be with his friends? We are not sure if he got there or not.

But, what if one day, in that January, just before his death, his studio was found empty? What if the paints were left neatly stacked and one brush with wet paint sat on his stool. What if "Imaginary Numbers," his last known painting was positioned on the easel with a piece of pink notebook paper stuck to one corner. It was a poem that had something to do with keeping on.

He was not a shallow man. His mind functioned at the very heights where men and women have always wanted to go. Yves' paintings reveal to us the workings of his mind. Just research his paintings and you will see strange lands. Listen to his paintings and you may hear a "chink." Let your mind roam free through his landscapes; once this is so, you will see all that I have written. You might even see Yves, Old Scratch with half a tail and Gourdhead waving their arms back at you, trying to get you to take notice. They are there. They must be there because they were in the mind of Yves Tanguy.

Epilogue

As you can see, Yves Tanguy's dreams were quite varied. Not all of his noted dreams were used in this account. There are other dreams, other descriptions of paintings I did not use.

I discovered that the richness of his imagination could barely be explained or covered in this short piece. But I hope you will study a few of his paintings. Paintings such as: Moma, Papa is wounded, 1927, Promontory Palace, 1931, The sun is in its jewel case, 1937, The motion has not yet ceased, 1945, From green to white, 1954 and Slowly toward the North are just a few of the mental landscapes he produced. Now imagine existences created by his mind.

And, who knows, maybe there are other stories that can be garnered from those old leather-bound papers.

List of dreams from Yves' papers I used in this book

Picked and ate an apple.
Cream colored paper.
Bones in shackles.
A large brass door.
Laughing into the wind.
Warm sand feels good.
Falling for several minutes.
Crystal cat clawing wood.
Crystal cat sitting on a shoreline.
Someone pointing in many directions.
Birds flying in morning light.
Multi-hued sky, clouds drifting.
Pendulum of a clock.
Overgrown landscape.
Flowers tossed onto a cart.
Piles of broken wax.
Sitting in the middle of a raft.
Gurgling of water.
Stumbling onto his backside.
Pushing hand into wood.
A crystal cat's facets.
Widespread devastation.
Touching something cool.
Creating lands separated by water.
Two green moons setting.
A hole in a hedge.
A resting place after hiking up a hill.
Loose papers and large books.
Sawdust and woodchips.
An auditorium filled with contestants.

ABOUT THE AUTHOR

Richard Albright served in the Navy during the Vietnam war and was awarded a bronze campaign service star. In 1972, he attended Utah State University Art School and graduated in 1975 with a BFA degree in photography with a minor in sculpture. In 1989, Richard and his wife were given special access inside Stonehenge and allowed to spend two nights alone in the monument, where they made photographs by electronic flash and flashlights. He now lives in Pocatello, Idaho and is married. They have two cats named Cookie and Sweetie Boots.

www.ingramcontent.com/pod-product-compliance
Lightning Source LLC
Chambersburg PA
CBHW020735180526
45163CB00001B/253